Currier's Price Guide to AMERICAN and EUROPEAN PRINTS at AUCTION

Current Price Ranges on the Original Prints of
Over 2600 American and European Artists at Auction

SECOND EDITION

text written by William P. Carl
prices edited by William P. Carl and William T. Currier

CURRIER
PUBLICATIONS

ISBN 0-935277-13-7 Softcover
Library of Congress
Catalog Card Number 91-72576

Printed in the United States of America

COVER PHOTO:

Bleeding Heart, **Margaret J. Patterson**, Color woodcut, 9 3/4" x 14 1/16", Courtesy of James R. Bakker Antiques, Inc., Cambridge, MA

Additional copies of this book may be obtained from bookstores and selected antique dealers. To order directly from the publisher, remit $18.95 per copy, plus $3.00 shipping and handling (book rate), or $4.00 (first class). MA addresses add 5% sales tax. For bulk order discounts (6 or more copies) please write, or call, for details to:

CURRIER PUBLICATIONS
P.O. Box 2098
Brockton, MA 02405
(508) 588-4509

[Make check or money order payable to CURRIER PUBLICATIONS]
(U.S. dollars only, please)

ACKNOWLEDGEMENTS

Many thanks for assistance with this new edition go out to:

William P. Carl, for the many hours he spent revising this second edition, the hundreds of new artists he added, and the revised and expanded bibliography.

Cynthia Tukis, for her expertise and valuable assistance in editing and preparation of the final copy of the text.

James R. Bakker Antiques, Inc., Skinner, Inc., and the Morisi Ortiz Family Trust for providing many of the photographs in this *Guide*.

Sara and Fred Keylor for assistance in compiling prices from auction catalogs.

Wanda Alves for her invaluable assistance in keeping this *Guide* accurate, and on schedule.

Nora Pires, for the many hours spent compiling and revising the thousands of prices which make up this *Guide*.

My parents, Lillian and William, for their encouragement and support - as always.

My wife, Donna, her mother, Lorraine, my daughter,Danielle, and my son, Christopher, who from the beginning, all supported me, encouraged me, and showed, most of all, understanding. I thank you especially, with love.

William T. Currier

Dedicated to all new and veteran print collectors.

About the Author

William P. Carl

A dealer in fine art prints and drawings in Boston, Massachusetts since 1976, William P. Carl is a well-known expert in fine art prints - 16th century to the present. His academic background includes a Bachelor of Arts degree from Colgate University and a Master of Science degree in library science from Simmons College. He has worked as a curatorial assistant in the Wiggin Print Room of the Boston Public Library and from 1976-1982 he was head of the print department of Childs Gallery, Boston. Mr. Carl has served as an advisor to museums and private collectors and has organized innumerable exhibitions.

Of special note is William P. Carl's own artistic ability. For the past several years he has specialized in producing color woodcuts, and to his credit the Boston Public Library, the National Museum of American Art in Washington, as well as several notable private collectors have acquired his work. He is presently represented by the Annex Galleries in Santa Rosa, California.

Mr. Carl can be reached in Boston by writing to Post Office Box 600, Astor Station, Boston, Massachusetts 02123 or telephoning him at (617) 353-1367.

TABLE OF CONTENTS

■ Preface xiii

CHAPTER ONE

Pricing Your Print

■ Purpose and Focus 15

■ Printmaking Techniques 15

 RELIEF 16
 INTAGLIO 20
 PLANOGRAPHIC 24

■ Factors Which Determine Value 30

 NAME 30
 CONDITION 30
 QUALITY OF IMPRESSION 32

■ Additional Factors Affecting Value 33

 MARGINS 33
 SIGNATURE 33
 EDITION SIZE 34
 RARITY 35
 STATES 36

- Caution - Reproductive Prints 37

- Types of Reproductive Prints 38
 - REPRODUCTIVE ENGRAVINGS 38
 - PHOTOGRAVURE REPRODUCTIONS 39
 - COMMERCIAL OFFSET 40
 LITHOGRAPHS

- Pricing Your Print: A Summary 40

CHAPTER TWO

Using This Guide

- An Overview 43

- Establishing Price Ranges 44

- Our Sources 44

- The Three Printing Techniques 45

- Artists in Dealer Catalogs 46

- DISCLAIMER 48

Fine Art Prints at Auction

- A - Z 49-197

Artists in Dealer Catalogs

■ A - Z 199-221

APPENDIX

■ **BIBLIOGRAPHY** 225

 AMERICAN PRINTS 225
 GENERAL 227
 CONTEMPORARY PRINTS 231
 PRINT COLLECTING 231
 PRINTMAKING 232
 PRINT CONNOISSEURSHIP 234
 CARE AND CONSERVATION OF 236
 PRINTS

■ **PRINT DEALERS** 237

■ **AUCTION HOUSES** 243

■ **REFERENCE BOOKS** 248

■ **INSTITUTIONS** 251

PREFACE

Until the author, William P. Carl, provided the information for this *Guide*, there was no other practical reference available in an inexpensive, compact, concise and easy to carry format that could help quickly assess the potential worth of fine examples of American and European prints, from the 16th century to the present. It will be invaluable to: antique dealers, auctioneers, print collectors, estate lawyers, bank trust officers, art consultants, appraisers, and print dealers. *Currier's Price Guide to American and European Prints at Auction* may well be the most profitable investment that anyone, who has occasion to buy and sell fine art prints, could ever make.

You will find that you have purchased the most practical price guide to 500 years of American and European prints available today. The compilation of data here will be useful to even the most seasoned veteran:

▶ Accurate spellings of artists' names.

▶ Accurate birth and death dates not easily found elsewhere.

▶ Price ranges for as many as three printing techniques for each of the over 2,600 artists listed.

▶ A "special" list of over 340 artists who appear frequently in dealer catalogs nationally, with the price ranges for their work.

▶ An appendix containing public and private institutions for research, auction houses selling prints, and an extensive bibliography for further reading.

There are many instances which can be sighted where this *Guide* will prove invaluable. Some examples follow.

Auctioneers can use the price ranges to help establish a starting

bid on prints by artists with whom they are unfamiliar, or help screen prints for possible consignment.

Print collectors will find the *Guide* extremely interesting and especially helpful when hunting for artists whose work falls only within certain price ranges (e.g., $400-$7,500) and/or who specialize in certain printing techniques (e.g., relief, intaglio, etc.). Many collectors will want to carry a copy with them as they frequent yard sales, flea markets, thrift shops, or country auctions. Not infrequently, many "sleepers" can be uncovered.

Appraisers can use the *Guide* to quickly find what the highest price realized at auction has been on a particular artist's work. They can use this information as a starting point, then proceed to do further research on the actual auction results.

Because of information gleaned from our *Guide*, many estate executors may want to pursue a professional appraisal on certain prints. It would not be unusual for someone running an estate "tag sale" to price something well below its true market value.

Antique dealers, who have occasion to buy and sell prints, but who have very little knowledge of the print market will find our *Guide* to be one of the most important reference books in their library. The *Guide* will help many dealers to avoid the problem of buying too high or selling too low. And help them to *quickly* assess the *potential* value of prints in many situations: house calls, estate sales, etc. Dealers can quickly determine if a recent purchase needs more research before pricing it for resale.

Add to the list, the many thrift shop owners, pickers, museum personnel, art framers, and yard sale and flea market fanatics who will find our *Guide* useful; and you can only agree that *Currier's Price Guide to American and European Prints at Auction* is the first place to look for values on the works of over 2,600 artists worldwide.

One final note: You are welcome and encouraged to comment, and feel free to suggest changes or additions which will improve this *Guide*. Please write or call:

CURRIER PUBLICATIONS
William T. Currier
P.O. Box 2098
Brockton, MA 02405
(508) 588-4509

CHAPTER ONE

Pricing Your Print

Purpose and Focus

The purpose of this *Guide* is to assist you in determining the value of a particular work of graphic art. This is not necessarily a quick and easy matter, as most of you probably realize. The field of original prints is complex, diverse and prone to all sorts of exceptions. Nonetheless, what we attempt to provide here, for the novice, is a starting point for further research and discovery. We are here to help you assess the *potential* value of your original prints, whatever they might be: good or bad, major or minor, old or not so old.

The focus of this *Guide* is the "fine art print." Broadly speaking, this refers to an original work of art produced from a matrix: a plate, block, stone or other such surface on which the artist *himself* has created an image. Every impression, or print, taken from this printing surface is an original work of art. The fact that more than one impression exists does not in any way lessen the merits of an artist's prints. Some artists simply choose printmaking over painting, drawing or sculpturing as a means to express their ideas at a particular moment. According to some art critics, many artists over the centuries produced their best work in fine prints - prints that they, themselves, created.

Printmaking Techniques

The fine prints of which we speak are most often produced by one of three basic techniques: relief, intaglio, and planographic. Nearly all forms of original graphic art will fit into one of these three categories. There are mixed media prints which can be quite complex but, for the purpose of this *Guide*, it will suffice to briefly describe the three working techniques. You should consult the bibliography at the end of this *Guide* for further information on the specific techniques of printmaking.

RELIEF

The relief technique, which is the oldest and most basic method of making original prints, encompasses woodcuts, linoleum cuts, metal cuts and wood engravings. Basically, a design is drawn on the surface of a block and the area around the design is cut away. The surface in relief is inked and then printed.

Albrecht Durer (1471-1528) used this technique with outstanding success in his woodcuts; the German Expressionist printmakers, among them Kirchner, Heckel, and Nolde, produced creative results with this technique during the first half of the twentieth century; and many contemporary artists are using it today.

Here are four examples of relief prints.

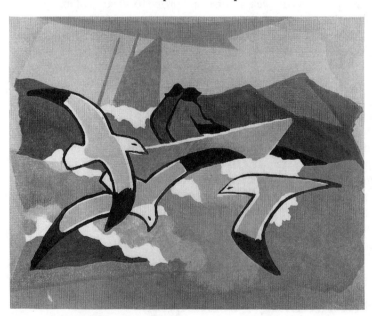

Dory Fishermen
by Tod Lindenmuth, color linocut
(Courtesy of James R. Bakker Antiques, Inc., Cambridge, MA)

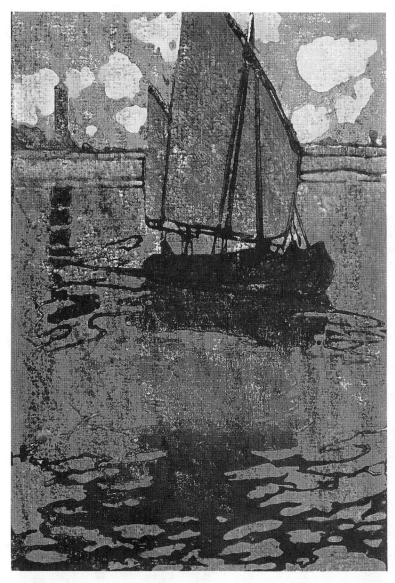

Torcello,
by Margaret J. Patterson, color wooblock
(Courtesy of James R. Bakker Antiques, Inc., Cambridge, MA)

The Convalescent
by Eliza D. Gardiner, color woodblock
(Courtesy of a Private Collection)

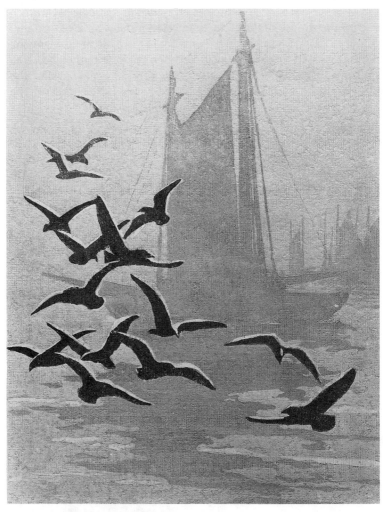

Gulls and the Fishing Fleet
by Tod Lindenmuth, color linocut
(Courtesy of James R. Bakker Antiques, Inc., Cambridge, MA)

INTAGLIO

The second basic technique of printmaking, intaglio, encompasses a variety of individual processes, such as, etching, drypoint, mezzotint, aquatint and soft-ground etching. Each can achieve quite different artistic expressions and can be used in combination or separately.

Intaglio, basically, employs an etched or incised design which is *below* the surface of the plate. In effect, it is the reverse of the relief technique. Acid is used to etch ("bite") into the plate or an engraving tool is employed to make an incision. Then the incised or etched area is inked and printed. The pressure of the press and plate against the paper results in a noticeable depression surrounding the border of the image. This depression mark is called the *platemark*.

The variety of effects that can be achieved is one of the strengths of this technique. Rembrandt, Goya and Picasso, for example, all used intaglio printmaking with success but their work side by side looks quite different. Although intaglio is a centuries old technique it is still being used today with great success.

Here are four examples of intaglio prints.

Morning, 1915
by Frank Weston Benson, drypoint
(Courtesy of Skinner, Inc., Bolton, MA)

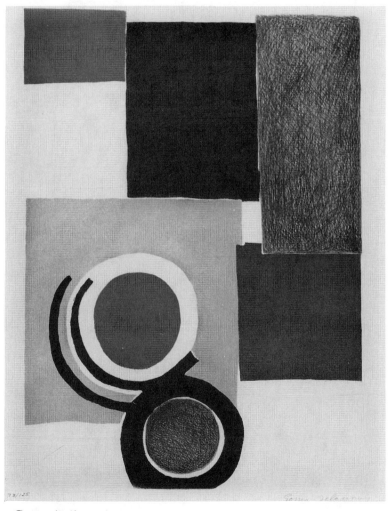

Geometric Abstractions
by Sonia Terk Delauney, color etching
(Courtesy of Skinner, Inc, Bolton, MA)

La Main, 1966
by Antonio Clave, aquatint
(Courtesy of James R. Bakker Antiques, Inc., Cambridge, MA)

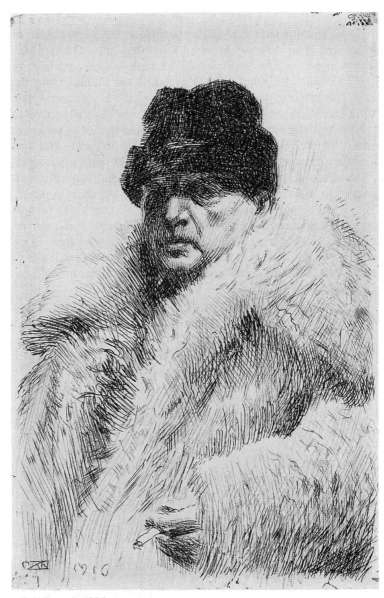

Self Portrait, 1906
by Anders Leonard Zorn, etching
(Courtesy of James R. Bakker Antiques, Inc., Cambridge, MA)

PLANOGRAPHIC

The third technique of printmaking is the planographic or surface technique, otherwise referred to as lithography. This late 18th century invention first flourished in western Europe and later in America. Unlike the relief or intaglio techniques, in lithography the design is drawn on a porous limestone or specially treated metal plate with a grease crayon. The design is then "fixed" to the surface to prevent the image from spreading. Water is then applied to the entire surface, followed by an application of ink. The greasy part of the surface - the design or image - attracts the ink, and the wet surface repels it. This inked design or image can then be run through a specially designed press from which the ink is transferred to a sheet of paper.

Lithographic printing is traditionally a complicated process and usually requires a professional printer to achieve the finest results. Unlike other graphic techniques, with this process there is the potential for producing very large editions (i.e., the total number of impressions) since the design on the stone and the stone itself do not easily wear down.

Here are three examples of planographic prints (all lithographs).

Westmorland Entrance
by Joseph Jones, lithograph
(Courtesy of James R. Bakker Antiques, Inc., Cambridge, MA)

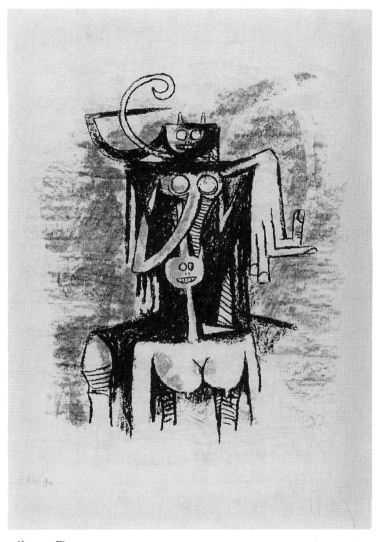

Abstract Figures
by Wilfredo Lam, lithograph
(Courtesy of James R. Bakker Antiques, Inc., Cambridge, MA)

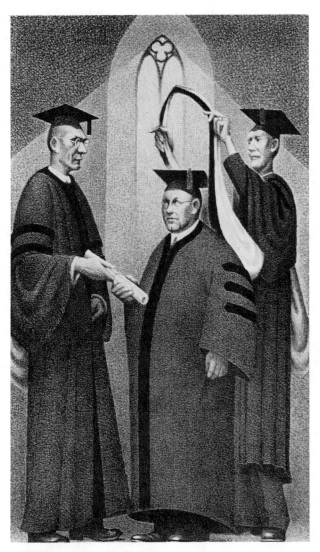

Honorary Degree, 1937
by Grant Wood, lithograph
(Courtesy of James R. Bakker Antiques, Inc., Cambridge, MA)

Please note: For the purpose of this Guide, the stencil and monotype process will be included under the planographic technique. A brief description of each follows:

Stencil

The stencil process, more commonly known today as silk-screen or serigraph, is a twentieth century innovation which first flourished in this country during the 1930's and 1940's in conjunction with the Federal Art Project in New York. Artists in France and England also employed this process during the first half of the century. The process is simple, requiring the artist to cut out a stencil through which pigment is squeegeed and an exact replica of the design appears on the paper. Silk is introduced as a supporting element to make printing easier and allow for more intricate design work. As the process became more sophisticated over the years, the cut stencil approach was superseded by the tusche wash-out method which is a bit more complicated.

The advantages of the silk-screen process are that it does not require a printing press and is well suited to designs which have broad areas of bold, flat colors. The disadvantage of this process is that the surface of a silk-screen print is easily damaged, as abrasions and cracks can appear quickly without proper handling. A detailed discussion of condition as it relates to prints and their value is addressed later in this text.

Monotype

The monotype process is an exciting and distinctive approach to making original prints, dating as far back as the 17th century. It flourished in the hands of Degas in the late 19th century, and today continues to be an improvisational and creative technique among contemporary printmakers.

The monotype process involves making a design with a quick-drying pigment on a flat surface, often a copperplate, and running it through a press. The resultant print is a unique work of art which generally cannot be printed in multiples, unlike the other

techniques which we discussed earlier. With this technique, if the same plate is run through the press again, the image will be much lighter and different in effect. Degas very successfully explored this concept and produced unique, but similar, multiple prints. As a general statement about monotypes, these uncommon prints have a very "painterly" look about them and brushwork is usually quite evident on the surface. Like etchings, monotypes *do* have a platemark as a means to identify them; lithographs do not.

Here are examples of a silkscreen and monotype print.

Petunias, 1943
by Blanche Lazzell, color monotype
(Courtesy of Skinner, Inc., Bolton, MA)

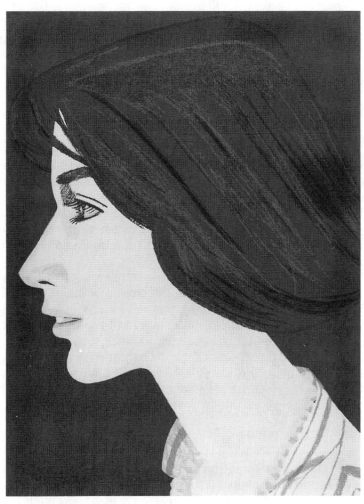

Susan, 1976
by Alex Katz, silkscreen
(Courtesy of Skinner, Inc., Bolton, MA)

Factors Which Determine Value

One of the most perplexing and ongoing issues is that of assessing the value of a particular original print, whether it is an etching, woodcut, lithograph, etc. Why is *this* Rembrandt etching worth more than *that* Rembrandt etching? Why does a tear in the image of *that* Whistler print make it worth so much less than another in fine condition? Why is *my* Durer print so close in many details to the one in the museum collection but still mine has no value as a photogravure? These are some of the questions which come to mind as we begin our discussion of values and relative values in the marketplace of fine prints.

NAME

First of all, the name of the artist is a key factor affecting the value of an original print. Who did it? That's the question which everyone asks first. Fortunately, most fine prints are signed; even most early engravings and etchings, e.g., those done during the time of Durer (16th Century), are signed in some way if only with a monogram; hence, the problem of dubious authorship which negatively affects the value of so many paintings and drawings is not as much a factor with prints.

So what's in a name? - quite a bit, unfortunately. There are innumerable lesser known artists who created beautiful prints and because of their lack of renown, they sell for less than what logic might suggest. Conversely, there are many well-known artists, particularly painters who also made prints, and their work sells for more than one would expect - even if the prints themselves are not particularly fine. Renoir, for one, who was primarily a painter, also produced graphic works which are of questionable quality; but the prints command a high price relative to a lot of other lesser known artists.

CONDITION

The question of condition is an important one, in fact, far more important than many people realize. Prints which have serious condition problems are indeed worth far less than impressions of the same print in fine condition. A tear into the image, faded colors, abrasions on the surface of the print, insoluble stains and other extreme condition problems are relevant issues which negatively affect the

value of a particular print. These are problems which cannot really be undone. A tear is a tear is a tear. Even if it is skillfully repaired by a professional paper conservator, the problem will continue to haunt the print for the rest of its life. The same permanency applies to faded colors.

Once a color print has been faded by over-exposure to sunlight (and this takes a long time), the damage is permanent. Hand-colored prints can be retouched with success but, nonetheless, the original stature of the print has been altered. This is true for printed colors as well. Many color woodcuts and color lithographs from the last hundred years have been affected by sunlight. The differences can be subtle or drastic since certain inks and certain colors are more susceptible to fading than others. To determine the extent of the fading it is important to do a comparative study by locating another impression and placing it side by side with the one you have. This takes time and effort but it is all part of assessing the value of an original print.

Surface abrasions are like tears - they will always be there. A scrape in the image can be "touched in" by a professional conservator but the problem remains. A print may look fine but closer scrutiny can often reveal a world of hidden problems. In fact, some repairs are so good they are not at all easy to spot. This is something to watch for at all times, particularly with old master prints where old, clever repair work has had time to age with the rest of the print.

There are other less serious condition problems such as foxing, small tears in the outer margins, old and improper hinges at the top of the sheet, and mat stains from an earlier acidic mat. These problems can, for the most part, be undone. A professional paper conservator can rescue a print in a sickly state and revive it to make it stable, presentable and ultimately more salable. It is important that beginning collectors realize that condition problems can be critical and some are more serious than others. Sensitivity to such matters comes about only with experience looking at prints of all kinds. A bad tear or stain will cut the value of a print sometimes in half, or even more, depending on the severity of the damage. There is no steadfast rule regarding how much condition affects value but always keep it in mind when buying. *If something appears especially cheap there just might be a good reason for it.*

QUALITY OF IMPRESSION

Quality of impression is another factor which affects the value of an original print. This is especially true with old master prints since printing presses were not as sophisticated and there was no established concept of the limited edition. During the early years of printmaking, the sixteenth to eighteenth centuries, prints were printed, for the most part, as they were needed. If a particular image was popular, then more and more impressions were printed from the copperplate or the woodblock. The problem with this is that after awhile the printing surface changes, so that one can begin to see a dramatic transformation as more and more impressions come off the press. This is particularly true with popular artists, such as, Rembrandt and Durer, whose prints were sought after early on and most extant impressions of their prints were actually printed after the artists were deceased.

Durer did not destroy his woodblocks after printing, nor did Rembrandt cancel out his copperplates. Many of their plates and blocks were passed on over the years (as with other artists) and certain individuals even re-worked many of the Rembrandt plates in an attempt to restore the qualities which were lost due to wear and tear and excessive printing. The results were usually not very successful but they *can* be very tricky and that's where further research and comparative study come into play.

The delicate richness of drypoint in a Rembrandt landscape etching is lost very quickly in the printing process, and a late impression of a Durer woodcut has breaks in the lines and lacks the clarity and sharpness of an early printing. For the untrained eye, the best way to ascertain the overall quality of the impression in question is to compare it with another good impression, preferably one in a reputable museum collection. In addition, a knowledgeable dealer, or the print specialist at an auction house, can be very helpful and informative. Only with this kind of effort can you begin to learn the subtleties of impressions and just how much they can vary.

The extent to which the quality of an impression affects the value of a print is no better illustrated than with the prints of Rembrandt (1606-1669). During the 1988 auction season, for example, there were ten impressions of the portrait etching, "Jan Lutma, Goldsmith," up for sale among the major auction houses. The range of prices realized varied from $960 to $506,000! This is a fairly extreme case but it is not uncommon to have

an enormous variation in value between a poor impression and a brilliant impression. Condition, of course, is always a factor but never underestimate the importance of impression quality. Just because someone tells you he owns an original Rembrandt does not necessarily mean a great deal. It may be a late, washed out, reworked impression of a common print. It could also be a superb, rich early impression of a rare and desirable subject, worth $200,000 - the differences are that extreme.

Additional Factors Affecting Value

In addition to name, condition and quality of impression, there are many other factors which can affect the value of a print to one degree or another. Here are a few more points to keep in mind when looking at a print that you may possibly purchase, whether from a dealer, auction house, or private party.

MARGINS

It is sometimes difficult to ascertain whether or not a print has trimmed margins and, most importantly, whether anything has been cut away from the original design. Most early prints were traditionally trimmed to slightly outside the platemark, which is perfectly acceptable today among collectors, but a print trimmed into the image is worth less than one with even the slightest margins. This is all relative and, unfortunately, there is no precise rule of thumb regarding prints cut into the image and the subsequent loss of value. It is, nevertheless, something to be aware of particularly with old master prints and large works from all periods. There are many unfortunate cases on record where the prints were cropped here and there to fit a frame!

SIGNATURE

It is important to know just what part an autograph, or lack of one, plays in determining the value of a print. Remember that up to the late 19th century, prints were signed *not* in pencil but rather, only in the plate. A monogram or a last name was etched or engraved into the plate or block as part of the overall design. The hand-signed print, as we know it today, is a fairly recent phenomenon which started to appear in the second half of the 19th century. As time went

on, the hand-signed print became more and more a regular part of printmaking, so that today an unsigned work is viewed with some suspicion.

Not all prints were intended to be hand-signed to begin with and this fact does not necessarily detract from their value. The only way to know for sure what you have, signature-wise, is to consult with someone more knowledgeable than yourself. Every artist's work is different. There are always exceptions to the rule and it takes time to learn what to expect when it comes to signatures.

For example, James McNeill Whistler etchings were sometimes signed in the plate with his last name; a few have a "W" only. Some were signed in pencil with a tiny butterfly design (which evolved from the "W") and some were not signed at all. An early Thames work signed in pencil by Whistler is uncommon and worth more because it is not usually encountered. His later Venetian etchings were normally signed with the pencil butterfly design but occasionally an unsigned impression turns up. The unsigned one is worth less than the signed one because the signature is expected to be there. A similar tale of exceptions and contradictions can be told about other artists as well!

Another kind of signature which you encounter on an original print is a stamped facsimile of the artist's written signature. This is an *estate stamp*. It generally means that a particular print by an artist had simply not been pencil signed by the time of that artist's death. The estate stamp "legitimizes" the authorship of the work in question. Most estate stamped prints are, in theory, as desirable as hand signed prints but, as you might suspect, many collectors feel more comfortable with the latter. Consequently, prices between the two can vary. In addition, an unsigned print left behind in the studio raises the question of whether or not the artist ever intended the work to be sold to begin with. This can be difficult to determine and further research may be necessary.

EDITION SIZE

An edition refers to the number of impressions, that is, the number of original prints taken from the block, the lithographic stone or the metal plate. A "small" edition is generally considered fewer than about twenty impressions. A "large" edition consists of more than one hundred and fifty impressions. Some artists printed only a few impressions of a particular image and others printed, perhaps, a thousand or more impressions as part of a portfolio or publication.

Popular artists, such as, Honore Daumier (1808- 1879) and William Hogarth (1697-1764) saw to it that much of their work was widely printed and published and consequently a great many impressions are in circulation today. Other artists, such as, Edgar Degas (1834-1917), printed very small editions and impressions rarely appear on the market today in any form. Even impressions from Degas' cancelled plates can sell for more than $1,000!

Impressions are sometimes taken long after the original edition was printed - even long after the death of the artist. Many of these prints known as restrikes are still in existence. It is often difficult to spot them, since the impressions may be quite good and, to the untrained eye, some restrikes don't appear to be very different from early impressions.

Always remember that an impression printed during the life of the artist is worth more than one printed after his or her demise. For example, many prints by the German artist, Kaethe Kollwitz (1867-1945), exist in posthumous impressions and are so identified with a small embossed stamp just below the image. A signed impression, printed during the artist's lifetime, may sell for several thousand dollars and a posthumous restrike may only be worth a few hundred. It is important to determine just what you are looking at if it is not clearly identified.

In many cases, multiple editions of an artist's work exist and each edition usually has specific characteristics to distinguish it from the rest. The paper may vary, the ink color may change, the descriptive caption at the bottom of the design may read differently and so on. Regarding the Spanish artist, Francisco Goya (1746-1828), for example, many of his plates went through as many as eight or more editions with subtle changes occurring from one printing to the next. It is important to know what edition you are looking at, since as a general rule the earlier the printing the more valuable the print. Fortunately, Goya's prints are well catalogued and researched and there are specific books which describe the various editions. The works of many other artists, however, are not as well documented or there is virtually nothing at all to refer to. If this is the case for a print you have, try to find someone who can at least point you in the right direction.

RARITY

How rare is rare? How does rarity and the size of the edition

affect the value of a print? The answer is simply that there is no precise, all-encompassing way to answer this, so the issue must be dealt with on a case by case basis. If, for example, the choice is between buying a rare Whistler lithograph or a Thomas Hart Benton (1889-1975) lithograph known to be printed in an edition of 250, the best decision, all other factors considered equal, is to buy the Whistler now because the Benton will almost certainly turn up again at a later date. The Whistler may not.

Remember that a small edition print, that is, one printed in fewer than twenty impressions, is simply not going to turn up as often as one which was printed in an edition of 250 impressions. Old master prints were generally printed as they were needed without a known, pre-established edition; hence the availability of a specific work can only be judged by how often it appears for sale on the market. For example, an important early italian engraving which hasn't turned up at auction for twenty years is bound to do well at auction today simply because it hasn't been available for a long time.

There are always exceptions, so don't necessarily be swayed by rarity as an all-important factor affecting value. A certain print may be extremely rare but it also may be extremely minor and unattractive. Only a few impressions of some prints exist because the artist was not satisfied with the results of his labor. Sometimes, a certain print simply did not sell to the public, so the edition was never completely printed. Just because something is considered "rare" does not necessarily enhance its desirability. "Rarity" can be used as a marketing ploy along with the word "Important." Don't let their true meanings be distorted.

STATES

An artist will often make changes and alterations in the initial design of a print and any such variation represents a change of *state*. A change of state can entail a reduction of the plate, additional work added to the image (a few more trees, perhaps, or more lines in the sky), or in the case of published prints, for example, a number or numeral may be added in the top right or left corner. Early states tend to be rare, in general, and they usually represent an "unfinished" artistic conception. The final state, or published state, represents the "completed" artistic conception and this is the state which turns up for sale most of the time. This is simply because far more impressions of the final state usually exist.

In terms of the marketplace, early states can at times be more interesting, more desirable and more valuable than the final state or the published state of a particular graphic work. In fact, sometimes later states of a print are posthumous impressions reworked by another hand. This is the case with many Rembrandt etchings and other old master prints.

Regarding the 19th century French etcher, Charles Meryon (1821-1868), for example, his early states tend to be more valuable since the artist, himself, did the printing. These impressions tend to be very dramatic, richly inked and especially appealing to the eye. The later states of most of his prints were professionally printed and although they are generally quite good, they do not command the same prices as the earlier impressions. This is a subtle matter, to be sure, but try to find out about the various states which comprise the development of a particular work of graphic art. There may be, for example, two states, four states, ten states or only one state.

A *catalogue raisonne*, a catalogue describing each print in detail, is available for most well-known artists and consulting such a publication will help you determine the state of a print (as well as providing other useful information). Knowing the state can assist you in assessing the value. This is just one more relevant factor which plays a part in determining the overall value of any given print.

Caution - Reproductive Prints

There are more reproductions available today than original prints. Most reproductions only qualify as decorative printed pictures. At one extreme we have the magnificent original prints by such artists as Durer, Rembrandt, Whistler and Jasper Johns; at the other end of the spectrum we have tedious reproductive steel engravings of old master paintings, colorful offset lithographs after Renoir's oil paintings and deceptive, confusing photogravure reproductions. The array is endless and the vast numbers of all kinds of prints in existence are enough to baffle the most serious student of fine original prints.

As a general rule, the more famous the artist the more susceptible the work is to being reproduced and copied. The French painter, Edouard Manet (1832-1883), produced many fine and desirable etchings after his own paintings but there are also innumerable photographic replicas of his paintings in existence which were printed by commercial companies. These are of no merit, whatsoever, even

though they might well qualify as pretty, decorative pictures. In fact, with the invention of photography in the mid-nineteenth century, the world of printmaking was forever dramatically altered by new and innovative ways to reproduce the works of famous masters. The technology continues to evolve today as better and better reproductive prints are produced with slicker and slicker advertising packages to back them up - there is no end in sight.

Types of Reproductive Prints

There are basically three different types of reproductive prints to be aware of - reproductive engravings, photogravure reproductions and commercial offset lithographs. It is often difficult to differentiate these *reproductions* from *original* prints, due to the skill with which they were printed years ago, and due to the more recent innovations in photomechanical technology. *Caveat emptor - let the buyer beware!*

REPRODUCTIVE ENGRAVINGS

Before the camera was invented, popular paintings were copied by skilled craftsmen who worked primarily in engraving, etching and mezzotint. There is a seemingly endless supply of these works in existence and they tend to be highly detailed, elaborate, uncolored replicas done after oil paintings, watercolors and drawings. There are always exceptions to the rule but, for the most part, the frames are usually worth more today than the prints they showcase.

The typical reproductive engraving has printed information at the bottom which usually includes the painter's name and the engraver's name. The place of publication might also appear along with the title of the piece. For example, at the bottom left it might say "Jan Vermeer, pinxit" (pinxit means painted or painter) and at the bottom right some obscure engraver's name will usually appear with the word "sculpsit" or "fecit" (meaning etched by, engraved by or made by). Keep in mind there are several variants in the spelling of these terms and sometimes they aren't even used. There are *always* exceptions to the rules!

Although most reproductive engravings have decorative value only, often $100 or less, there are *many* prints done after paintings and watercolors which are indeed valuable. In fact, they can be

very valuable especially when we consider the better English sporting prints, certain color floral prints and the engraved prints after John James Audubon, among others. (In keeping with the focus of this *Guide*, fine quality *decorative* prints will not be covered.)

The point here is that many reproductive engravings, especially those which bear the name of a well-known artist, can deceive the untrained viewer into thinking they are highly valuable. Just because the name Rembrandt, or Gainsborough, or Homer appears somewhere on the work, it does not necessarily mean this artist had anything to do with the making of the print itself. These reproductive engravings are, in effect, original reproductions.

PHOTOGRAVURE REPRODUCTIONS

Photogravures are among the most deceptive photomechanical reproductions ever made. Perfected during the second half of the nineteenth century, the photogravure process has produced some of the finest facsimiles of works by Durer, Rembrandt, Meryon and other well-known and important printmakers. Fortunately, many of the best photogravure reproductions are stamped on the verso identifying them as facsimile reproductions. Some, however, are not marked in any way and when framed and under glass, or just mounted, they can fool even the most seasoned print enthusiast. One of the best known firms, Amand-Durand, active in France in the 1870's and 1880's, made reproductions which are identified on the verso with the following small red ink stamp:

(twice actual size)

If you see this mark on the back of a print, you are looking at an inexpensive reproduction. They make important study pieces but they have little value.

The best way to appreciate and learn about photogravure reproductions is to place one next to an original of the same print. The line quality is different and the photogravure lacks the subtlety, the richness and the overall "character" of the original etching. Sometimes the platemark of a photogravure is not where it should be so be prepared to measure the overall dimensions to see if there is any appreciable difference. A *catalogue raisonne* will provide dimensions of the original print in question and if your measurements are off by

up to one half inch, something is probably wrong. If you are not sure what you have, you should also consult a reliable dealer, an auction house, or a print curator at a local museum.

COMMERCIAL OFFSET LITHOGRAPHS

This modern day process has been a boon for large-scale, quantity-minded printing companies, but it has caused considerable problems for the world of fine prints. With this new technology, it became easy to print, *en masse*, colorful, deceptive reproductions of paintings, drawings and watercolors by old and modern masters.

This is especially the case for well-known 20th century European artists: Picasso, Dufy, Chagall, Miro, Dali, Buffet, Matisse and others. Their work has been subjected to innumerable commercial abuses of one kind or another and it is up to you to be an informed buyer. Consult a *catalogue raisonne* and other published information on the artist and print in question. Check with a reliable dealer and get an informed opinion (even if it means paying for an appraisal); consult with a museum curator about a work if you are in a position to do so; but always question what you are looking at and assume something is wrong with a piece until proven otherwise. This is especially advisable at small country auctions, for example, where the person who catalogued the prints is also responsible for oriental rugs, porcelains, paintings and any number of other collectibles. No one is an expert in all fields and mistakes are often made even when the most honorable intentions are involved!

For a detailed, thorough examination of reproductions, fakes and forgeries in the print world you should consult Theodore B. Donson's 1977 book, *Prints and the Print Market*. Further information about this and other publications relevant to our discussion is contained in the *Appendix*.

Pricing Your Print: A Summary

One thing for certain is that pricing and evaluating fine prints is not an exact science. This *Guide* will not necessarily provide a "quick fix" for every print which comes your way but we consider it an excellent place to start. If you know the name of the artist and the technique employed to produce the work (i.e., etching, engraving, lithograph, woodcut, etc.) you can refer to this *Guide* to determine a

potential value for your print - assuming his/her name appears in the *Guide* to begin with.

The pursuit of a more precise fair market value can take much more time and energy than you want to expend. The print you have may be a rare state of a rare work by an important artist whose prints, unfortunately, seldom appear for sale - anywhere. The quickest and most reliable approach for pricing your print may be to have your print appraised, either verbally or in writing, by a print expert (i.e., print dealer, art dealer, or a print specialist at an auction house) - only they will have the accumulated knowledge, experience, and necessary references on hand to accurately assess your print's worth.

If you are determined to research the worth of your print yourself, you may want to consider the following multi-step process:

- Determine who authored the work and the technique employed (i.e., intaglio, relief, planographic).

- Knowing who the artist is and the printing technique employed, next check within this *Guide* to get an idea of the *potential* value for your print.

- Research the title of your piece by checking a *catalogue raisonne*, if available, for your artist. You will have to painstakingly take the time to match up your print with one in the *catalogue raisonne*. If you know that more than one *state* exists for your title, determine which *state* you have.

- Knowing who the artist was, the technique employed in producing the work, and the title of the print, you would now want to find previous sales of similarly titled prints to note what prices they had realized. The best place to check previous auction results is either, or both, Martin Gordon's *Gordon's Print Price Annual*, and E. Mayer's *International Auction Records* (see the bibliography in the *Appendix* of this *Guide*). You may have to go back through several annuals to locate, hopefully with success, a previous sale of your similarly titled print. These important, and expensive references may be available at larger museums and public libraries. If you wish to begin purchasing these annuals for your personal library, you may find many art book dealers with these titles in stock. [Note: As this *Guide*

goes to press, Sound View Press, in Madison, Connecticut, is announcing the availability, September, 1991, of an annual compilation of actual print price sales at auction. It will be in hardcover, and sell for $149. Please check the bibliography in the *Appendix* for further details - under print connoisseurship.]

- After you have noted the prices realized for prints of similar title to yours, keep in mind the additional effect of condition problems (i.e., foxing, stains, holes, tears, abrasions, etc.), if any, on the value of your print.

- And finally, *always remember that a reputable dealer is an invaluable resource, whose advice you should seek out as much as possible.*

CHAPTER TWO

Using This Guide

An Overview

The following information is provided by the publisher. Please read it thoroughly, so you will understand how the price entries in this *Guide* were derived. Remember, as explained in the previous chapter, we are focusing on fine art prints - including some important posters - and not the decorative prints (e.g., Currier & Ives, Audubon prints, city bird's eye views, etc.).

In the process of compiling the over 2,600 names of artists for this *Guide*, it was found that in many instances the spelling of names was incorrect or incomplete, with only initials and a surname, as they appeared in many of the auction house catalogs, nationally. This was due in part, understandably, to the haste with which many of these artists were researched and then recorded in the catalog in time for the pre-sale promotion. We recorded the full and correct spelling of names as accurately as possible by checking more than one dictionary of artists for each name. If no birth and death dates were available, the century during which that artist is known to have worked was placed next to the name. Also added, when available, was the nationality of the artist. If you are aware of any errors or omissions we would certainly like to hear from you. You are welcome and encouraged to comment, and feel free to suggest changes or additions which will improve this *Guide*.

Establishing Price Ranges

After carefully recording the auction prices for each artist for the last six years, we established a price range which reflected the "practical" low and high for that particular artist. If only one auction result could be found for an artist during the past six years, and it was deemed significant enough to report, we included it in this *Guide*. For consistency, we frequently rounded off odd prices to the next highest whole amount. In instances where very few auction results were available for a particular artist, we occasionally used the low end of a catalog estimate, if the print were passed, in establishing our price range for that artist.

Please keep in mind that, when looking at auction results, those prints which have previously sold may not have been the best or worst efforts by the artist. For this reason, in future auction sales, prints by artists listed herein may sell for far less or far more than previously. And never forget how **CONDITION** affects the value of a print!

Our Sources

In compiling the artists and prices for this *Guide* our most frequently used source was *Martin Gordon's Print Price Annual* - thru the 1991 edition. Most of the prices and/or price ranges entered in our *Guide* were compiled from the results reported in *Martin Gordon's Print Price Annual* for the past six years (1986 to 1991). We found "Gordon's" to be, without question, the most comprehensive source for auction print price results, worldwide.

The published catalogs of prices paid for prints sold at auction during the 1990-1991 season provided another valuable source of price information. We researched print sales (through May, 1991) of the following leading auction houses and adjusted our prices accordingly. The addresses of these auction houses can be found in the *Appendix*.

- James R. Bakker Antiques, Inc., Massachusetts
- Richard A. Bourne Co., Inc., Massachusetts
- Butterfield & Butterfield, California

- Christie, Manson & Woods, London
- Christie, Manson & Woods, New York
- Bruce Collins Auctions, Maine
- William Doyle Galleries, New York
- Leslie Hindman Auctions, Illinois
- Phillips, Son & Neale, London
- Robert W. Skinner, Massachusetts
- Sotheby's, London
- Sotheby's, New York
- Swann Galleries, New York
- Winter Associates, Connecticut
- Wolf's Auction Gallery, Ohio

The Three Printing Techniques

In the previous chapter author William Carl discussed the three basic printing techniques available to an artist: intaglio, planographic, and relief. Some artists may have worked in only one technique throughout their career, but others may have worked in all three techniques.

When artists worked in more than one technique we found the prices realized at auction for each technique could be, in many instances, quite different. For example, an artist may have realized only a few hundred dollars for his etchings (intaglio technique) at auction, but realized several thousand dollars for his lithographs (planographic technique) at auction. Because each technique an artist employed could result in a different price range, we decided to research the prices realized for each technique and record them separately for your use. With many artists, you may find as many as three price ranges - one for each printing technique. On the other hand, many of the artists listed herein only worked in one technique and, therefore, will only have one entry.

In the alphabetical list of artists with prices, you will find the intaglio technique represented by "I", the planographic technique by "P", and the relief technique by "R". The following examples illustrates the format for presenting price ranges corresponding to the various techniques:

ACKERMANN, MAX (B.1887) GERMAN
 I/ 150-430 P/ 75-904
AMIET, CUNO (1868-1961) SWISS
 I/ 350-1200 P/ 75-2800 R/ 700-1100

Under each printing technique you may encounter the following types of prints (or combination of processes):

I Intaglio
 o etching
 o drypoint
 o steel engraving
 o stipple engraving
 o aquatint
 o mezzotint
 o soft-ground etching
 o crayon manner

P Planographic
 o lithograph
 o monotype
 o silk-screen
 o cliche verre
 o serigraph

R Relief
 o wood block
 • woodcut
 o chiaroscuro
 • wood engraving
 o linoleum cut (linocut)

Artists in Dealer Catalogs

Beginning on page 199 William Carl has compiled an important alphabetical list of over 340 artists that rarely turn up at auctions but appear with frequency in numerous dealer catalogs across the

country. The list emphasizes American, English, and French artists who produced prints primarily from 1860 to 1960. The price range given indicates where roughly 75% of an artist's works fall, price wise, based on a broad survey of numerous dealer catalogues. The printing technique listed is the technique for which he/she is best known. An asterisk after the ranges indicates that prints by this artist are *rare*.

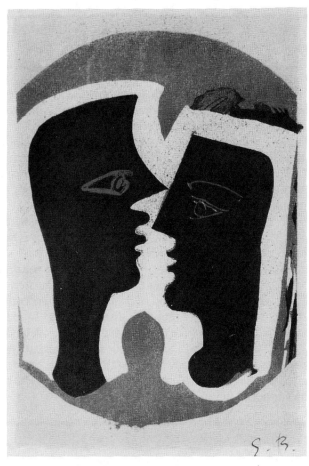

"Le Couple" from LETTERA AMOROSA, 1963
by Georges Braque, lithograph
(Courtesy of Skinner, Inc., Bolton, MA)

DISCLAIMER

Although every attempt, within reason, has been made to keep the price ranges herein as accurate as possible, there may be mistakes, both typographical and in content. Therefore, this guide should be used only as a general guide not as the final or ultimate source of the only prices which may be realized at auction for prints by any particular artist. Remember, prints in very poor condition may realize only a fraction of the price realized for a similar print in excellent condition.

Special care must be exercised when examining the prices of prints by contemporary artists. With living artists, it is best to check with those galleries that represent them for the "final" word on current print prices. Prices charged in the galleries for the prints of living artists can often be many times those realized at auction.

Also, the compilation of auction houses and private dealers in the *Appendix* is only a representative sampling of the hundreds of auction houses and private dealers which may be of equal distinction.

The author and Currier Publications shall have neither liability nor responsibility to any person with respect to any loss or damage caused or alleged to be caused directly or indirectly by the information contained in this book.

Fine Art Prints
at Auction

ABBE, WILLIAM (20TH C) AMERICAN
 I/ 40-100 R/ 30-100
ABELMAN, IDA (B. 1910) AMERICAN
 P/ 40-300
ABLETT, WILLIAM (1877-1937) BRITISH
 I/ 150-500 P/ 125
ABRAHAMS, IVOR (B. 1935) BRITISH
 P/ 65-750
ABRAMS, WILLIAM R. (B. 1920) AMERICAN
 R/ 25-100
ACHENBACH, ANDREAS (1815-1910) GERMAN
 I/ 240 P/ 300
ACKERMANN, MAX (B. 1887) GERMAN
 I/ 150-430 P/ 75-925
ACKERMANN, PETER (B. 1934) GERMAN
 I/ 20-250
ADAM, ALBRECHT (1786-1862) GERMAN
 I/ 170
ADAM, HENRI GEORGES (1904-1967) FRENCH
 I/ 160
ADAMI, VALERIO (B. 1935) ITALIAN
 I/ 100-450 P/ 25-621
ADAMS, KENNETH M. (1897-1966) AMERICAN
 P/ 50-250
ADAMS, MARK (B. 1925) AMERICAN
 I/ 300-700 P/ 330-950
ADDERLY, CHARLES (20TH C) AMERICAN
 R/ 50-150
ADLER, JANKEL (1895-1949) POLISH
 I/ 200-400
AFFLECK, ANDREW F. (active 1910-1930) BRITISH
 I/ 30-100
AFRO, BASADELLA (B. 1912) ITALIAN
 I/ 360 P/ 175-850
AGAM, YAACOV (B. 1928) ISRAELI
 P/ 50-2750

AGHIB, JOAN (20TH C) AMERICAN ?
I/ 50-150
AGOSTINI, TOBY (B. 1916) AMERICAN
P/ 500
AHLERS-HESTERMANN, FRITZ (B. 1883) GERMAN
P/ 60-250
AID, GEORGE C. (1872-1938) AMERICAN
I/ 25-100
AIKMAN, WALTER (1857-1939) AMERICAN
I/ 25-100
AIZPIRI, PAUL (B. 1919) FRENCH
P/ 150-2400
AKEN, JAN VAN (1614-1661) DUTCH
I/ 100-1000
AKERSLOOT, WILLEM (B. 1600) DUTCH
I/ 15000
ALBEE, GRACE (1890-1985) AMERICAN
R/ 35-1000
ALBERS, ANNI (B. 1899) AMERICAN
I/ 150-450
ALBERS, JOSEF (1888-1976) AMERICAN
I/ 600-900 P/ 10-4400 R/ 100-5280
ALBERT, HERMANN (B. 1937)
I/ 100-350
ALBERT-LASARD, L. (1891-1969) GERMAN
P/ 25-300
ALBERTI, CHERUBINO (1553-1615) ITALIAN
I/ 100-1500
ALBERTI, PIETRO FRANCESCO (1584-1638) ITALIAN
I/ 100-1000
ALBIKER, KARL (1878-1961) GERMAN
P/ 150-800
ALBRIGHT, IVAN LE LORRAINE (1897-1983) AMERICAN
P/ 350-5600
ALDEGREVER, HEINRICH (1502-1558) GERMAN
I/ 22-23100
ALDIN, CECIL CHARLES WINDSOR (1870-1935) BRITISH
I/ 175-1200 P/ 300
ALECHINSKY, PIERRE (B.1927) BELGIAN
I/ 25-34300 P/ 25-882 R/ 25-1512
ALESI, HUGO DE (1840-1906) FRENCH
P/ 40-850
ALEXEIEFF, ALEX (1901-1982) RUSSIAN
I/ 25 P/ 4000

ALLEN, JAMES E. (1894-1964) AMERICAN
I/ 300-7150 P/ 40-800
ALMELOVEEN, JAN VAN (17TH C) DUTCH
I/ 100-250
ALOISI, GIOVANNI (active Ca. 1600) ITALIAN
I/ 7000
ALT, OTMAR (B. 1940) GERMAN
I/ 145-275 P/ 25-800 R/ 30-150
ALTDORFER, ALBRECHT (1480-1538) GERMAN
I/ 150-12200 R/ 120-14000
ALTENBOURG, GERHARD (20TH C) GERMAN
I/ 300-480 R/ 100-2800 P/ 100-1000
ALTHIEM, WILHELM (1871-1914) GERMAN
I/ 200-500
ALTMAN, HAROLD (B. 1925) AMERICAN
I/ 50-200 P/ 100-200
AMAN-JEAN, EDMOND FRANCOIS (1860-1935) FRENCH
I/ 250 P/ 275-1200
AMATO, FRANCESCO (17TH C) ITALIAN
I/ 600
AMELIN, ALBIN (B. 1902) SWEDISH ?
P/ 150-1500
AMEN, IRVING (B. 1918) AMERICAN
P/ 75-200 R/ 30-100
AMENOFF, GREGORY (B. 1948) AMERICAN
R/ 1100-1925
AMERO, EMILIO (20TH C) MEXICAN
P/ 50-275
AMIET, CUNO (1868-1961) SWISS
I/ 350-1200 P/ 75-2820 R/ 700-1100
AMIGONI, JACOPO (1682-1752) ITALIAN
I/ 200-300
AMLING, KARL GUSTAV (1651-1702) GERMAN
I/ 350
AMMAN, JOST (1539-1591) GERMAN
I/ 10-4500 R/ 25-300
AMTSBERG, OTTO (19TH/20TH C) NORWEGIAN
P/ 600-2000
ANDERSON, C.W. (20TH C) AMERICAN
P/ 50-125
ANDERSON, STANLEY (1884-1966) BRITISH
I/ 75-600
ANDREA, ZOAN (active 1475-1505) ITALIAN
I/ 600-25000

ANDREANI, ANDREA (1560-1623) ITALIAN
R/ 100-6300
ANDREENKO, MIKHAIL (1895-1982) RUSSIAN
P/ 300-600
ANDREWS, SYBIL (B. 1898) BRITISH
I/ 300-650 R/ 200-8400
ANDRI, FERDINAND (19TH/20TH C)
P/ 100-428
ANTES, HORST (B.1936) GERMAN
I/ 60-7800 P/ 25-1950
ANTHONY, CAROL (B. 1943) AMERICAN
P/ 50-1100
ANUSKIEWICZ, RICHARD (B. 1930) AMERICAN
P/ 44-660
APPEL, KAREL (B.1921) DUTCH/AMERICAN
I/ 200-1900 P/ 25-7000 R/ 300-8500
APPIAN, JACQUES B. (Called ADOLPHE) (1818-1898) FRENCH
I/ 75-700
ARAKAWA, SHUSAKU (B.1936) JAPANESE
I/ 1200-1700 P/ 200-6050
ARCANGELO, ALLAN D' (B. 1930) AMERICAN
P/ 110-880
ARCHIPENKO, ALEXANDER (1887-1964) RUSSIAN
I/ 7000 P/ 75-7600
ARMAN, (ARMAN FERNANDEZ) (B. 1928) FRENCH
I/ 297-2300 P/ 50-3200
ARMINGTON, FRANK M. (1876-1940) AMERICAN
I/ 25-100
ARMS, JOHN TAYLOR (1887-1953) AMERICAN
I/ 50-8800 P/ 187
ARNESON, ROBERT (20TH C) AMERICAN
I/ 75-1100 P/ 350-1100
ARNHOLD, JOHANN (1766-1828) GERMAN
P/ 1500-4600
ARNOLDI, CHARLES (B. 1946) AMERICAN
I/ 90-1300 P/ 100-6100 R/ 70-400
ARP, JEAN (HANS) (1887-1966) FRENCH
I/ 25-650 P/ 100-3600 R/ 50-6000
ARPKE, OTTO (20TH C) ?
P/ 800
ARROYO, EDUARDO (B. 1937) SPANISH
P/ 100-350
ARTSCHWAGER, RICHARD (B. 1924) AMERICAN
I/ 3080 P/ 1000-4000

ARTZYBASHEFF, BORIS (1899-1965) RUSSIAN/AMERICAN
R/ 300-750
ASMUS, DIETER (B. 1939) ?
P/ 125-3600
ASSCH, FRANK H. (19TH/20TH C) AMERICAN
P/ 900
ASSELIN, MAURICE (1882-1947) FRENCH
P/ 197-275
ATCHE, JANE (19TH C) FRENCH
P/ 900-3800
ATLAN, JEAN-MICHEL (1913-1960) FRENCH
P/ 200-2655
ATTERSEE, CHRISTIAN (B. 1941) ?
P/ 100-500
AUBERJONOIS, RENE (1872-1957) SWISS
P/ 100-1200
AUERBACH, FRANK (B. 1931) AMERICAN
P/ 200-644
AUGER, ADRIEN V. (B. 1787) FRENCH
P/ 300
AUSTIN, ROBERT S. (B. 1895) BRITISH
I/ 100-850
AVATI, MARIO (B. 1921) FRENCH
I/ 100-1104
AVERY, MILTON (1893-1965) AMERICAN
I/ 160-6600 P/ 110-2090 R/ 300-4000
AVRIL, JEAN JACQUES (1744-1831) FRENCH
I/ 1200
AXELROD, EILEEN (20TH C) AMERICAN
I/ 25-150
AZOULAY, GUILLAUME A. (B. 1949) MOROCCO
I/ 75-450

B

BABOULENE, EUGENE (B. 1905) FRENCH
P/ 100-400
BAC, FERNAND (1859-1952) FRENCH
P/ 400-2500
BACH, ELVIRA (20TH C) GERMAN

P/ 500-1800
BACHEM, BELE (B. 1916) GERMAN
P/ 25-500
BACHILOFF, M. (19TH C) RUSSIAN
I/ 20-80
BACHMANN, OTTO (19TH C) GERMAN
P/ 56-2430
BACKHUIZEN, LUDOLF (1631-1708) DUTCH
I/ 51-1256
BACON, FRANCIS (B. 1909) BRITISH
I/ 800-8100 P/ 25-31000
BACON, PEGGY B. (1895-1987) AMERICAN
I/ 150-1900 P/ 150-660
BADMIN, STANLEY ROY (B. 1906) BRITISH
I/ 200-449
BAECHLER, DONALD (20TH C) AMERICAN
I/ 550 P/ 2500-4500
BAEDER, JOHN (B. 1938) AMERICAN
P/ 30-12000
BAERTLING, OLLE (1911-1981)
P/ 50-2500
BAIER, JEAN (B. 1932) SWISS
I/ 50-400
BAILEY, VERNON H. (1874-1953) AMERICAN
P/ 25-100
BAILEY, WILLIAM H. (B. 1930) AMERICAN
I/ 250-4950 P/ 700-2900
BAJ, ENRICO (B. 1924) ITALIAN
I/ 50-3048 P/ 60-750
BALDUNG, HANS (1484-1545) GERMAN
R/ 139-46000
BALESTRIERI, LIONELLO (1872-1958) ITALIAN
I/ 300
BALLINGER, R. MAXIL (B. 1914) AMERICAN
R/ 25-100
BALTEN, PIETER (1525-1598) FLEMISH
I/ 200-300
BALUSCHEK, HANS (B. 1870) GERMAN
P/ 200-600
BARBARI, JACOPO DE (1440-1516) ITALIAN
I/ 300-19000
BARBATELLI, BERNARDO (1548-1612) ITALIAN
I/ 12000
BARBIER, GEORGES (1882-1932) FRENCH

Technique Key

Under each <u>printing technique</u> you may encounter the following types of prints (or combination of processes):

I <u>Intaglio:</u>
- etching
- drypoint
- steel engraving
- stipple engraving
- aquatint
- mezzotint
- soft-ground etching
- crayon manner

P <u>Planographic:</u>
- lithograph
- monotype
- silk-screen
- cliche verre
- serigraph

R <u>Relief:</u>
- wood block
 - woodcut
 - chiaroscuro
 - wood engraving
- linoleum cut (linocut)

P/ 1500-4620 R/ 15000
BARBIERE, DOMENICO (1506-1565) ITALIAN
 I/ 100-9800
BARGHEER, EDUARD (B. 1901) GERMAN
 I/ 25-6000 P/ 25-2500 R/ 50-300
BARLACH, ERNST (1870-1938) GERMAN
 P/ 50-8820 R/ 25-4500
BARNET, WILL (B. 1911) AMERICAN
 I/ 165-500 P/ 50-750 R/ 500-1500
BAROCCI, FEDERICO (1526-1612) ITALIAN
 I/ 300-9800 R/ 500-4000
BARR, NORMAN (B. 1908) AMERICAN
 P/ 100-450
BARRAUD, MAURICE (1889-1955) SWISS
 I/ 25-1300 P/ 100-900
BARRERE, ADRIEN (1877-1931) FRENCH
 P/ 500-1300
BARRETT, HOPE B. (20TH C) AMERICAN
 R/ 25-100
BARRIBAL, W. H. (?) BRITISH
 P/ 2700
BARRY, JAMES (1741-1806) BRITISH
 I/ 1500-12000 P/ 1600-7100
BARTLETT, ELWOOD (B. 1906) AMERICAN
 R/ 25-100
BARTLETT, JENNIFER (B. 1941) AMERICAN
 I/ 3500-7500 P/ 440-55000 R/ 900-7980
BARTLETT, CHARLES WILLIAM (1860-1940) BRITISH
 R/ 150-825
BARTOLOZZI, FRANCESCO (1727-1815) ITALIAN
 I/ 100-1100
BARTON, LOREN (B. 1983) AMERICAN
 I/ 25-100
BARTSCH, ADAM VON (1757-1821) AUSTRIAN
 I/ 75-800
BASAN, PIERRE FRANCOIS (1723-1797) FRENCH
 I/ 150-300
BASELITZ, GEORG (B. 1938) GERMAN
 I/ 125-20000 R/ 300-29700
BASKIN, LEONARD (B. 1922) AMERICAN
 I/ 40-2100 P/ 100-1320 R/ 30-1320
BASQUIAT, JEAN M. (20TH C) AMERICAN
 P/ 200-30250
BASSE, WILHELM (B. 1613) DUTCH

I/ 600
BASSET (18TH/19TH C) FRENCH
 I/ 400 P/ 600
BASTARD, MARC A. (B. 1863) SWISS
 P/ 850-1200
BATE, STANLEY (B. 1903) AMERICAN
 I/ 30-125
BATTKE, HEINZ (1900-1966) GERMAN
 I/ 100-175
BAUDOUIN, PIERRE ANTOINE (1723-1769) FRENCH
 I/ 300-400
BAUER, CARL (20TH C) FRENCH
 I/ 30-100 P/ 190
BAUER, MARIUS A. J. (1867-1932) DUTCH
 I/ 100-200
BAUER, RUDOLF (1889-1953) GERMAN
 I/ 100-400 P/ 125-1900
BAUKNECHT, PHILIPP (1884-1933) GERMAN
 I/ 300 R/ 150-1200
BAUM, CARL (CHARLES ?) (19TH C) AMERICAN
 I/ 150
BAUM, PAUL (1859-1932) GERMAN
 I/ 150-550 P/ 400-800
BAUMANN, GUSTAVE (1881-1971) AMERICAN
 P/ 800 R/ 200-3575
BAUMBACH, HAROLD (20TH C) AMERICAN
 P/ 25-100
BAUMBERGER, OTTO (20TH C) GERMAN
 P/ 200-3000
BAUMEISTER, WILLI (1889-1955) GERMAN
 I/ 2400 P/ 50-15500 R/ 1000-1500
BAXTER, GEORGE (1804-1867) BRITISH
 I/ 700
BAY, H. (20TH C) EUROPEAN
 I/ 10-50
BAYER, HERBERT (B. 1900) AMERICAN
 P/ 75-1500
BAYLAC, LUCIEN (19TH C) FRENCH
 P/ 350-700
BAYNARD, ED (B. 1940) AMERICAN
 I/ 200-2200 R/ 400-2700
BAYROS, FRANZ VON (1866-1924) GERMAN
 I/ 50-2000
BAZAINE, JEAN RENE (B. 1904) FRENCH

I/ 100-550 P/ 100-500
BAZICALUVA, ERCOLE (17TH C) ITALIAN
I/ 100-500
BEAL, JACK (B. 1931) AMERICAN
P/ 25-350
BEAL, REYNOLDS (1867-1951) AMERICAN
I/ 50-4130
BEARDEN, ROMARE (1914-1988) AMERICAN
I/ 1043-3500 P/ 275-4500
BEARDSLEY, AUBREY (1872-1898) BRITISH
P/ 100-1200
BEATRIZET, NICOLAS (B. 1515) FRENCH
I/ 40-4900
BEAUDIN, ANDRE (1895-1980) FRENCH
P/ 20-1100
BEAUFRERE, ADOLPH-MARIE-TIMOTHEE (1876-1960) FRENCH
I/ 25-700
BEAUSSIER, EMILE (B. 1874) FRENCH
P/ 800
BEAUVARLET, JACQUES-FIRMIN (1731-1797) FRENCH
I/ 200-525
BECCAFUMI, DOMENICO (1486-1551) ITALIAN
I/ 8500-90000 R/ 36000
BECHTLE, ROBERT ALAN (B. 1932) AMERICAN
I/ 800-1600 P/ 300-600
BECK, LEONHARD (1480-1542) GERMAN
R/ 25-1200
BECKMANN, MAX (1884-1950) GERMAN/AMERICAN
I/ 45-173000 P/ 25-78000 R/ 185-40000
BEERI, TUVIA (B. 1929) ISRAELI
I/ 75-275
BEGA, CORNELIS PIETERSZ (1620-1664) DUTCH
I/ 22-3000
BEHAM, BARTHEL (1502-1540) GERMAN
I/ 100-9000 R/ 350
BEHAM, HANS SEBALD (1500-1550) GERMAN
I/ 15-15000 R/ 19-3500
BEHMER, MARCUS (1879-1958) GERMAN
I/ 25-700 R/ 250-1600
BEHRENS, PETER (1868-1940) GERMAN
P/ 500-8000 R/ 175-2430
BEJOT, EUGENE (1867-1931) FRENCH
I/ 75-600
BELL, LARRY (B. 1939) AMERICAN

P/ 500-1300
BELLA, STEFANO DELLA (1610-1664) ITALIAN
I/ 40-7300
BELLANGE, JACQUES (1594-1638) FRENCH
I/ 75-87300
BELLANGE, JOSEPH L.H. (1800-1866) FRENCH
P/ 25-75
BELLING, RUDOLF (B. 1886) GERMAN
P/ 90-150
BELLMER, HANS (1902-1975) FRENCH
I/ 25-7400 P/ 100-1100
BELLONI, GIORGIO (1861-1944)
P/ 300-2640 (monotypes only)
BELLOTTO, BERNARDO (1724-1780) ITALIAN
I/ 800-20000
BELLOWS, ALBERT F. (1829-1883) AMERICAN
I/ 25-100
BELLOWS, GEORGE W. (1882-1925) AMERICAN
P/ 250-86000
BELON, JOSE (D. 1927) FRENCH
P/ 425
BEMMEL, PETER VON (1685-1754) GERMAN
I/ 50-300
BENAZECH, CHARLES (1767-1794) BRITISH
I/ 503-1100
BENDINER, ALFRED (B. 1899) AMERICAN
P/ 25-100
BENGSTON, BILLY AL (B. 1934) AMERICAN
P/ 150-700
BENNETT, ALFRED J. (B. 1891) AMERICAN
I/ 20-100
BENNETT, WILLIAM JAMES (1787-1844) AMERICAN
I/ 500-12100
BENSON, FRANK WESTON (1862-1951) AMERICAN
I/ 200-1400 P/ 473-500
BENTON, THOMAS HART (1889-1975) AMERICAN
P/ 275-23100
BERCHEM, NICOLAES (1620-1683) DUTCH
I/ 130-6200
BERCHMANS, EMILE (B. 1867) BELGIAN
P/ 50-700
BERGERE, RICHARD (B. 1912) AMERICAN
P/ 25-100
BERGES, WERNER (B. 1941) GERMAN

P/ 80-170
BERGMEISTER, HERMANN (B. 1869) GERMAN
 I/ 20-100
BERKE, HUBERT (B. 1908) GERMAN
 R/ 25-350
BERNARD, DAVID (B. 1913) AMERICAN
 I/ 25-100
BERNARD, EMILE (1868-1941) FRENCH
 I/ 50-500 P/ 1400-10000 R/ 200-18000
BERNASCONI, F. (19TH C) ITALIAN
 P/ 1500
BERNDT, SIEGFRIED (B. 1880) GERMAN
 R/ 100-175
BERRY, CARROLL THAYER (1886-1978) AMERICAN
 R/ 50-400
BERTANI, GIOVANNI-BATTISTA (1516-1576) ITALIAN
 I/ 250
BERTHON, PAUL (1872-1909) FRENCH
 P/ 40-2640
BERTOIA, HARRY (1915-1978) AMERICAN
 P/ 1000-3000
BERTON, ARMAND (B. 1854-1927) FRENCH
 I/ 100-300 P/ 50-350
BESNARD, PAUL ALBERT (1849-1934) FRENCH
 I/ 50-1600 P/ 100-650
BETHERS, RAY (B. 1902) AMERICAN
 R/ 25-100
BEURDELEY, JACQUES (1874-1954) FRENCH
 I/ 40-250
BEUYS, JOSEF (1921-1986) GERMAN
 I/ 400-5000 P/ 35-16500 R/ 1955-15000
BEVAN, ROBERT (1865-1925) BRITISH
 P/ 400-2800
BEVERLOO, CORNELIS VAN (B. 1922) FRENCH
 P/ 75-450
BEWICK, THOMAS (1753-1828) BRITISH
 R/ 150-600
BICKEL, KARL (20TH C)
 P/ 300-3960
BICKNELL, WILLIAM HENRY WARREN (B. 1860) AMERICAN
 I/ 60-220
BIDDLE, GEORGE (1885-1973) AMERICAN
 P/ 30-175
BIGOT, GEORGES (19TH C) FRENCH

I/ 3000
BILL, MAX (B. 1908) SWISS
 P/ 25-8000 R/ 400-1300
BILLINGS, HENRY (B. 1901) AMERICAN
 P/ 75-150
BILLMYER, JOHN (B. 1912) AMERICAN
 I/ 30-100
BINCK, JACOB (1500-1569) GERMAN
 I/ 97-6500
BINDER, JOSEPH (1805-1863) AUSTRIAN
 P/ 400-900
BIRCH, WILLIAM (1755-1834) AMERICAN
 I/ 600
BISCAINO, BARTOLOMMEO (1632-1657) ITALIAN
 I/ 75-3000
BISCHOFF, HENRY (1882-1951) SWISS
 R/ 80-150
BISHOP, ISABEL (1902-1988) AMERICAN
 I/ 150-2750
BISHOP, RICHARD EVETT (1887-1975) AMERICAN
 I/ 50-125
BISSCHOP, JAN DE (1628-1671) DUTCH
 I/ 175-700
BISSIER, JULES (1893-1965) GERMAN/SWISS
 P/ 100-5900 R/ 600-1400
BISSIERE, ROGER (1884-1964) FRENCH
 I/ 150-500 P/ 100-600 R/ 1445
BISTTRAM, EMIL (1895-1976) AMERICAN
 P 500
BLAKE, PETER (B. 1932) BRITISH
 I/ 510 P/ 40-600
BLAKE, WILLIAM (1757-1827) BRITISH
 I/ 50-92500 P/ 41000
BLAMPIED, EDMUND (1886-1966) BRITISH
 I/ 25-2000 P/ 350-750 R/ 200
BLAUSTEIN, AL (B. 1924) AMERICAN
 I/ 20-75
BLECHEN, KARL (1798-1840) GERMAN
 I/ 500-600 P/ 1400-5300
BLECKNER, ROSS (B. 1949) AMERICAN
 P/ 750-3900
BLEKER, GERRIT C. (active 1625-1656) DUTCH
 I/ 150-3200
BLEYL, FRITZ (B. 1881) GERMAN

Technique Key

Under each <u>printing technique</u> you may encounter the following types of prints (or combination of processes):

I <u>Intaglio:</u>
- etching
- drypoint
- steel engraving
- stipple engraving
- aquatint
- mezzotint
- soft-ground etching
- crayon manner

P <u>Planographic:</u>
- lithograph
- monotype
- silk-screen
- cliche verre
- serigraph

R <u>Relief:</u>
- wood block
 - woodcut
 - chiaroscuro
 - wood engraving
- linoleum cut (linocut)

R/ 250-3000
BLOCH, LUCIENNE (B. 1909) AMERICAN
 P/ 150
BLOEMAERT, ABRAHAM (1564-1651) DUTCH
 I/ 50-1100 R/ 350-3000
BLOMAERT, CORNELIS (1603-1680) DUTCH
 I/ 300-400
BLOOTELING, ABRAHAM (1640-1690) BRITISH
 I/ 50-450
BLOTT, GEORGE (19TH/20TH C) FRENCH
 P/ 250-1000
BOBLETER, LOWELL (1902-1973) AMERICAN
 I/ 25-100
BOCHNER, MEL (B. 1940) AMERICAN
 I/ 200-550
BOCKSTIEGEL, PETER (1889-1951) GERMAN
 I/ 200-1900 P/ 750-2000
BODMER, KARL (1809-1893) SWISS
 P/ 250-9400
BOEHLE, FRITZ (1873-1916) GERMAN
 I/ 75-1300
BOEL, PETER (1622-1674) FRENCH
 I/ 350
BOHL, WALTER (20TH C) AMERICAN
 I/ 15-50
BOHROD, AARON (B. 1907) AMERICAN
 P/ 25-250
BOISSIEU, JEAN-JACQUES DE (1736-1810) FRENCH
 I/ 50-450
BOL, FERDINAND (1616-1680) DUTCH
 I/ 50-5500
BOLDRINI, NICOLO (B. 1510) ITALIAN
 I/ 350 R/ 100-1100
BOLSWERT, BOETIUS (1580-1633) DUTCH
 I/ 200-600
BOLSWERT, SCHELTE (1586-1659) DUTCH
 I/ 150-1600
BOLTON, CLARENCE (1893-1962) AMERICAN
 P/ 25-100
BOMBLED, LOUIS CHARLES (1862-1927) FRENCH
 P/ 400
BOMBERG, DAVID (1890-1957) BRITISH
 P/ 400-750
BONACINO, G. (19TH C) ITALIAN

I/ 750
BONASONE, GIULIO (1498-1580) ITALIAN
 I/ 25-6000
BONE, SIR MUIRHEAD (1876-1953) SCOTTISH
 I/ 100-2400 P/ 50-575
BONI, PAOLO (B. 1926) ITALIAN
 I/ 100-575
BONINGTON, RICHARD PARKES (1802-1828) BRITISH
 I/ 50 250 P/ 50-1300
BONNANO, CARMEN (20TH C) AMERICAN
 I/ 50-125
BONNARD, PIERRE (1867-1947) FRENCH
 I/ 50-2200 P/ 75-268000
BONNET, LOUIS MARIN (1736-1793) FRENCH
 I/ 125-10000
BONTECOU, LEE (B. 1931) AMERICAN
 P/ 50-850
BORCHT, HENDRIK VAN DER II (B. 1614) DUTCH
 I/ 800
BOREIN, EDWARD (1873-1945) AMERICAN
 I/ 200-2100
BORG, CARL OSCAR (1879-1947) AMERICAN
 I/ 400-950 R/ 300-1000
BORGIANI, H. (16TH C) ITALIAN
 I/ 200
BORGIANNI, ORAZIO (1578-1616) ITALIAN
 I/ 25-4800
BOROFSKY, JONATHAN (B. 1942) AMERICAN
 I/ 11000 P/ 400-13200
BORTNYIK, SANDOR (B. 1893) HUNGARIAN
 P 225
BOS, B.VAN DEN (1518-1580) FLEMISH
 I/ 100-850
BOS, CORNELIS (1506-1570) FRENCH
 I/ 100-1400
BOSCOVITZ, FRITZ (B. 1871) SWISS
 P/ 100-1600
BOSMAN, RICHARD (B. 1944) AMERICAN
 I/ 350-825 R/ 220-3575
BOSSE, ABRAHAM (1602-1676) FRENCH
 I/ 125-5700
BOTERO, FERNANDO (B. 1932) COLOMBIAN
 P/ 1000-5500
BOTH, JAN (1618-1652) DUTCH

I/ 75-1100

BOTT, FRANCIS (B. 1904) GERMAN
I/ 250 P/ 40-1600

BOTTGER, KALUS (1942) GERMAN
I/ 75-550

BOTTINI, GEORGES (1874-1907) FRENCH
I/ 1300-2400 R/ 900

BOTTS, HUGH (1903-1964) AMERICAN
I/ 20-75

BOUDIN, EUGENE (1824-1898) FRENCH
I/ 150-1100 P/ 350

BOUISSET, FIRMIN (1859-1925) FRENCH
P/ 600-3000

BOULANGER, GUSTAVE C. (1824-1888) FRENCH
P/ 450-500

BOULLOGNE, LOUIS DE II (1654-1733) FRENCH
I/ 250

BOURDON, SEBASTIEN (1616-1671) FRENCH
I/ 150-300

BOURGEOIS DU CASTELET, FLORENT F. C. (1767-1836) FRENCH
P/ 100

BOUT, PEETER (1658-1719) FLEMISH
I/ 450-4400

BOUTET, HENRI (1851-1919) FRENCH
I/ 30-125 P/ 15-1100

BOYD, FISKE (1895-1975) AMERICAN
I/ 30 R/ 100-300

BOYDELL, JOHN (1719-1804) BRITISH
I/ 100

BOYER, RALPH L. (1879-1952) AMERICAN
I/ 25-100

BRACQUEMOND, FELIX (1833-1914) FRENCH
I/ 25-9900 R/ 350

BRADFORD, HOWARD (B. 1919) AMERICAN
P/ 20-60

BRADLEY, WILLIAM H. (1868-1962) AMERICAN
I/ 70-5500 P/ 800-5000

BRAEU, NICHOLAS DE (17TH C) DUTCH
I/ 725

BRANGWYN, SIR FRANK (1867-1956) BRITISH
I/ 25-1200 P/ 50-1300 R/ 25-600

BRAQUE, GEORGES (1882-1963) FRENCH
I/ 175-93500 P/ 50-56000 R/ 275-15400

BRASILIER, ANDRE (B. 1929) FRENCH

P/ 90-6200
BRAUER, ERICH (B. 1929) AUSTRIAN
 I/ 100-600 P/ 150
BRAUNER, VICTOR (1903-1966) RUMANIAN
 I/ 375-1900 P/ 100-755
BRAUER, ARIK (B. 1929) GERMAN
 I/ 50-600 P/ 75-450
BRAYER, YVES (B. 1907) FRENCH
 I/ 126-350 P/ 25-6000
BREAUTE, ALBERT (B. 1853) FRENCH
 P/ 200
BREBIETTE, PIERRE (1598-1650) FRENCH
 I/ 100-400
BRECKERVELD, HERMAN (17TH C) DUTCH
 I/ 300
BREITER, HERBERT (B. 1923) GERMAN
 P/ 20-150
BREMER, UWE (B. 1940) GERMAN
 I/ 12-600 R/ 145-300
BRENDEL, KARL A. (B. 1877) GERMAN
 R/ 150
BRENOT, PIERRE LAURENT (B. 1913) FRENCH
 P/ 300
BRESCIA, GIOVANNI (16TH C) ITALIAN
 I/ 900-62000
BRESDIN, RODOLPHE (1822-1885) FRENCH
 I/ 77-16000 P/ 200-47000
BRESSLERN-ROTH, NORBERTINE (1891-1978) AUSTRIAN/AMERICAN
 R/ 100-525
BREUIL, A. (?) FRENCH
 P/ 700
BRIANCHON, MAURICE (B. 1899) FRENCH
 P/ 100-400
BRIGHTWELL, L. R. (20TH C) AMERICAN
 I/ 25-100
BRIGNONI, SERGE (B. 1903) ITALIAN
 P/ 75-800
BRIOT, ISAAC II (1585-1670) FRENCH
 I/ 1100
BRISCHLE, EMIL (B. 1884) GERMAN
 P/ 250
BRISCOE, ARTHUR JOHN TREVOR (1873-1943) BRITISH
 I/ 75-750
BRIZZIO, FRANCESCO (1574-1623) ITALIAN

I/ 150-750

BROCKHURST, GERALD LESLIE (1890-1978) BRITISH
I/ 100-15400 P/ 130-990

BROCKHUSEN, THEO (19TH/20TH C) GERMAN
I/ 200-425

BRODOVITCH, ALEXEV (1898-1971) AMERICAN
P/ 1800

BROODTHAERS, MARCEL (B. 1924) BELGIAN
P/ 500-8000

BROOKS, JAMES (20TH C) AMERICAN
P/ 30-100

BROOKS, MILDRED B. (B. 1901) AMERICAN
I/ 200

BROOKSHAW, GEORGE (?) BRITISH
I/ 150

BROSAMER, HANS (1506-1554) GERMAN
I/ 100-1700 R/ 768

BROUET, AUGUSTE (1872-1941) FRENCH
I/ 40-300

BROWN, BOLTON (COIT)(1865-1936) AMERICAN
P/ 50-125

BROWN, HAROLD HAVEN (1869-1932) AMERICAN
R/ 40-100

BRUN, EDME GUSTAVE FREDERIC (1817-1881) FRENCH
P/ 375-500

BRUNELLESCHI, UMBERTO (20TH C) ITALIAN
I/ 150-830 P/ 400-2600

BRUNI, BRUNO (FRANCESCO) (1648-1726)
I/ 120-275 P/ 75-610

BRUNING, PETER (1929-1970) GERMAN
I/ 1000-2100 P/ 70-1200

BRUS, GUNTER (B. 1938) AUSTRIAN
I/ 100-1200 P/ 100

BRUSTOLON, GIOVANNI (B. 1726) ITALIAN
I/ 200-2200

BRUYCKER, JULES DE (1870-1945) BELGIAN
I/ 400-800

BRUYN, NICHOLAS DE (17TH C) DUTCH
I/ 25-1000

BRY, JAN THEODOR DE (1528-1598) FLEMISH
I/ 100-3894

BUCHHEISTER, CARL (KARL) (1890-1964) GERMAN
I/ 10-1600 P/ 630-690

BUCHHOLZ, ERICH (B. 1891) GERMAN

P/ 50-1300 R/ 227
BUCHHOLZ, WOLFF (B. 1935) GERMAN
 I/ 50-500 P/ 75-250
BUCKLEY, STEPHEN (B. 1944) BRITISH
 P/ 600-1200
BUELL, ALICE STANDISH (20TH C) AMERICAN
 I/ 50-200
BUFANO, REMO (B. 1894) AMERICAN
 P/ 300
BUFFET, BERNARD (B. 1928) FRENCH
 I/ 40-22000 P/ 40-39600
BUHOT, FELIX HILAIRE (1847-1898) FRENCH
 I/ 45-9200 P/ 100-2700
BUNBURY, HENRY W. (1750-1811) BRITISH
 I/ 800
BURCHARTZ, MAX (1887-1961) GERMAN
 P/ 150-8000
BURCHFEILD, CHARLES E. (1893-1967) AMERICAN
 P/ 2600-9900
BURGKMAIR, HANS (1473-1531) GERMAN
 I/ 200-5500 R/ 100-13200
BURKNER, HUGO (19TH C) GERMAN
 I/ 400
BURLIUK, DAVID (1882-1966) AMERICAN
 P/ 392-1650
BURNS, MILTON J. (B. 1953) AMERICAN
 I/ 25-100
BURR, GEORGE ELBERT (1859-1939) AMERICAN
 I/ 125-1200
BURRA, EDWARD (1905-1976) BRITISH
 I/ 100-300 R/ 100
BURRELL, ALFRED R. (B. 1877)
 I/ 25-250
BURRI, ALBERTO (B. 1915) ITALIAN
 I/ 500-4600
BUSINCK, LUDOLPH (B. 1635) GERMAN
 R/ 225-2200
BUSSE, GEORG (1810-1868) GERMAN
 I/ 150
BUSSENMACHER, JOHANN (active 1580-1613) GERMAN
 I/ 400
BUTHE, MICHAEL (B. 1944) AMERICAN
 I/ 200-1100 P/ 150-400
BUTLER, REG (B. 1913) BRITISH

Technique Key

Under each <u>printing technique</u> you may encounter the following types of prints (or combination of processes):

I <u>Intaglio:</u>
- etching
- drypoint
- steel engraving
- stipple engraving
- aquatint
- mezzotint
- soft-ground etching
- crayon manner

P <u>Planographic:</u>
- lithograph
- monotype
- silk-screen
- cliche verre
- serigraph

R <u>Relief:</u>
- wood block
 - woodcut
 - chiaroscuro
 - wood engraving
- linoleum cut (linocut)

P/ 150-550
BYE, MARCUS DE (1639-1688) DUTCH
 I/ 50-150
BYXBE, LYMAN (B. 1886) AMERICAN
 I/ 25-100

C

CADMUS, PAUL (B. 1904) AMERICAN
 I/ 300-9350 P/ 200-825
CADY, HARRISON (1877-1970) AMERICAN
 I/ 100-500
CAGE, JOHN (B. 1912) AMERICAN
 P/ 100-1000
CAIN, CHARLES W. (1893-1962) BRITISH
 I/ 30-75
CALDER, ALEXANDER STERLING (1870-1945) AMERICAN
 I/ 50-18000 P/ 50-3700
CALDERARA, ANTONIO (B. 1903) ITALIAN
 P/ 25-300
CALETTI, GIUSEPPE (1600-1660) ITALIAN
 I/ 175-900
CALEWAERT, LOUIS (B. 1894) AMERICAN
 I/ 25-100
CALLOT, JACQUES (1592-1635) FRENCH
 I/ 10-25300
CAMACHO, JORGE (B. 1934) CUBAN
 P 106-225
CAMARO, ALEXANDER (B. 1901) GERMAN
 I/ 200 P/ 100-950
CAMERON, SIR DAVID YOUNG (1865-1945) BRITISH
 I/ 15-600
CAMOIN, CHARLES (1879-1965) FRENCH
 I/ 250-350 P/ 200-350
CAMPAGNOLA, DOMENICO (1484-1550) ITALIAN
 I/ 1500-17000 R/ 400-6795
CAMPENDONK, HEINRICH (1889-1957) GERMAN
 R/ 60-10000
CAMPI, ANTONIO (D. 1591) ITALIAN
 R/ 335-800

CAMPIGLI, MASSIMO (1895-1971) ITALIAN
 I/ 1400-2400 P/ 250-2700
CANADE, VINCENT (B. 1879) AMERICAN
 P/ 250
CANALETTO, (GIOVANNI ANTONIO)(1697-1768) ITALIAN
 I/ 229-19500
CANCARET, JACQUES (19TH C) FRENCH
 P/ 1700
CANOGAR, RAFAEL (B. 1934) SPANISH
 P/ 300
CANTARINI, SIMONE (1612-1648) ITALIAN
 I/ 125-7800
CANUTI, DOMENICO (1620-1684) ITALIAN
 I/ 300-1600
CAPITELLI, BERNARDINO (1589-1639) ITALIAN
 I/ 150-1800
CAPOGROSSI, GIUSEPPE (1900-1972) ITALIAN
 P/ 150-690
CAPPELLE, JAN VAN DE (1624-1679) DUTCH
 I/ 800
CAPPIELLO, LEONETTO (1875-1942) ITALIAN
 P/ 118-5100
CARAGLIO, GIOVANNI-JACOPO (1500-1570) ITALIAN
 I/ 41-16000
CARBONELL, G. (B. 1915) FRENCH
 P/ 700
CARDENAS, JUAN (B. 1939) SPANISH
 I/ 725
CARDINAUX, EMILE (1877-1936) SWISS
 P/ 300-3800
CARIGIET, ALOIS (B. 1902) ?
 P/ 175-19000
CARISS, HENRY T. (1840-1903) AMERICAN
 I/ 30-75
CARLEVARIJS, LUCA (1665-1731) ITALIAN
 I/ 50-400
CARLIN, JAMES (B. 1909) AMERICAN
 P/ 75-200
CARLU, JEAN (B. 1900) FRENCH
 P/ 150-6600
CARO-DELAVAILLE, HENRY (1876-1926) FRENCH
 P/ 3200
CARPI, UGO DA (1480-1523) ITALIAN
 R/ 200-26550

CARPIONI, GIULIO (1611-1674) ITALIAN
 I/ 50-2900
CARR, GEORGE (20TH C) AMERICAN
 P/ 207-1540
CARRA, CARLO (1881-1966) ITALIAN
 I/ 600 P/ 400-2400
CARRACCI, AGOSTINO (1557-1602) ITALIAN
 I/ 100-5310
CARRACCI, ANNIBALE (1560-1609) ITALIAN
 I/ 100-14000
CARRACCI, LODOVICO (1555-1619) ITALIAN
 I/ 250-2600
CARRE, LEON GEORGES J. B. (1882-1962) FRENCH
 P/ 400
CARRIER, AUGUSTE-JOSEPH (1800-1875) FRENCH
 P/ 500
CARRIERE, EUGENE (1849-1906) FRENCH
 P/ 50-2000
CARRINGTON, LEONORA (20TH C) AMERICAN
 P/ 500-900
CARTER, CLARENCE HOLBROOK (B. 1904) AMERICAN
 I/ 150-1200
CARTON, JEAN (B. 1912) FRENCH
 I/ 50-350
CARZOU, JEAN (B. 1907) FRENCH
 P/ 25-530
CASA, NICOLO DELLA (16TH C) ITALIAN
 I/ 600-900
CASAS, RAMON (B. 1866) SPANISH
 P/ 900-5400
CASORATI, FELICE (1886-1963) ITALIAN
 I/ 2000-4000
CASPAR, KARL (1879-1956) GERMAN
 P/ 50-690
CASSANDRE, A. J. M. MOURON (1901-1968) FRENCH
 P/ 300-60500
CASSATT, MARY (1844-1926) AMERICAN
 I/ 300-225500 P/ 6300-21000
CASSIERS, HENRY (1858-1944) BELGIAN
 I/ 300 P/ 200-3000
CASSIGNEUL, JEAN-PIERRE (B. 1935) FRENCH
 P/ 550-7500
CASTELLON, FEDERICO (1914-1971) AMERICAN
 I/ 25-450 P/ 40-450

CASTIGLIONE, GIOVANNI BENEDETTO (1616-1670) ITALIAN
I/ 160-5500
CASTIGLIONE, GUISEPPE (1829-1908) ITALIAN
I/ 125-518000
CASTILLO, JORGE (B. 1933) SPANISH
I/ 75-3500 P/ 426
CATLIN, GEORGE (1796-1872) AMERICAN
P/ 200-2000
CAULAERT, JEAN DOMINIQUE VAN (20TH C) FRENCH
P/ 150-3600
CAULFIELD, PATRICK (B. 1936) BRITISH
P/ 25-1000
CAVAEL, ROLF (B. 1898) GERMAN
P/ 100-850
CAVALLIERI, GIOVANNI BATTISTA (1525-1597) ITALIAN
I/ 100-1500
CAZALS, FREDERIC A. (1865-1941) FRENCH
P/ 200-2100
CEMINS, VIJA (B. 1939) AMERICAN
P/ 450-600
CESAR, (B. 1921) FRENCH
P/ 30-500
CEZANNE, PAUL (1839-1906) FRENCH
I/ 100-13200 P/ 200-79750
CHADWICK, LYNN (B. 1914) BRITISH
P/ 50-1200
CHAGALL, MARC (1887-1985) RUSSIAN/FRENCH
I/ 100-77400 P/ 25-99000 R/ 800-50000
CHAHINE, EDGAR (1874-1947) FRENCH
I/ 55-8000
CHAKA, FRANK (B. 1887) AMERICAN
I/ 25-100
CHAMBERLAIN, PRICE A. (B. 1905) AMERICAN
R/ 25-100
CHAMBERLAIN, SAMUEL (1895-1975) AMERICAN
I/ 50-800
CHANDLER, GEORGE W. (20TH C) AMERICAN
I/ 25-100
CHAPELLIER, PH. (20TH C) ?
P/ 375-900
CHAPIN, JAMES ORMSBEE (1887-1975) AMERICAN
P/ 175
CHAPLIN, PRESCOTT (1897-1968) AMERICAN
R/ 50-125

CHARBONNIER, LOUISE (20TH C) FRENCH
P/ 1500
CHARLET, NICOLAS T. (1792-1845) FRENCH
P/ 75-1400
CHARLOT, JEAN (1898-1979) AMERICAN
P/ 75-400
CHASE, LOUISA (B. 1951) AMERICAN
R/ 800-2700 P/ 500-600
CHASE, WILLIAM MERRITT (1849-1916) AMERICAN
I/ 75-1210 P/ 4950-5500
CHASSERIAU, THEODORE (1819-1856) FRENCH
P/ 50-1200
CHASTEL, ROGER (1897-1981) FRENCH
I/ 50
CHAVANNES, PIERRE (19TH/20TH C) FRENCH
P/ 400
CHAVIGNIERE, LOUIS (1922-1972) FRENCH
I/ 2100
CHEFFER, HENRY (B. 1880) FRENCH
I/ 25-200
CHEFFETZ, ASA (1896-1965) AMERICAN
R/ 75-880
CHENEY, PHILIP (B. 1897) AMERICAN
P/ 75-250
CHERET, JULES (1836-1932) FRENCH
P/ 40-7700
CHERRY, EDWARD J. (20TH C) BRITISH
I/ 25-100
CHEVILLET, JUSTE (1729-1790) FRENCH
I/ 800
CHIA, SANDRO (B. 1946) ITALIAN
I/ 400-1500 P/ 1000-7700
CHIARI, FABRIZIO (1621-1695) ITALIAN
I/ 200-825
CHICAGO, JUDY (B. 1939) AMERICAN
P/ 300-500
CHILDS, BERNARD (B. 1910) AMERICAN
I/ 150
CHILLIDA, EDUARDO (B. 1924) SPANISH
I/ 30-2000 P/ 100-1700 R/ 150-1500
CHIMOT, EDOUARD (20TH C) FRENCH
I/ 50-270
CHIRICO, GIORGIO DE (1888-1978) ITALIAN
I/ 600-3600 P/ 50-9700

CHODOWIECKI, DANIEL (1726-1801) GERMAN
 I/ 50-3200
CHOUBRAC, ALFRED (1853-1902) FRENCH
 P/ 100-2200
CHRISTIANSEN, NILS HANS (1873-1960) DANISH
 P/ 3200
CHRISTO, (CHRISTO JAVACHEFF) (B. 1935) AMER/BULGARIAN
 P/ 100-22000
CIRY, MICHEL (B. 1919) FRENCH
 I/ 50-500
CISSARZ, JOHANN (1873-1942) GERMAN
 P/ 150-2000
CITRON, MINNA (B. 1896) AMERICAN
 P/ 150-500
CLAESZ, ALLAERT (17TH C) DUTCH
 I/ 600-2400
CLAPP, WILLIAM HENRY (1879-1954) AMERICAN
 I/ 385 P/ 450
CLARENBACH, MAX (1880-1952) GERMAN
 I/ 100-1900 P/ 250
CLAUSEN, GEORGE (1852-1944) BRITISH
 I/ 100-300
CLAVE, ANTONI (B. 1913) SPANISH
 I/ 10-2100 P/ 75-3600
CLEMENTE, FRANCESCO (B. 1952) SPANISH
 I/ 175-13000 P/ 150-19800 R/ 375-11000
CLOSE, CHUCK (B. 1940) AMERICAN
 I/ 80-11550 P/ 3000-16000 R/ 3300-33000
CLOUWET, PEETER (1629-1670) FLEMISH
 I/ 800
COCHIN, CHARLES NICOLAS (1715-1790) FRENCH
 I/ 300-4500
COCK, HIERONYMUS (1510-1570) FLEMISH
 I/ 175-5100 R/ 882
COCK, JAN WELLENS (1480-1526) FLEMISH
 R/ 2700
COCLERS, J.B.B. (1741-1817) FLEMISH
 I/ 1800
COCTEAU, JEAN (1889-1963) FRENCH
 I/ 50-175 P/ 65-13200
COESTER, OTTO (B. 1902) GERMAN
 I/ 25-100
COK, ZLATANA (20TH C) ?
 I/ 30-125

Technique Key

Under each <u>printing technique</u> you may encounter the following types of prints (or combination of processes):

I <u>Intaglio:</u>

- etching
- drypoint
- steel engraving
- stipple engraving
- aquatint
- mezzotint
- soft-ground etching
- crayon manner

P <u>Planographic:</u>

- lithograph
- monotype
- silk-screen
- cliche verre
- serigraph

R <u>Relief:</u>

- wood block
 - woodcut
 - chiaroscuro
 - wood engraving
- linoleum cut (linocut)

COIGNARD, JAMES (B. 1925) FRENCH
I/ 75-1400 P/ 690
COLEMAN, GLENN O. (1887-1932) AMERICAN
P/ 550-4700
COLIN, PAUL EMILE (1892-1984) FRENCH
P/ 50-8300 R/ 25-200
COLLAERT, ADRIAEN (1560-1618) FLEMISH
I/ 50-900
COLLAERT, HANS I/ (16TH C) FLEMISH
I/ 200-500
COLLIEN, PETER (20TH C) ?
I/ 50-250
COLQUHOUN, ROBERT (20TH C) ?
P/ 664-2000
COLVILLE, ALEX (B. 1920) CANADIAN
P/ 2700
COMBA, PAUL (B. 1926) FRENCH
P/ 400
COMBAZ, GISBERT (B. 1869) BELGIAN
P/ 500-7000
COMMARMOND, PIERRE (20TH C) FRENCH
P/ 225-550
CONGDON, THOMAS R. (1862-1917) AMERICAN
I/ 25-100
CONSTABLE, JOHN (1776-1837) BRITISH
I/ 150-4300
CONTE, ANTONIO (1780-1837) ITALIAN
I/ 800
CONZ, WALTER (B. 1872) GERMAN
I/ 75-200 P/ 75-150
COOGHEN, LEENDERT VAN DER (1610-1681) DUTCH
I/ 400-2400
COOK, HOWARD (1901-1980) AMERICAN
I/ 150-6600 P/ 100-6600 R/ 200-3850
COOPER, AUSTIN (B. 1890) CANADIAN
P/ 200-4000
COORNHERT, DIRK (1522-1590) DUTCH
I/ 125-500
COPLEY, JOHN (1875-1950) BRITISH
P/ 25-250
CORBUSIER, LE (1887-1965) FRENCH
I/ 90-4500 P/ 250-7300 R/ 625
CORINTH, LOVIS (1858-1925) GERMAN
I/ 25-8500 P/ 25-7000 R/ 296-1000

CORIOLANO, BARTOLOMEO (1599-1676) ITALIAN
 R/ 200-3490
CORNEILLE, (CORNELIUS G. B.) (B. 1922) DUTCH
 I/ 300-650 P/ 25-3600 R/ 150-1000
CORNELL, JOSEPH (1903-1972) AMERICAN
 I/ 300 P/ 1000-3300
CORNELL, THOMAS (B. 1937) AMERICAN
 I/ 25-100
COROT, JEAN BAPTISTE CAMILLE (1796-1875) FRENCH
 I/ 175-15000 P/ 50-15000
CORPORA, ANTONIO (B. 1909) ITALIAN
 P/ 100-250
CORRELL, RICHARD (B. 1904) AMERICAN
 P 25-100
CORT, CORNELIS (1533-1578) DUTCH
 I/ 150-1200
COSTIGAN, JOHN EDWARD (1888-1972) AMERICAN
 I/ 88-300
COTTINGHAM, ROBERT (B. 1935) AMERICAN
 I/ 125-500 P/ 200-1100
COUDREY, R. DU (19TH/20TH C) FRENCH
 P/ 500-600
COUGHLIN, JACK (B. 1932) AMERICAN
 I/ 10-75
COULTER, MARY J. (1880-1966) AMERICAN
 R/ 1800
COURBET, GUSTAVE (1819-1877) FRENCH
 P/ 275-1000
COURTOIS, GUSTAVE CLAUDE ETIENNE (1853-1923) FRENCH
 P/ 450
COUSSENS, ARMAND (1881-1935) FRENCH
 I/ 50-200
COUTAUD, LUCIEN (1904-1977) FRENCH
 I/ 200-300 P/ 50-300
COWIN, JACK (20TH C) ?
 P/ 200-300
COX, CHARLES BRINTON (1864-1905) AMERICAN
 P/ 800
CRAIG, EDWARD G. (1872-1966) BRITISH
 I/ 50 R/ 11-1100
CRANACH, LUCAS I (1472-1553) GERMAN
 I/ 1100-4400 R/ 125-75000
CRANACH, LUCAS II (1515-1586) GERMAN
 R/ 200-500

CRAWFORD, RALSTON (1906-1978) AMERICAN
P/ 330-38500 R/ 3000
CREMER, FRITZ (B. 1906) ?
P/ 50-100
CREMONINI, LEONARDO (B. 1925) ITALIAN
I/ 300
CROME, JOHN (1768-1821) BRITISH
I/ 25-250
CRESPIN, ADOLPHE (B. 1859) BELGIAN
P/ 300-5500
CRODEL, CHARLES (B. 1894) FRENCH
P/ 100-1800 R/ 475-2000
CROSS (DELACROIX), HENRI EDMOND (1856-1910) FRENCH
P/ 300-1000
CROTTI, JEAN (1878-1958) FRENCH
P/ 500
CRUTCHFIELD, WILLIAM (B. 1932) AMERICAN
P/ 50-150
CRUZ-DIEZ, CARLOS (B. 1923) VENEZUELAN
P/ 250
CUCCHI, ENZO (B. 1950) ITALIAN
I/ 600-18000 P/ 605-3300
CUEVAS, JOSE LUIS (B. 1934) MEXICAN/AMERICAN
I/ 150 P/ 75-900
CUITT, GEORGE (THE YOUNGER) (1779-1854) BRITISH
I/ 300-375
CUNEGO, DOMENICO (1727-1794) ITALIAN
I/ 200-250
CUNNINGHAM, W. PHELPS (1904-1980) AMERICAN
I/ 75-200
CURRY, JOHN STEUART (1897-1946) AMERICAN
P/ 200-6325
CURTI, BERNARDINO (B. 1645) ITALIAN
I/ 150

D

D'ARCANGELO, ALLAN (B. 1930) AMERICAN
P/ 500-900
DAHL, PETER (B. 1934) SWEDISH

P/ 1100
DAHLGREEN, CHARLES W. (1864-1955) AMERICAN
 I/ 40-100
DAHM, HELEN (B. 1878) GERMAN
 I/ 212 P/ 200-1500 R/ 1100
DAHMEN, KARL FRED (B. 1917) AMERICAN
 I/ 25-10000 P/ 100-1000
DALEN, CORNELIS VAN (1602-1665) DUTCH
 I/ 150-1000
DALEN, CORNELIS II (1638-1664) DUTCH
 I/ 300-1100
DALI, SALVADOR (1904-1989)) SPANISH
 I/ 25-8800 P/ 50-10240 R/ 55-800
DALLMAN, DANIEL (B. 1942) AMERICAN
 I/ 30-125
DANIEL, LEWIS C. (1901-1952) AMERICAN
 I/ 20-75
DASKALOFF, GEORGE (B. 1923) BULGARIAN
 P/ 75-125
DAUBIGNY, CHARLES FRANCOIS (1817-1878) FRENCH
 I/ 40-1200 P/ 100-600
DAUMIER, HONORE (1808-1879) FRENCH
 P/ 9-27000
DAVENT, LEON (16TH C) FRENCH
 I/ 200-5500
DAVIE, ALAN (B. 1920) BRITISH
 P/ 100-1500
DAVIES, ARTHUR BOWEN (1862-1928) AMERICAN
 I/ 125-4100 P/ 150-550
DAVIS, GENE (B. 1920) AMERICAN
 P/ 130-600
DAVIS, RONALD (RON) WENDELL (B. 1937) AMERICAN
 I/ 100-525 P/ 125-1500
DAVIS, STUART (1894-1964) AMERICAN
 P/ 275-17600
DAVIS, WARREN B. (1865-1928) AMERICAN
 I/ 50-250
DAVIS, WILLIAM S. (1884-1959) AMERICAN
 I/ 25-100 R/ 25-100
DAVRINGHAUSEN, HENRI DARVING (B. 1900) GERMAN
 P/ 100-450
DEBUCOURT, PHILIBERT LOUIS (1755-1832) FRENCH
 I/ 175-11000
DECORDOBA, MATHILDE (1875-1942) AMERICAN

I/ 25-100
DEFAU, CLEMENTINE (19TH/20TH C) ?
P/ 4000
DEGAS, EDGAR (1834-1917) FRENCH
 I/ 100-204000 P/ 700-551000
DEHN, ADOLPH ARTHUR (1895-1968) AMERICAN
P/ 25-770
DEHNER, DOROTHY (B. 1908) AMERICAN
I/ 75-250
DEINEKA, ALEXANDER (B. 1899) RUSSIAN
P/ 600
DEINES, E. HUBERT (20TH C) AMERICAN
R/ 220
DELACROIX, EUGENE (1798-1863) FRENCH
 I/ 50-16000 P/ 75-20000
DELARUE-NOUVELLIER (20TH C) FRENCH
P/ 1200
DELATRE, EUGENE (1864-1938) FRENCH
I/ 50-1500
DELAUNAY, ROBERT (1885-1941) FRENCH
P/ 75-57000
DELAUNAY, SONIA (1885-1979) RUSSIAN/FRENCH
 I/ 150-3400 P/ 90-13000
DELTEIL, LOYS (1869-1927) FRENCH
I/ 200
DELVAUX, PAUL (B. 1897) BELGIAN
 I/ 200-10000 P/ 75-36000
DE MARTELLY, JOHN STOCKTON (B. 1903)
P/ 80-600
DEMARTEAU, GILLES (1722-1776) FRENCH
I/ 100-2900
DENIS, MAURICE (1870-1943) FRENCH
 I/ 122 P/ 100-11000 R/ 25-11000
DENNIS, MORGAN (1892-1960) AMERICAN
I/ 50-125
DENON, DOMINIQUE V. (1747-1825) FRENCH
 I/ 200-550 P/ 271
DENTE, MARCO (D. 1527) ITALIAN
I/ 75-1100
DERAIN, ANDRE (1880-1954) FRENCH
 I/ 25-2600 P/ 50-1100 R/ 100-7900
DESBOUTIN, MARCELIN (1823-1902) FRENCH
I/ 200
DESCOURTIS, CHARLES-MELCHOIR (1753-1820) FRENCH

I/ 200-2800
DESNOYER, FRANCOIS (1894-1972) FRENCH
 P/ 80-170
DETHOMAS, MAXIME (1867-1929) FRENCH
 P/ 1200
DETMOLD, CHARLES MAURICE (1883-1908) BRITISH
 and
DETMOLD, EDWARD J. (1883-1957) BRITISH
 I/ 100-1100
DETOUCHE, HENRY (1854-1913) FRENCH
 I/ 110-600 P/ 100-1000
DEUTSCH, ERNST (B. 1883) AUSTRIAN
 P/ 175-3520
DEXEL, WALTER (1890-1973) GERMAN
 P/ 100-1200 R/ 300-2000
DEYROLLE, JEAN (1911-1967) FRENCH
 P/ 150-325
DEYSTER, LUDWIG VAN (1656-1711) GERMAN
 I/ 100-1200
DIACRE, JEAN DOMINIQUE (17TH/18TH C) GERMAN
 I/ 50
DICHTL, MARTIN (17TH C) GERMAN
 I/ 24-400
DICKINSON, WILLIAM (1746-1767) BRITISH
 I/ 200
DICKSEE, HERBERT (1862-1942) BRITISH
 I/ 100-400
DIEBENKORN, RICHARD (B. 1922) AMERICAN
 I/ 450-113800 P/ 650-66000 R/ 2750-44100
DIES, ALBERT C. (1755-1822) AUSTRIAN
 I/ 100-200
DIETRICH, CHRISTIAN WILHELM ERNST (1712-1774) GERMAN
 I/ 25-1900 R/ 250-1000
DIEZ, JULIUS (B. 1870) GERMAN
 P/ 189-1000
DIGGELMANN, ALEX W.
 P/ 300-3100
DIGHTON, ROBERT (1752-1812) BRITISH
 I/ 250
DILL, LADDIE JOHN
 P/ 250-825
DILL, OTTO (1884-1957) GERMAN
 P/ 19-300
DINE, JIM (B. 1935) AMERICAN

Technique Key

Under each <u>printing technique</u> you may encounter the following types of prints (or combination of processes):

I <u>Intaglio:</u>

- etching
- drypoint
- steel engraving
- stipple engraving
- aquatint
- mezzotint
- soft-ground etching
- crayon manner

P <u>Planographic:</u>

- lithograph
- monotype
- silk-screen
- cliche verre
- serigraph

R <u>Relief:</u>

- wood block
 - woodcut
 - chiaroscuro
 - wood engraving
- linoleum cut (linocut)

I/ 100-45100 P/ 50-41000 R/ 75-42000
DISTLER, RUDOLPH ?
 I/ 100-450
DITTRICH, SIMON ?
 I/ 80-300 P/ 25-100
DIX, OTTO (1891-1969) GERMAN
 I/ 300-27000 P/ 50-50400 R/ 100-14000
DIXON, FREDERICK C. (B. 1902) BRITISH
 I/ 100-300
DOBKIN, ALEXANDER (1908-1975) ITALIAN
 P/ 6-75
DOBSON, FRANK (1888-1963) BRITISH
 P/ 600
DODD, FRANCIS (1874-1949) BRITISH
 I/ 100-600
DODEIGNE, EUGENE (B. 1923) FRENCH
 P/ 200
DODGE, OZIAS (1868-1925) AMERICAN
 I/ 25-100
DOESER, JACOB (1623-1673) ITALIAN
 P/ 1200
DOHANOS, STEVAN (B. 1907) AMERICAN
 P/ 150-440 R/ 100-450
DOLICE, LEON (1892-1960) AMERICAN
 I/ 50-125
DOMELA, CESAR (B. 1900) DUTCH
 P/ 75-550
DOMENJOZ, RAOUL (B. 1896) SWISS
 P/ 200
DOMERGUE, JEAN GABRIEL (1889-1962) FRENCH
 I/ 300-650 P/ 100-2500
DOMINGUEZ, OSCAR (1906-1958) SPANISH
 I/ 800 P/ 75-955
DOMJAN, JOSEPH (B. 1907) AMERICAN
 R/ 50-125
DONGEN, KEES VAN (1877-1968) DUTCH/FRENCH
 I/ 150-500 P/ 25-7200
DONNAY, AUGUSTE (1862-1921) BELGIAN
 P/ 450-700
DOOLITTLE, HAROLD LUKENS (20TH C) AMERICAN
 I/ 100-450
DORAZIO, PIERO (B. 1927) ITALIAN
 I/ 75-560 P/ 150-750
DORIVAL, GEORGES (B. 1879) FRENCH

P/ 300-900
DORN, LEO F. (B. 1879) AMERICAN
 R/ 50-125
DORNY, BERTRAND (B. 1931) FRENCH
 I/ 125-450
DOUGLAS, LUCILLE (D. 1935) AMERICAN
 I/ 25-100
DOW, ARTHUR WESLEY (1857-1922) AMERICAN
 R/ 50-12000
DRESSLER, AUGUST W. (20TH C) ?
 I/ 100-450 P/ 2250
DREWES, WERNER (1899-1985) AMERICAN
 I/ 660 P/ 303 R/ 50-990
DRIAN, A. (20TH C) FRENCH
 I/ 75-350
DROIT, JEAN (20TH C) FRENCH
 P/ 2400-4400
DROOCHSLOOT, JOOST CORNELISZ (1586-1666) DUTCH
 I/ 2900
DRURY, PAUL (1903-1988) BRITISH
 I/ 400-475
DRURY, WILLIAM (1888-1959) AMERICAN
 I/ 25-100
DUBUFFET, JEAN (1901-1985) FRENCH
 I/ 550 P/ 5-88000 R/ 200-2400
DUCHAMP, MARCEL (1887-1968) FRENCH/AMERICAN
 I/ 200-8500 P/ 50-9700 R/ 12000
DUCHAMP, SUZANNA (1898-1963) FRENCH
 I/ 27 P/ 175-500
DUCK, JACOB (1600-1667) DUTCH
 I/ 250
DUDOVICH, MARCELLO (B. 1878) ITALIAN
 P/ 400-6600
DUFAU, CLEMENTINE (B. 1869) FRENCH
 P/ 900-9000
DUFRESNE, CHARLES (1876-1938) FRENCH
 P/ 400-600
DUFY, RAOUL (1877-1953) FRENCH
 I/ 40-3550 P/ 90-6400 R/ 75-8100
DUJARDIN, KAREL (1622-1678) DUTCH
 I/ 25-400
DUNCAN, RAYMOND (20TH C) BRITISH
 R/ 75-200
DUNKER, BALTHASAR ANTON (1746-1807) GERMAN

I/ 950
DUNOYER DE SEGONZAC, ANDRE (1884-1974) FRENCH
I/ 75-5500
DUPAS, JEAN THEODORE (1882-1964) FRENCH
I/ 500-7700 P/ 600-19250
DUPUIS, EDMOND-MARIE (20TH C) FRENCH
I/ 350
DURER, ALBRECHT (1471-1528) GERMAN
I/ 100-512000 R/ 25-167587
DUSAMANTES, FRANCISCO (20TH C) AMERICAN
P/ 100-300
DUSART, CORNELIUS (1660-1704) DUTCH
I/ 175-20600
DUTHE, J. (19TH C) FRENCH
I/ 100-400
DUVENECK, FRANK (1848-1919) AMERICAN
I/ 990-3300
DUVET, JEAN (1485-1570) FRENCH
I/ 3600-98000
DUVIVIER, IGNACE (1758-1832) FRENCH
I/ 200-300
DWIGHT, MABEL (1876-1955) AMERICAN
P/ 75-600
DYCK, SIR ANTHONY VAN (1599-1641) FLEMISH
I/ 150-65000
DZUBAS, FRIEDEL (B. 1915) GERMAN/AMERICAN
P/ 700-9350

E

EAMES, JOHN H. (B. 1900) AMERICAN
I/ 25-100
EARLOM, RICHARD (1743-1822) BRITISH
I/ 150-2300
EBERZ, JOSEF (B. 1880) GERMAN
I/ 50-1300 P/ 25-375 R/ 25-580
EBY, KERR (1889-1946) AMERICAN
I/ 40-3300 P/ 80-440
EDEL, EDMUND (B. 1863) GERMAN
P/ 500-1200

EDELMANN, YRJO (B. 1941) FINNISH
P/ 75-225
EDZARD, DIETZ (1893-1963) GERMAN
I/ 250
EGGENSCHWILER, FRANZ (B. 1930) SWISS
R/ 100-3200
EGGERS, GEORGE WILLIAM (1883-1958) AMERICAN
P/ 50-125
EGGIMANN, HANS (B. 1872) SWISS
I/ 150
EGLAU, OTTO (B. 1917) GERMAN
I/ 64-900
EHMSEN, HEINRICH
I/ 100-828 P/ 335 R/ 100-800
EHRLICH, GEORG (1897-1966) AUSTRIAN
I/ 100-700 P/ 150-400
EICHENBERG, FRITZ (B. 1901) AMERICAN
R/ 50-200
EISEN, CHARLES DOMINIQUE JOSEPH (1720-1778) FRENCH
I/ 400-700
ELIASBERG, PAUL (B. 1907) GERMAN
I/ 50-600
ELZINGRE, EDOUARD (20TH C) SWISS)
P/ 800-1100
ENDE, EDGAR (1901-1965) GERMAN
I/ 225-1300 P/ 150-1000
ENDE, HANS AM (1864-1918) GERMAN
I/ 150-1900
ENDELL, FRITZ (B. 1873) AMERICAN
R/ 25-100
ENGEL, JULES (B. 1915)
P/ 450
ENGELBRECHT, MARTIN (1684-1756) GERMAN
I/ 600-12000
ENGELHARDT, PAUL (?) ?
P/ 800-2000
ENSOR, JAMES (1860-1949) BELGIAN
I/ 80-19400 P/ 125-5400
ERBSLOH, ADOLF (1881-1947) GERMAN
P/ 275-1200
ERDT, HANS RUDI ?
P/ 200-2600
ERHARD, JOHANN C. (1795-1822) GERMAN
I/ 75-800

ERLER, ERICH ?
 I/ 25-200 P/ 400-1200
ERLER, GEORG (B. 1871) GERMAN
 I/ 150-250
ERNI, HANS (B. 1909) SWISS
 I/ 75-1800 P/ 25-3200
ERNST, MAX (1891-1976) FRENCH
 I/ 150-70000 P/ 20-18000
ERRO, GUDMUNDUR (B. 1932) ICELANDIC
 P/ 100-530
ERTE, (ROMAIN DE TIRTOFF) (B. 1892) RUSSIAN
 P/ 125-5000
ERTZ, EDWARD F. (B. 1862) AMERICAN
 I/ 25-100
ESCHER, MAURITS CORNELIS (1898-1972) DUTCH
 I/ 700-3500 P/ 200-37000 R/ 150-35000
ESCHER, ROLF (RUDOLF) (1662-1721) SWISS
 I/ 125
ESTEBY, J.M. (20TH C) AMERICAN
 I/ 75-150
ESTES, RICHARD (B. 1936) AMERICAN
 P/ 600-16000
ESTEVE, MAURICE (B. 1904) FRENCH
 I/ 1755 P/ 175-8700
ETTINGER, CHURCHILL (B. 1903) AMERICAN
 I/ 40-125
EVENEPOEL, HENRI (1872-1899) BELGIAN
 P/ 700-2200
EVERDINGEN, ALLART VAN (1621-1675) DUTCH
 I/ 29-1700
EVERGOOD, PHILIP (1901-1973) AMERICAN
 I/ 99 P 100-440
EXTER, ALEXANDRA (1884-1949) RUSSIAN
 P/ 350-400

F

FABER, WILL (?) ?
 P/ 100-300
FABRI, RALPH (20TH C) AMERICAN

I/ 25 -125
FACCINI, PIETRO (1562-1602) ITALIAN
I/ 400-2400
FAIVRE, JULES ABEL (1867-1945) FRENCH
P/ 850-4200
FALCK, JEREMIAS (17TH C) ?
I/ 100-2400
FALCONE, ANIELLO (1607-1656) ITALIAN
I/ 400-1100
FALDONI, GIOVANNI (1690-1770) ITALIAN
I/ 200-300
FALK, HANS (?) ?
P/ 175-2100
FANTIN-LATOUR, IGNACE HENRI J. T. (1836-1904) FRENCH
I/ 346 P/ 25-2200
FANTUZZI, ANTONIO (16TH C) ITALIAN
I/ 1200-21000
FARINATI, ORAZIO (1559-1616) ITALIAN
I/ 40-600
FARINATI, PAOLO (1524-1606) ITALIAN
I/ 250-850
FARLEY, FREDERICK (B. 1895) AMERICAN
I/ 30-125
FASSBENDER, JOSEPH (B. 1903) GERMAN
I/ 193 P/ 125-3700
FATHWINTER, F.A. TH. (B. 1906) GERMAN
P/ 250
FAURE, LUCIEN (1828-1904) FRENCH
P/ 300-800
FAUTRIER, JEAN (1898-1964) FRENCH
I/ 125-7400 P/ 350-2000
FEININGER, LYONEL (1871-1956) AMERICAN
I/ 600-17600 P/ 700-8200 R/ 100-19000
FEKETE, ESTEBAN (B. 1924)
I/ 225 P/ 250 R/ 50-400
FELBER, CARL FRIEDRICH (1880-1932) SWISS
I/ 250 P/ 300
FELDMAN, WALTER (B. 1925) AMERIACAN
R/ 25-100
FELIXMULLER, CONRAD (B. 1897) GERMAN
I/ 200-8000 P/ 100-26000 R/ 25-19000
FENNEKER, JOSEPH (?) ?
P/ 1900-10000
FENNITZER, GEORG (17TH C) GERMAN

Technique Key

Under each <u>printing technique</u> you may encounter the following types of prints (or combination of processes):

I Intaglio:

- etching
- drypoint
- steel engraving
- stipple engraving
- aquatint
- mezzotint
- soft-ground etching
- crayon manner

P Planographic:

- lithograph
- monotype
- silk-screen
- cliche verre
- serigraph

R Relief:

- wood block
 - woodcut
 - chiaroscuro
 - wood engraving
- linoleum cut (linocut)

I/ 200
FENTON, JOHN WILLIAM (1875-1939) AMERICAN
 I/ 125
FERGUSON, EDWARD R. (B. 1914) AMERICAN
 P/ 25-100
FERNEL ?
 P/ 150-1300
FETTING, RAINER
 I/ 700 P/ 1900-2500
FEURE, GEORGES DE (1868-1943) FRENCH
 P/ 150-10000
FIALETTI, ODOARDO (1573-1638) ITALIAN
 I/ 150-1800
FIENE, ERNEST (1894-1965) AMERICAN
 I/ 125-900 P/ 80-1300
FILMUS, TULLY (B.1908) AMERICAN
 P/ 40-125
FINCKEN, JAMES H. (1860-1943) AMERICAN
 I/ 50-100
FINDLAY, ANNE (20TH C) AMERICAN
 R/ 30-100
FINGESTEN, MICHAEL
 I/ 75-550 P/ 100-400
FINI, LEONOR (B. 1918) ARGENTINIAN
 I/ 50-1400 P/ 110-900
FIORINI, MARCEL (B. 1922) FRENCH
 I/ 100-250
FISCHER, CLEMENS
 I/ 200-350
FISCHL, ERIC (B. 1948) AMERICAN
 I/ 150-14000 P/ 3200-9000 R/ 2336
FISH, JANET (B. 1938) AMERICAN
 R/ 1540-1600
FIX-MASSEAU, PIERRE (1869-1937) FRENCH
 P/ 500-6000
FLACK, AUDREY (B. 1931) AMERICAN
 P/ 50-350
FLAMEN, ALBERT (17TH C) FLEMISH
 I/ 75-300
FLANAGAN, ALBERT (B. 1886) AMERAICAN
 I/ 25-100
FLEISCHMANN, ADOLF (1892-1969) GERMAN
 P/ 150-1000
FLETCHER, F. MORLEY (1866-1949) BRITISH/AMERICAN

R/ 400-900
FLIGHT, CLAUDE (1881-1955) BRITISH
R/ 50-18000
FLINT, SIR WILLIAM RUSSELL (1880-1969) BRITISH
I/ 100-1500 P/ 200-830
FLIPART, JEAN-JACQUES (1719-1782) FRENCH
I/ 800
FLORIS, FRANS (1516-1570) FLEMISH
I/ 300-1600
FLORSHEIM, RICHARD (1916-1979) AMERICAN
P/ 50-125
FOLON, JEAN MICHEL (B. 1934) BELGIAN
I/ 220-1100 P/ 50-1600
FONTANA, GIOVANNI BATTISTA (1524-1587) ?
I/ 400-4300
FONTANA, LUCIO (1899-1968) ITALIAN
I/ 100-4675 P/ 250-6100 R/ 5237
FONTEBASSO, FRANCESCO (1709-1769) ITALIAN
I/ 600-5840
FORAIN, JEAN LOUIS (1852-1931) FRENCH
I/ 35-2000 P/ 80-2200
FOREST, ROY DEAN DE (B. 1930) AMERICAN
P/ 200-850
FORTUNY Y CARBO, MARIANO (1838-1874) SPANISH
I/ 250-2800
FOULKES, LYN (20TH C) AMERICAN
P/ 75-175
FOUJITA, TSUGUHARU LEONARD (1886-1968) JAPANESE
I/ 100-46800 P/ 60-48000 R/ 150-6600
FOWLER, FRANK (1852-1910) AMERICAN
I/ 25-100
FRAME, WALTER (B. 1895) AMERICAN
I/ 20-80
FRANCIA, JACOPO (1487-1557) ITALIAN
I/ 500-10000
FRANCIS, SAM (B. 1923) AMERICAN
I/ 500-29000 P/ 200-83600 R/ 15000-21000
FRANCK, PHILIPP (1860-1944) GERMAN
I/ 100-400
FRANCKSEN, JEAN E. (B. 1914) AMERIACAN
P/ 25-100
FRANCO, GIOVANNI BATTISTA (1510-1580) ITALIAN
I/ 200-1600
FRANK, HANS (B. 1884) GERMAN

I/ 350 R/ 100-300
FRANK, MARY (B. 1933) AMERICAN
 I/ 700-1320 P/ 400-2500
FRANK, SEPP (?) ?
 I/ 25-950
FRANKENTHALER, HELEN (B. 1928) AMERICAN
 I/ 1100-52250 P/ 50-42840 R/ 3500-44000
FRASCONI, ANTONIO M. (B. 1919) AMERICAN
 R/ 25-900
FREDERICK, FRANK FOREST (B. 1866) AMERICAN
 R/ 200
FREEDMAN, LOUISE A. (B. 1915) AMERICAN
 P/ 50-200
FREEMAN, DON (1908-1978) AMERICAN
 P/ 75-900
FREEMAN, MARK (B. 1908) AMERICAN
 P/ 100-935
FRELAUT, JEAN (1879-1954) FRENCH
 I/ 150-2500
FRESNAYE, ROGER DE LA (1885-1925) FRENCH
 P/ 75-1500
FREUD, LUCIEN (B. 1922) BRITISH
 I/ 275-32000
FREUNDLICH, OTTO (1878-1943) GERMAN
 R/ 100-1543
FRIDELL, AXEL (1894-1935) ?
 I/ 450-3600
FRIEDLAENDER, JULIUS (1810-1861) DANISH
 I/ 80-3700 P/ 80-700
FRIEDLANDER, ISAC (1890-1968) AMERICAN
 I/ 200 R/ 100-250
FRIEDLANDER, JOHNNY (B. 1912) GERMAN
 P/ 80-800
FRIEDRICH, ADOLF (1750-1803) SWEDISH
 I/ 150-700
FRIEDRICH, CASPAR DAVID (1774-1840) GERMAN
 I/ 400-4000
FRIES, ERNST (1801-1833) GERMAN
 P/ 75-4000
FRIESZ, ACHILLE EMILE OTHON (1879-1949) FRENCH
 I/ 450 P/ 25-1200 R/ 50-300
FRINK, ELIZABETH (B. 1930) BRITISH
 I/ 25-330 P/ 40-1100
FRISCHMANN, MARCEL

I/ 150-300
FRITZSCH, CHRISTIAN F. (1695-1747) DUTCH
I/ 950
FROHNER, ADOLF (B. 1934) AUSTRIAN
I/ 25-200 P/ 475
FRUHTRUNK, GUENTER (B. 1923) GERMAN
P/ 100-600
FRY, ROWENA (20TH C) AMERICAN
P/ 25-75
FUCHS, ERNST (B. 1930) AUSTRIAN
I/ 25-6000 P/ 75-1000
FUHR, ERNEST (1874-1933) AMERICAN
I/ 25-100 P/ 25-100
FULLER, ALFRED (B. 1899) AMERICAN
P/ 25-100
FULLER, BUCKMINISTER
I/ 150-4000
FUSS, ALBERT (?) ?
P/ 150-8000
FUSSMANN, KLAUS (B. 1938) GERMAN
I/ 25-800 P/ 150-350

G

GABAIN, ETHEL (1883-1950) BRITISH
P/ 200-350
GABO, NAUM (1890-1977) AMERICAN/BRITISH
R/ 2800
GACHET, PAUL F. (19TH/20TH C) FRENCH
I/ 500-1500
GACHNANG, JOHANNES (B. 1939) SWISS
I/ 50
GAG, WANDA (1893-1946) AMERICAN
P/ 200-400
GAILLARD, EMMANUEL (20TH C) FRENCH
P/ 800-1300
GALE, GEORGE (8193-1951) AMERICAN
I/ 50-100
GALESTRUSSI, GIOVANNI-BATTISTA (1615-1669) ITALIAN
I/ 500-750

GALLAGHER, MICHAEL J. (B. 1898) AMERICAN
P/ 25-100 R/ 25-100
GALLAGHER, SEARS (1869-1955) AMERICAN
I/ 75-400 P/ 50-150
GALLAND, A.
P/ 200-1100
GALLE, CORNELIS (1576-1650) DUTCH
I/ 150-1000
GALLE, PHILIPPE (1537-1629) DUTCH
I/ 25-1000
GALLE, THEODOR (1571-1633) DUTCH
I/ 250-550
GALLI, RICCARDO (B. 1839) ITALIAN
P/ 990
GALLICE, A. (19TH C) MEXICAN
P/ 275
GANDINI, ALESSANDRO (active 1550-1600) ITALIAN
R/ 650-3700
GANGOLF, PAUL
I/ 200-400 P/ 100-800 R/ 400-450
GANSO, EMIL (1895-1941) AMERICAN
I/ 50-300 P/ 150-400
GANTNER, BERNARD (B. 1930) FRENCH
P/ 100-300
GARBER, DANIEL (1880-1958) AMERICAN
I/ 250-400
GARCIA, HIDALGO JOSE (1656-1712) SPANISH
P/ 400
GARDINER, ELIZA D. (1871-1955) AMERICAN
R/ 100-2400
GARET, JEDD
P/ 300-800
GARNERAY, AMBROSE (1783-1857) FRENCH
I/ 1200
GASSEL, LUCAS (1500-1570) GERMAN
I/ 150-1100
GASSI, FRITZ
P/ 200-600
GAUDY, GEORGES (B. 1872) BELGIAN
P/ 300-4500
GAUG, MARGARET ANN (B. 1909) AMERICAN
I/ 75-200
GAUGENGIGL, IGNAZ MARCEL (1855-1932) AMERICAN
I/ 50-500

GAUGUIN, PAUL (1848-1903) FRENCH
 I/ 175-280544 P/ 700-580000 R/ 200-216000
GAUL, AUGUST (1869-1921) GERMAN
 I/ 250-625 P/ 50-250
GAULTIER, LEONARD (1561-1641) FRENCH
 I/ 200-400
GAUTIER D'AGOTY, JACQUES FABIEN (B. 1710-1781) FRENCH
 I/ 8000-13000
GAVARNI, SULPICE-GUILLAUME C.(called PAUL) (1804-1866) FRENCH
 P/ 30-850
GEARHART, FRANCES (1869-1958) AMERICAN
 R/ 175-900
GEDNEY, CHARLES (1854-1906) AMERICAN
 I/ 25-100
GEERLINGS, GERALD K. (B. 1897) AMERICAN
 I/ 150-2000
GEIGER, RUPPRECHT (B. 1908) GERMAN
 P/ 50-550
GEIGER, WILLI (1878-1971) GERMAN
 I/ 40-600 P/ 25-400
GEIS, JOSEPH N.
 P/ 500-2500
GEITLINGER, ERNST
 P/ 250-450
GELLEE, CLAUDE (1600-1682) FRENCH/ITALIAN
 I/ 50-10000
GEN-PAUL (1895-1974) FRENCH
 I/ 100-300 P/ 25-400
GENIN, ROBERT (1884-1934) RUSSIAN
 I/ 50-400 P/ 30-450
GENKINGER, FRITZ (B. 1934) GERMAN
 P/ 100-300
GEORGES, JOANNES (19TH C) FRENCH
 P/ 1000-2500
GERICAULT, JEAN-LOUIS ANDRES THEODORE (1791-1824) FRENCH
 P/ 200-63000
GERITZ, FRANZ (1895-1945) AMERICAN
 R/ 200-300
GERUNG, MATHIAS (1500-1568) GERMAN
 R/ 1100-2100
GERVAIS, PAUL JEAN LOUIS (1859-1936) FRENCH
 P/ 100
GESMAR, CHARLES (?) ?
 P/ 500-3800

Technique Key

Under each <u>printing technique</u> you may encounter the following types of prints (or combination of processes):

I <u>Intaglio:</u>
- etching
- drypoint
- steel engraving
- stipple engraving
- aquatint
- mezzotint
- soft-ground etching
- crayon manner

P <u>Planographic:</u>
- lithograph
- monotype
- silk-screen
- cliche verre
- serigraph

R <u>Relief:</u>
- wood block
 - woodcut
 - chiaroscuro
 - wood engraving
- linoleum cut (linocut)

GESSNER, RICHARD (?) ?
 I/ 200-350
GESSNER, SALOMON (1730-1788) SWISS
 I/ 25-550
GESTEL, LEENDERT (1881-1941) DUTCH
 P/ 800
GEYER, HAROLD (B. 1905) AMERICAN
 I/ 25-100
GEYLING, REMIGIUS
 P/ 25-800
GEYSER, CHRISTIAN (1742-1803) GERMAN
 I/ 550-650
GHEYN, JACOB DE I (1532-1582) DUTCH
 I/ 3200
GHEYN, JACOB DE II (1565-1629) DUTCH
 I/ 100-14300
GHEYN, JACOB DE III (1596-1641) DUTCH
 I/ 800
GHISI, DIANA (1536-1590) ITALIAN
 I/ 5000
GHISI, GIORGIO (1520-1582) ITALIAN
 I/ 100-18000
GHISI, GIOVANNI BATTISTA (1498-1563) ITALIAN
 I/ 60-3200
GIACOMETTI, ALBERTO (1901-1966) SWISS
 I/ 180-14000 P/ 50-10500
GIACOMETTI, AUGUSTO (1877-1947) SWISS
 P/ 800-2300
GIACOMETTI, GIOVANNI (1868-1933) ?
 P/ 100-3200 R/ 250-5500
GIBRAL, ANTON (?) ?
 P/ 500
GIGER, HANS-RUEDI (?) ?
 P/ 75-1000
GIKOW, RUTH (B. 1913) AMERICAN
 P/ 25-100
GILL, ERIC (1882-1940) BRITISH
 R/ 125-1000
GILLES, WERNER (1894-1961) GERMAN
 P/ 150-1250 R/ 600
GILLETTA, FRANCOIS (20TH C) FRENCH
 I/ 375
GILLOT, CLAUDE (1673-1722) FRENCH
 I/ 40-400

GILLRAY, JAMES (1757-1815) BRITISH
I/ 25-1500
GILMOUR, LEON (?) ?
R/ 350-550
GIMMI, WILHELM (1886-1960) SWISS
P/ 25-350
GINNER, CHARLES (1878-1952) BRITISH
R/ 400-600
GIORDANO, LUCA (1632-1705) ITALIAN
I/ 100-13000
GIPKENS, JULIUS
P/ 1200-2200
GIRARD, ANDRE (20TH C) FRENCH
P/ 500-1700
GIRARDET, PAUL (1821-1893) FRENCH
I/ 2200
GIRBAL, GASTON (?) ?
P/ 300-1500
GIRKE, RAIMUND (B. 1930) GERMAN
P/ 100-300
GIRTIN, THOMAS (1775-1802) BRITISH
I/ 550
GISCH, WILLIAM (B. 1906) AMERICAN
P/ 75-400
GLACKENS, WILLIAM J. (1870-1938) AMERICAN
P/ 1500-3000
GLARNER, FRITZ (1899-1972) SWISS
P/ 400-5300
GLEIZES, ALBERT (1881-1953) FRENCH
I/ 140-5000 P/ 125-3300
GLINES, DAVID (B. 1931) AMERICAN
I/ 25-100 R/ 25-100
GLOVER, D.L. (?) ?
I/ 1100
GMELIN, WILHELM (1760-1820) GERMAN
I/ 200-450
GNOLI, DOMENICO (1933-1970) ITALIAN
P/ 700-7400
GOENEUTTE, NORBERT (1854-1894) FRENCH
I/ 125-950
GOERG, EDOUARD (1893-1969) FRENCH
I/ 25-700 P/ 50-300
GOFF, LLOYD (B. 1917) AMERICAN
P/ 25-100

GOGH, VINCENT VAN (1853-1890) DUTCH
 I/ 95000-165500 P/ 165495
GOINES, DAVID LANCE (20TH C) AMERICAN
 P/ 150-1980
GOLDTHWAITE, ANNE WILSON (1869-1944) AMERICAN
 I/ 40-125
GOLDYNE, JOSEPH (20TH C) AMERICAN
 P/ 600-800
GOLE, JACOB (1660-1737) DUTCH
 I/ 200-1558
GOLINKIN, JOSEPH WEBSTER (1896-1964) AMERICAN
 P/ 100-770
GOLTZIUS, HENDRIK (1558-1616) FLEMISH
 I/ 50-31000 R/ 300-96000
GONTCHAROVA, NATALIA (1881-1962) RUSSIAN
 P/ 100-6000
GOODE, JOE (B. 1937) AMERICAN
 P/ 125-350
GOODMAN, ARTHUR J. (19TH C) BRITISH
 P/ 2200
GOODMAN, BERTRAM (B. 1904) AMERICAN
 P/ 40-100
GOODNOUGH, ROBERT (B. 1917) AMERICAN
 P/ 25-200
GORDON, JEFFREY (?) ?
 P/ 20-250
GORGONI, M. (?) ?
 P/ 2000
GORIN, JEAN (1899-1981) FRENCH
 P/ 90-250
GORKY, ARSHILE (1904-1948) AMERICAN
 P/ 3500-28000
GORMAN, R.C. (B. 1933) AMERICAN
 P/ 200-1300
GORNIK, APRIL (B. 1953) AMERICAN
 I/ 450
GORSLINE, DOUGLAS (1913-1985) AMERICAN
 I/ 300-660
GOSSAERT, JAN (called MABUSE) (15TH/16TH C) FLEMISH
 R/ 7300
GOTHEIN, WERNER
 R/ 25-2100
GOTSCH, FRIEDRICH (B. 1900) GERMAN
 I/ 630-1700 P/ 75-6700 R/ 100-4600

GOTTLIEB, ADOLPH (1903-1974) AMERICAN
I/ 800-3900 P/ 200-5000
GOTTLIEB, MAXIM B. (B. 1903) AMERICAN
P/ 25-100
GOTTLOB, FERNAND (B. 1873) FRENCH
P/ 275-825
GOTTSCHICK, JOHANN CHRISTIAN BENJAMIN (1776-1844) GERMAN
I/ 400-1400
GOTZ, KARL OTTO (B. 1914) GERMAN
P/ 300-5600 R/ 1400
GOUDT, HENDRIK (1585-1648) DUTCH
I/ 40-7500
GOURMONT, JEAN DE I/ (16TH C) FRENCH
I/ 700-6200 R/ 1500
GOUWEN, WILLEM VAN (17TH/18TH C) DUTCH
I/ 250-1600
GOYA Y LUCIENTES, FRANCISCO JOSE DE (1746-1828) SPANISH
I/ 90-129000
GRAESER, CAMILLE (B. 1892) SWISS
P/ 400
GRAF, OSKAR (B. 1870) GERMAN
I/ 200-300
GRAF, URS (1485-1527) SWISS
R/ 100-1100
GRAFF, ANTON (1736-1813) GERMAN
I/ 175-2000
GRAHAM, ROBERT ALEXANDER (1873-1946) AMERICAN
I/ 150-400 P/ 400
GRAMATTE, WALTER (1897-1929) GERMAN
I/ 25-2700 P/ 100-3500 R/ 200-1200
GRANIE (1866-1915) FRENCH
P/ 200
GRANT, GORDON HOPE (1875-1962) AMERICAN
I/ 100-450 P/ 50-375
GRASS, GUNTER (B. 1927) GERMAN
I/ 25-450
GRASSET, EUGENE (1841-1917) FRENCH
I/ 300-400 P/ 70-6000
GRAUMANN, ERWIN (B. 1902) GERMAN
I/ 200-450
GRAVES, MORRIS COLE (B. 1910) AMERICAN
P/ 200
GRAVES, NANCY (B. 1940) AMERICAN
I/ 935 P/ 50-1100

GRAY, HENRY PETERS (1819-1877) AMERICAN
 P/ 200-3100
GREAVES, DERRICK (B. 1927) BRITISH
 P/ 150
GRECO, EMILIO (B. 1913) ITALIAN
 I/ 200-300
GREEN, RUSSELL (1856-1940) AMERICAN
 P/ 40-100
GREEN, SAMUEL M. (B. 1909) AMERICAN
 I/ 25-100
GREEN, VALENTINE (B. 1739-1813) BRITISH
 I/ 450-4300
GREENWOOD, JOHN (1727-1792) AMERICAN
 I/ 250-625
GREENWOOD, MARION (20TH C) AMERICAN
 P/ 20-75
GREINER, OTTO (1869-1916) GERMAN
 I/ 275 P/ 200-500
GRENIER, FRANCOIS (?) ?
 P/ 125-525
GRIEN, HANS BALDUNG (1484-1545) GERMAN
 R/ 150-26000
GRIESHABER, HAP (B. 1909) GERMAN
 P/ 50-12600 R/ 25-17000
GRIGGS, FREDERICK L. (1876-1938) BRITISH
 I/ 125-2900
GRIGNON, P. F.
 P/ 300-400
GRIMALDI, GIOVANNI FRANCESCO (1606-1680) ITALIAN
 I/ 100-600
GRIMM, LUDWIG EMIL (1790-1863) GERMAN
 I/ 100-1600
GRIMM, WILLEM
 I/ 150-400 P/ 50-250 R/ 100-350
GRIS, JUAN (1887-1927) SPANISH
 P/ 125-3500
GROMAIRE, MARCEL (1892-1971) FRENCH
 I/ 35-1650
GRONOWSKI, TADEUSZ
 P/ 1000-1700
GROOMS, RED (B. 1937) AMERICAN
 I/ 100-3300 P/ 175-17600 R/ 6600
GROPPER, WILLIAM (1897-1977) AMERICAN
 I/ 150-350 P/ 25-1100

GROS, ANTOINE JEAN BARON (1771-1835) FRENCH
P/ 1400-2300
GROSS, CHAIM (B. 1904) AMERICAN
P/ 25-660
GROSS, HANS (?) GERMAN
R/ 150-450
GROSSMAN, EDWIN BOOTH (1887-19570 AMERICAN
P/ 75-175
GROSSMANN, RUDOLF (1882-1941) GERMAN
I/ 80-600 P/ 25-1035
GROSZ, GEORGE (1893-1959) AMERICAN
I/ 200-1500 P/ 24-5400
GROTH, JOHN (B. 1908) AMERICAN
I/ 25-100
GRUAU, RENE
P/ 800
GRUBER, HEINRICH R. (15TH C) GERMAN
I/ 25 P/ 50
GRUN, JULES ALEXANDRE (1868-1934) FRENCH
P/ 150-5100
GRUTZKE, JOHANNES
I/ 125-285 P/ 170-230
GUBITZ, FRIEDRICH (1786-1870) GERMAN
R/ 400-525
GUDIN, ROBERT
P/ 2200
GUERCINO, (GIOVANNI F. IL BARBIERI) (1591-1666) ITALIAN
I/ 200
GUERIN, CHARLES (1875-1939) FRENCH
P/ 40-1000
GUIDO, RAFFAELO
I/ 150-700
GUILBEAU, HONORE (B. 1907) AMERICAN
P/ 20-100
GUILLAME, ALBERT (1873-1942) FRENCH
P/ 200-1500
GULBRANSSON, OLAF (B. 1873) NORWEGIAN
P/ 75-1000
GULDENMUNDT, HANS (D. 1560) GERMAN
R/ 15400
GUNST, PIETER STEVENS VAN (1659-1724) DUTCH
I/ 50-125
GURR, LENA (B. 1897) AMERICAN
P/ 100-350

Technique Key

Under each <u>printing technique</u> you may encounter the following types of prints (or combination of processes):

I <u>Intaglio:</u>
- etching
- drypoint
- steel engraving
- stipple engraving
- aquatint
- mezzotint
- soft-ground etching
- crayon manner

P <u>Planographic:</u>
- lithograph
- monotype
- silk-screen
- cliche verre
- serigraph

R <u>Relief:</u>
- wood block
 - woodcut
 - chiaroscuro
 - wood engraving
- linoleum cut (linocut)

GUSTON, PHILIP (1912-1980) AMERICAN
P/ 200-5500
GUTTUSO, RENATO (B. 1912) ITALIAN
I/ 150-900 P/ 125-1300
GWATHMEY, ROBERT (1903-1989) AMERICAN
P/ 200-1500
GYARMATY, MICHEL (?) ?
P/ 3000-5000

H

HAAGENSEN, F. (19TH C) EUROPEAN
I/ 25-75
HAAS, RICHARD (B. 1936) AMERICAN
I/ 200-1500 P/ 350
HACKAERT, JAN (1629-1699) DUTCH
I/ 700
HACKERT, JACOB PHILIPPE (1737-1807) GERMAN
I/ 75
HADEN, FRANCIS SEYMOUR (1818-1910) BRITISH
I/ 50-6900
HAGERMAN, KURT (20TH C) AMERICAN
I/ 25-100
HAGHE, LOUIS (1806-1885) BELGIAN
P/ 50
HAGIWARA, HIDEO (B. 1913) JAPANESE
R/ 25-1650
HAID, JOHANN ELIAS (1780-1809) GERMAN
I/ 175-4700
HAID, JOHANN JAKOB (1704-1767) GERMAN
I/ 100-450
HAID, JOHANN LORENZ (1702-1750) GERMAN
I/ 200-350
HAIG, AXEL H. (1835-1921) SWEDISH
I/ 50-200
HAJDU, ETIENNE (B. 1907) FRENCH
I/ 250-3200
HAJEK, OTTO H. (B. 1927) GERMAN
P/ 25-500
HALL, ARTHUR W. (B. 1889) AMERICAN

I/ 25-100
HALL, OLIVER (1869-1957) BRITISH
 I/ 25-75
HALLIDAY, C. J. (2OTH C) AMERICAN
 R/ 25-75
HALM, PETER (B. 1854) GERMAN
 I/ 75-500
HALTEN, E. (?) ?
 I/ 275
HAM, GEORGES
 P/ 150-10450
HAMAGUCHI, YOZO (B. 1909) JAPANESE
 I/ 400-57750 P/ 900-2100
HAMILTON, HAMILTON (1847-1928) AMERICAN
 I/ 50-650
HAMILTON, RICHARD (B. 1922) BRITISH
 I/ 35-26100 P/ 175-11000
HANKEY, WILLIAM LEE (1869-1952) BRITISH
 I/ 30-175
HANNA, BOYD (B. 1907) AMERICAN
 I/ 25-100
HANSEN, ARMIN CARL (1886-1957) AMERICAN
 I/ 200-4700
HANSEN, DIANA (20TH C) AMERICAN
 P/ 50-200
HANSEN-BAHIA, K.H.
 R/ 25-410
HANSI (1873-1951) FRENCH
 P/ 200-275
HARDY, DUDLEY (1865-1922) BRITISH
 P/ 200-4000
HARING, KEITH (B. 1958) AMERICAN
 I/ 350 P/ 400-27600
HARNEST, FRITZ (B. 1905) GERMAN
 R/ 200-900
HARPIGNIES, HENRI JOSEPH (1819-1916) FRENCH
 I/ 1200
HARRIS, SAM HYDE (20TH C) AMERICAN
 R/ 100-715
HARRY, PHILIP (active 1833-1857) CANADIAN
 P/ 250-750
HART, GEORGE O. ("POP") (1868-1933) AMERICAN
 I/ 50-400 P/ 175-350
HARTLEY, MARSDEN (1878-1943) AMERICAN

P/ 175-4400
HARTMAN, BERTRAM (1882-1960) AMERICAN
P/ 30-100
HARTMANN, HANS (B. 1845) GERMAN
P/ 900
HARTRICK, ARCHIBALD STANDISH (1864-1950) BRITISH
P/ 50-200
HARTUNG, HANS (B. 1904) GERMAN
I/ 200-8100 P/ 100-3100 R/ 300-1600
HASEGAWA, KIYOSHI (B. 1891) JAPANESE
I/ 800-57400 P/ 1000-2000 R/ 900-47000
HASEGAWA, SHOICHI (B. 1929) JAPANESE
I/ 60-650
HASKELL, ERNEST (1876-1925) AMERICAN
I/ 25-300 P/ 660
HASSALL, JOHN (1868-1948) BRITISH
P/ 800-1900
HASSAM, FREDERICK CHILDE (1859-1935) AMERICAN
I/ 200-25300 P/ 400-6050
HASUI, KAWASE (20TH C) JAPANESE
R/ 150-4300
HAUPTMANN, IVO (B. 1886) BRITISH
I/ 175-500 P/ 175-200
HAUSER, ERICH (B. 1930) GERMAN
I/ 150-315
HAUSNER, RUDOLF (B. 1914) AUSTRIAN
I/ 25-200 P/ 125-550
HAUSSMANN, RAOUL (1886-1971) AUSTRIAN
R/ 125-1600
HAVELL, WILLIAM (1782-1857) BRITISH
P/ 700-1000
HAYTER, STANLEY WILLIAM (1901-1988) BRITISH/AMERICAN
I/ 50-8800 P/ 50-825
HEARTFIELD, JOHN (1891-1968) GERMAN
P/ 600
HEASLIP, WILLIAM (1898-1970) AMERICAN
I/ 50-125
HEBERT, MARIAN (B. 1899) AMERICAN
I/ 25-350
HECHT, JOSEPH (1891-1951) POLISH/BRITISH
I/ 75-200
HECKE, JAN VAN DEN (1620-1684) DUTCH
I/ 50-600
HECKEL, ERICH (1883-1970) GERMAN

I/ 50-20000 P/ 100-39000 R/ 25-385000
HEEMSKERCK, JACOB EDUARD VAN BEEST (1828-1894) DUTCH
 R/ 100-700
HEEMSKERCK, MAERTEN (1498-1578) DUTCH
 I/ 30-1700
HEGENBARTH, JOSEF (1884-1962) GERMAN
 I/ 40-575 P/ 150-350
HEILIGER, BERNHARD (B. 1915) GERMAN
 I/ 200-525 P/ 50-250
HEINE, THOMAS TH. (B. 1867) GERMAN
 I/ 100-450 P/ 50-2900 R/ 1200
HEINTZELMAN, ARTHUR W. (1891-1965) AMERICAN
 I/ 40-200
HEISE, WILHELM (B. 1892) GERMAN
 P/ 300-450
HEIZER, MICHAEL (B. 1944) AMERICAN
 I/ 900-2000
HELBIG, WALTER (B. 1878) GERMAN
 R/ 25-650
HELDT, WERNER (1904-1954) GERMAN
 P/ 150-2000
HELFOND, RIVA (B. 1910) AMERICAN
 P/ 25-300
HELLEU, PAUL CESAR (1859-1927) FRENCH
 I/ 50-15600 P/ 100-1500
HELMAN, ISIDORE S. (1743-1809) FRENCH
 I/ 200
HEMELMAN, ALBERT
 P/ 800-1700
HENRION, ARMAND FRANCOIS JOSEPH (B. 1875) FRENCH
 I/ 120-200 P/ 550
HERBIG, OTTO (1889-1971) GERMAN
 P/ 100-900
HERBIN, AUGUSTE (1882-1960) FRENCH
 P/ 100-5700
HERKENRATH, PETER (B. 1900) GERMAN
 R/ 275
HERKOMER, HUBERT VON (1849-1914) BRITISH
 I/ 100-400
HERMES, ERICH (B. 1881) GERMAN
 P/ 800
HERMES, GERTRUDE (B. 1901) BRITISH
 R/ 500
HERMS, GEORGE (20TH C) AMERICAN

P/ 100-200
HERRMANN, PAUL (B. 1864) GERMAN
 I/ 100-300 P/ 150-600
HESSE, EVA (1936-1970) AMERICAN
 P/ 1800
HEUBNER, FRITZ
 I/ 25-60
HEYBOER, ANTON (B. 1924) DUTCH
 I/ 75-2200
HILAIRE, CAMILLE (B. 1916) FRENCH
 P/ 40-525
HILER, HILAIRE (1898-1966) AMERICAN
 P/ 75-225
HILL, JOHN WILLIAM (1812-1879)(after) AMERICAN
 I/ 770-7150
HILL, POLLY K. (B. 1900) AMERICAN
 I/ 25-100
HILLS, ROBERT (1769-1844) BRITISH
 I/ 150
HIRSCH, JOSEPH (1910-1981) AMERICAN
 P/ 75-1700
HIRSCH, KARL JAKOB (B. 1892) GERMAN
 I/ 150-300
HIRSCHFELD, ALBERT (B. 1903) AMERICAN
 I/ 110 P/ 500-1320
HIRSCHVOGEL, AUGUSTIN (1503-1553) GERMAN
 I/ 200-60000
HJORTZBERG, OLLE (1872-1959) SWEDISH
 P/ 1200-2200
HOBBS, MORRIS HENRY (B. 1892) AMERICAN
 I/ 40-150
HOCKELMANN, ANTONIUS (B. 1937) ?
 I/ 125-525 P/ 331 R/ 200-700
HOCKNEY, DAVID (B. 1937) BRITISH
 I/ 100-49500 P/ 75-316800
HODGKIN, HOWARD (B. 1932) BRITISH
 I/ 400-13240 P/ 200-29700
HODLER, FERDINAND (1853-1918) SWISS
 I/ 300 P/ 100-3700 R/ 1700
HOEHME, GERHARD (B. 1920) GERMAN
 I/ 400-4500 P/ 850-1600
HOESEN, BETH VAN
 I/ 150-1500
HOFBAUER, ARNOST (B. 1869)

P/ 1100-1750
HOFER, KARL (1878-1955) GERMAN
 I/ 100-6200 P/ 40-1800 R/ 630-940
HOFFMAN, GUSTAVE (1869-1945) AMERICAN
 I/ 25-100
HOFKUNST, ALFRED (B. 1942) SWISS
 I/ 275-725
HOFFMAN, IRWIN D. (B. 1901) AMERICAN
 I/ 40-300
HOFMANN, HANS (1880-1966) AMERICAN
 P/ 200-3300
HOFMANN, LUDWIG (1832-1895) GERMAN
 I/ 100-250 P/ 25-250 R/ 50-740
HOGARTH, WILLIAM (1697-1764) BRITISH
 I/ 25-4000
HOGUE, ALEXANDER (B. 1898) AMERICAN
 P/ 200-400
HOHENSTEIN, ADOLF (1854-1917) GERMAN
 P/ 600-5500
HOHLWEIN, LUDWIG (?) ?
 P/ 175-5000
HOLLAND, TOM (B. 1936) AMERICAN
 I/ 400-1100 P/ 100-500
HOLLAR, WENCESLAUS (1607-1677) BOHEMIAN
 I/ 25-12000
HOLLENBERG, FELIX (1868-1945) GERMAN
 I/ 100-400
HOLST, ROLAND (B. 1869) DUTCH
 P/ 200-600
HOLTZ, KARL (B. 1899) GERMAN
 I/ 400 P/ 300-1600 R/ 300
HOLZER, JOHANN E. (B. 1875) GERMAN
 I/ 400-1200
HOMER, WINSLOW (1836-1910) AMERICAN
 I/ 50-31000 P/ 43000-68750
HONDIUS, HENDRIK (17TH C) DUTCH
 I/ 200-1000
HOOD, THOMAS R. (B. 1910) AMERICAN
 I/ 25-100
HOOK, SANDY
 P/ 275-700
HOOVER, ELLISON (1888-1955) AMERICAN
 P/ 100-150
HOPFER, DANIEL (1470-1536) DUTCH

Technique Key

Under each <u>printing technique</u> you may encounter the following types of prints (or combination of processes):

I <u>Intaglio:</u>

- etching
- drypoint
- steel engraving
- stipple engraving
- aquatint
- mezzotint
- soft-ground etching
- crayon manner

P <u>Planographic:</u>

- lithograph
- monotype
- silk-screen
- cliche verre
- serigraph

R <u>Relief:</u>

- wood block
 - woodcut
 - chiaroscuro
 - wood engraving
- linoleum cut (linocut)

I/ 50-24000
HOPFER, HIERONYMUS (1525-1550) DUTCH
I/ 30-1675
HOPFER, LAMBERT (16TH C) DUTCH
I/ 75-6600
HOPFNER, WILHELM
I/ 300-500
HOPKINS, EDNA BOIES (1872-1937) AMERICAN
R/ 1500-3100
HOPPER, EDWARD (1882-1967) AMERICAN
I/ 800-52250
HOPPNER, JOHN (1758-1810) BRITISH
I/ 350
HORNBY, LESTER GEORGE (1882-1956) AMERICAN
I/ 25-400
HORTER, EARL (1881-1940) AMERICAN
I/ 40-275
HOSFORD, HARRY L. (1877-1945) AMERICAN
I/ 25-100
HOWE, R.C. (19TH/20TH C) AMERICAN
R/ 100-200
HOYLAND, JOHN (B. 1934) BRITISH
I/ 332 P/ 200-800
HOYTON, EDWARD BOUVERIE (B. 1900) BRITISH
I/ 50-250
HRDLICKA, ALFRED (B. 1928) AUSTRIAN
I/ 25-2000 P/ 50-350
HUBBUCH, KARL (B. 1891)
I/ 125-3200 P/ 200-3200 R/ 150-1200
HUBER, ERNST (1896-1960) AUSTRIAN
P/ 15-60
HUCHTENBURG, JAN VAN (1646-1733) DUTCH
I/ 50-1200
HUET, PAUL (1803-1869) FRENCH
I/ 200-700
HUGIN, KARL (B. 1887) SWISS
I/ 100-450
HUNDERTWASSER, FRIEDRICH (B. 1928) AUSTRIAN
I/ 330-3900 P/ 85-5500 R/ 800-5400
HUNT, BRYAN (B. 1947) AMERICAN
I/ 3000-5500
HUNT, LEIGH (1858-1937) AMERICAN
I/ 30-75
HUNT, WILLIAM HENRY (1790-1864) BRITISH

I/ 75-1100
HUNTER, COLIN (1841-1904) BRITISH
 I/ 30-100
HUNTER, MEL (B. 1927) AMERICAN
 P/ 25
HUNTLEY, VICTORIA HUTSON (1900-1971) AMERICAN
 P/ 40-450
HUNZIKER, MAX
 I/ 25-2100 P/ 100-300
HURD, PETER (1904-1984) AMERICAN
 P/ 250-1210
HURLEY, EDWARD TIMOTHY (1869-1950) AMERICAN
 I/ 75-200
HUSZAR, VILMOS (B. 1884) DUTCH
 I/ 800 R/ 1500-2400
HUTTER, WOLFGANG (B. 1928) AUSTRIAN
 I/ 40-200
HUYBRECHTS, ADRIAEN (active 1573-1614) GERMAN ?
 I/ 400-750
HYDE, HELEN H. (1868-1919) AMERICAN
 I/ 100-300 R/ 50-1300
HYMAN, MOSES (B. 1870) AMERICAN
 I/ 25-100
HYNCHES, RAOUL (B. 1893) DUTCH
 P/ 300-1500

I

IBELS, HENRI GABRIELLE (1867-1936) FRENCH
 I/ 660 P/ 50-4000
ICART, LOUIS (1888-1950) FRENCH
 I/ 400-30000 P/ 200-5500
IHLE, JOHN (B. 1925) AMERICAN
 I/ 20-75
ILLIES, ARTHUR (B. 1870) GERMAN
 I/ 75-850 P/ 200-800 R/ 250-315
IMMENDORFF, JORG (B. 1945) GERMAN
 P/ 300-400 R/ 150-10500
IMPERIALE, GIROLAMO (D. 1630) ITALIAN
 I/ 700-1400

INDIANA, ROBERT (B. 1928) AMERICAN
 P/ 50-1700
INGRAHAM, KATHERINE (1900-1982) AMERICAN
 I/ 25-100
INGRES, JEAN AUGUSTE DOMINIQUE (1780-1867) FRENCH
 I/ 275-2000 P/ 1900-11000
INMAN, PAULINE W. (B. 1904) AMERICAN
 R/ 25-100
IONESCO, EUGENE (B. 1912) FRENCH
 P/ 200-275
ISABEY, JEAN BAPTISTE (1767-1855) FRENCH
 P/ 40-100
ISABEY, EUGENE (1803-1886) FRENCH
 P/ 200
ISELI, ROLF (B. 1934) SWISS
 I/ 175-1600 P/ 100-900
ISRAELS, JOSEF (1824-1911) DUTCH
 I/ 100-600
ITTEN, JOHANNES (1888-1967) SWISS/GERMAN
 P/ 220-3100
ITURRINO, FRANCESCO (1864-1924) SPANISH
 I/ 300

J

JACKSON, F. ERNEST (20TH C) AMERICAN
 P/ 100-300
JACKSON, JOHN B. (1778-1831) BRITISH
 R/ 88-3540
JACOB, WALTER (B. 1893) GERMAN
 R/ 200-550
JACOBSEN, ROBERT (B. 1912) DANISH
 I/ 393-600 P/ 200-650
JACOBY, JOHANN (1733-1797) GERMAN
 P/ 900-1000
JACOULET, PAUL (1902-1960) FRENCH
 P/ 275 R/ 130-15700
JACQUE, CHARLES EMILE (1813-1894) FRENCH
 I/ 25-7000
JACQUEMIN, ANDRE (B. 1904) FRENCH

I/ 75-600
JACQUES, BERTHA CLAUSEN (1863-1941) AMERICAN
I/ 50-100
JACQUETTE, YVONNE (B. 1934) AMERICAN
I/ 1200 P/ 2000-3100 R/ 4620
JAECKEL, WILLI (B. 1888) GERMAN
I/ 50-300 P/ 75-4700 R/ 250
JAHN, GEORG (B. 1869) GERMAN
P/ 400
JAMNITZER, C.
I/ 200-550
JANINET, JEAN F. (1752-1814) FRENCH
I/ 150-2900
JANSEN, FRNZ MARIA (1885-1958) GERMAN
I/ 125-828 R/ 25-2200
JANSSEN, HORST (B. 1929) DUTCH
I/ 20-5300 P/ 75-7300 R/ 1000-25800
JAWLENSKY, ALEXEI VON (1864-1941) GERMAN
P/ 300-20600
JEANNIOT, GEORGES (1848-1934) FRENCH
I/ 25-400
JEGHER, CHRISTOFFEL (1596-1653) GERMAN
R/ 350-31500
JENICHEN, BALTHASAR (D. 1621)
I/ 300
JENKINS, PAUL (B. 1923) AMERICAN
P/ 50-2100
JENSEN, ALFRED J. (1903-1981) AMERICAN
P/ 300-1400
JETTMAR, RUDOLF (B. 1869) POLISH
I/ 200-400
JIRLOW, LENNART (20TH C) GERMAN
P/ 500-2000
JOBBE-DUVAL, GASTON (20TH C) FRENCH
P/ 250-700
JODE, PIETER DE II (1606-1674)
I/ 25-375
JOHN, AUGUSTUS (1878-1961) BRITISH
I/ 100-1100 P/ 75-600
JOHNS, JASPER (B. 1930) AMERICAN
I/ 150-58000 P/ 270-500000
JOHNSON, AVERY F. (B. 1906) AMERICAN
I/ 25-100
JOHNSON, WILLIAM (20TH C) AMERICAN

P/ 1600-2000
JONES, ALLEN (B. 1937) BRITISH
P/ 50-4900
JONES, DAVID (1895-1974) BRITISH
I/ 50-125
JONES, JOE (OR JOSEPH JOHN) (1909-1963) AMERICAN
P/ 500
JONGKIND, JOHAN BARTHOLD (1819-1891) DUTCH
I/ 100-8300
JORN, ASGER (1914-1973) DANISH
I/ 75-4600 P/ 88-9800 R/ 1400-5000
JOSSOT, HENRI GUSTAVE (B. 1866) FRENCH
P/ 400-650
JOUVE, PAUL (1880-1973) FRENCH
I/ 125-2000 P/ 608 R/ 90-150
JOYAU, AMEDEE (B. 1872) FRENCH
R/ 150
JUDD, DONALD (B. 1928) AMERICAN
I/ 275-3000 P/ 400-1100 R/ 275-6000
JULES, MERVIN (B. 1912) AMERICAN
P/ 40-160
JUNGNICKEL, LUDWIG HEINRICH (1881-1965) GERMAN
I/ 150-260 P/ 25-450 R/ 200-3200
JUSTE, JUSTE DE (1505-1559) FRENCH
I/ 500-26000

K

KAGY, SHEFFIELD (B. 1907) AMERICAN
R/ 50-150
KALAS, ERNEST (B. 1861) FRENCH
P/ 2400-3500
KALCKREUTH, KARL WALTER LEOPOLD VON (1855-1925) GERMAN
I/ 50-650
KALER, JOHANN (?) ?
I/ 30-100
KALIONWSKI, HORST EGON (B. 1924) GERMAN
I/ 100-175 P/ 200-350
KALLMORGEN, FRIEDRICH (1856-1924) GERMAN
P/ 125-300

KAMMULLER, PAUL (B. 1885) GERMAN
P/ 600-1100
KAMPMANN, GUSTAV (1859-1917) GERMAN
P/ 100-275
KANDINSKY, WASSILY (1866-1944) RUSSIAN
I/ 500-15900 P/ 250-175000 R/ 22-110000
KANEIAN, A. (20TH C) AMERICAN
P/ 75-150
KANOLDT, ALEXANDER (1881-1939) GERMAN
P/ 100-3800
KAPLAN, ANATOLI (B. 1903) RUSSIAN
P/ 150-760
KAPPEL, PHILIP (B. 1901) AMERICAN
I/ 50-250
KARDON, DENNIS (?) ?
R/ 100-225
KARSCH, JOACHIM (B. 1897) GERMAN
I/ 350-860
KASIMIR, LUIGI (B. 1881) AUSTRIAN
I/ 50-900 P/ 25-175
KASIMIR-HOERNES, T. (FANNA) (B. 1887) AUSTRIAN
I/ 200-375 P/ 25
KATELHON, HERMANN (?) ?
I/ 100-1400 P/ 100-200
KATZ, ALEX (B. 1927) AMERICAN
I/ 450-21100 P/ 100-27000 R/ 300-5000
KATZ, HILDA (B. 1909) AMERICAN
R/ 25-100
KATZIEFF, JULIUS (B. 1892) AMERICAN
P/ 40-150
KAUFFER, E.MCKNIGHT (?) ?
P/ 150-6100
KAUFFMAN, ANGELICA (1740-1807) SWISS
I/ 275-1250
KAUFFMAN, CRAIG (B. 1932) AMERICAN
P/ 400-475
KAUL, AUGUST (B. 1873) GERMAN
I/ 175
KAUS, MAX (1891-1977) GERMAN
I/ 175 P/ 25-7900 R/ 50-3000
KECK, LEO (?) ?
P/ 1100
KEIMEL, HERMANN (B. 1889) GERMAN
P/ 3100

Technique Key

Under each <u>printing technique</u> you may encounter the following types of prints (or combination of processes):

I <u>Intaglio:</u>
- etching
- drypoint
- steel engraving
- stipple engraving
- aquatint
- mezzotint
- soft-ground etching
- crayon manner

P <u>Planographic:</u>
- lithograph
- monotype
- silk-screen
- cliche verre
- serigraph

R <u>Relief:</u>
- wood block
 - woodcut
 - chiaroscuro
 - wood engraving
- linoleum cut (linocut)

KEITH, ELIZABETH (1887-1956) BRITISH
I/ 100-400 R/ 75-1300
KELLER, HENRY G. (1869-1949) AMERICAN
I/ 30-150 P/ 75-150
KELLER, LAURENT F. (B. 1855) FRENCH
P/ 2100
KELLOGG, HAROLD F. (B. 1887) AMERICAN
I/ 25-100
KELLY, ELLSWORTH (B. 1923) AMERICAN
I/ 500-6100 P/ 100-34100
KENT, ROCKWELL (1882-1971) AMERICAN
I/ 20 P/ 50-2800 R/ 50-2400
KERKOVIUS, IDA (1879-1970) GERMAN
P/ 175-1100
KERSCHBAUMER, ANTON (B. 1885) GERMAN
P/ 125-800 R/ 400
KESSEL, THEODOR VAN (B. 1620) DUTCH
I/ 300-400
KHNOPFF, FERNAND (1858-1921) BELGIAN
I/ 400-2000 P/ 150-1000
KHODOSSIEVITCH, N. (?) ?
P/ 100-650
KIFFER, CHARLES (B. 1902) FRENCH
P/ 150-3700
KIKOINE, MICHEL (1892-1968) FRENCH
P/ 325
KILIAN, LUKAS (1579-1637) GERMAN
I/ 150-735
KINGMAN, EUGENE (B. 1909-1975) AMERICAN
P/ 25-100
KIRCHNER, ERNST LUDWIG (1880-1938) GERMAN
I/ 165-94000 P/ 125-680000 R/ 25-142500
KIRMSE, MARGUERITE (1885-1954) AMERICAN
I/ 40-175
KIRKPATRIACK, DONALD M. (B. 1887) AMERICAN
I/ 25-100
KIRKEBY, PER (B. 1938) DANISH
I/ 150-560 P/ 125-1250 R/ 525
KISLING, MOISE (1891-1953) POLISH/FRENCH
I/ 200-3100 P/ 150-2000 R/ 800-1000
KISSEL, IRENE (B. 1904) AMERICAN
I/ 50-150
KITTENSTEYN, CORNELIS VAN (B. 1600) DUTCH
I/ 500-1300

KITAJ, RONALD B. (B. 1932) BRITISH/AMERICAN
I/ 75-725 P/ 30-2000
KLAPHECK, KONRAD (B. 1935) GERMAN
I/ 100-1100 P/ 150-800
KLAUKE, JURGEN (B. 1943) GERMAN
I/ 350-450
KLEE, PAUL (1879-1940) SWISS
I/ 1800-115600 P/ 100-96600
KLEBE, CHARLES E. (20TH C) AMERICAN
R/ 40-75
KLEIBER, HANS (1887-1967) AMERICAN
I/ 40-220
KLEIN, JOHANN ADAM (1792-1875) GERMAN
I/ 75-1900
KLEINSCHMIDT, PAUL (1883-1949) GERMAN
I/ 50-2200 P/ 200-1400
KLEMM, WALTER (B. 1883) GERMAN
I/ 25-350 P/ 25-475 R/ 50-350
KLENGEL, JOHANN CHRISTIAN (1751-1824) GERMAN
I/ 125-400
KLEUKENS, FRIEDRICH WILHELM (B. 1878) GERMAN
I/ 300 P/ 145-2000
KLIEMANN, CARL H. (B. 1924) GERMAN
I/ 250-550 R/ 50-625
KLINE, FRANZ J. (1910-1962) AMERICAN
R/ 200-2600
KLINGER, JULIUS (B. 1876) AUSTRIAN
P/ 300-1650
KLINGER, MAX (1857-1920) GERMAN
I/ 25-4400
KLOSS, GENE (B. 1903) AMERICAN
I/ 100-990
KLUZIS, GUSTAV (?) ?
P/ 1400-6600
KNAB, ALBERT (B. 1870) GERMAN
P/ 400-2000
KNAPP, JOSEPH D. (B. 1875) AMERICAN
I/ 15-75
KNIE, FOLF JUN (?) ?
P/ 300-600
KNIGHT, DAME LAURA (1877-1970) BRITISH
I/ 75-1700 P/ 150-1500
KNIGHT, LOXTON (20TH C) BRITISH
R/ 300

KOBELL, FERDINAND (1740-1799) GERMAN
I/ 60-300
KOBELL, WILHELM VON (1766-1855) GERMAN
I/ 30-1000
KOCH, JOSEF ANTON (1768-1839) GERMAN
I/ 100-1900
KOCH, WALTER (1875-1915) GERMAN
P/ 700-1500
KOGAN, MOISHE (MOISSEJ) (B. 1879) RUSSIAN
R/ 150-800
KOHN, MISCH (B. 1916) AMERICAN
I/ 350
KOKOSCHKA, OSKAR (1886-1980) AUSTRIAN
I/ 100-2200 P/ 25-22000 R/ 350
KOLAR, JIRI (B. 1914) CZECHOSLOVAKIAN
I/ 100-440 P/ 75-375
KOLB, ALOIS (B. 1875) AUSTRIAN
I/ 15-1200
KOLBE, CARL WILHELM (1757-1835) GERMAN
I/ 75-4700
KOLBE, GEORG (1877-1947) GERMAN
I/ 125-1600 P/ 400-650
KOLLWITZ, KATHE (1867-1945) GERMAN
I/ 100-14000 P/ 70-46000 R/ 500-16000
KONIG, FRIEDRICH (1857-1914) AUSTRIAN
P/ 2600 R/ 456
KONINCK, SALOMON (1609-1656) DUTCH
I/ 200-1700
KOONING, WILLEM DE (B. 1904) DUTCH/AMERICAN
I/ 3300-6600 P/ 135-22000
KOPP, MAX (?) ?
P/ 2000
KOPPEL, HENNING (?) ?
P/ 2600
KORAB, KARL (B. 1937) AMERICAN
I/ 15-1700 P/ 15-373
KOSA (JR), EMIL JEAN (1903-1968) AMERICAN
P/ 150
KOW, ALEXIS (?) ?
P/ 440-1760
KRAEMER, DIETER (B. 1937) GERMAN
I/ 150
KRAMER, JACOB (1892-1962) BRITISH
P/ 250-2400

KRAUS, GUSTAV (1804-1852) GERMAN
P/ 630-1600
KRENEK, CARL (B. 1880) AUSTRIAN
P/ 500-1300 R/ 150-700
KRESSEL, DIETER (?) ?
I/ 100-1200
KRETSCHMAN, A. (?) ?
P/ 1600
KRETSCHMAR, B. (?) ?
I/ 150-30000 P/ 100-1100
KROLL, LEON (1884-1974) AMERICAN
P/ 150-880
KRONBERG, LOUIS (1872-1964) AMERICAN
I/ 50-150
KROTOWSKI, STEPHAN (?) ?
P/ 2000-4000
KRUCK, CHRISTIAN (?) ?
I/ 100-150 P/ 75-800
KRUG, LUDWIG (B. 1489-1532) GERMAN
I/ 500-6000 R/ 275-600
KRUGER, FRANZ (1799-1857) GERMAN
P/ 150-850
KRUSE, ALEXANDER ZEROIN (B.1890) AMERICAN
P/ 25-100
KUBIN, ALFRED (1877-1959) AUSTRIAN
I/ 80-175 P/ 25-900
KUBINYI, KALMIN (1906-1973) AMERICAN
I/ 50-180 P/ 40-75
KUCHENMEISTER, RAINER (B. 1926) GERMAN
P/ 100-550
KUGLER, RUDOLF (?) ?
I/ 175
KUHLER, OTTO (1894-1977) AMERICAN
I/ 150-850
KUHN, WALT (1877-1949) AMERICAN
I/ 275-525 P/ 200-1700
KUHNERT, WILHELM FRIEDRICH KARL (1865-1926) GERMAN
I/ 150-1400
KUMM, MARGUERITE E. (B. 1902) AMERICAN
R/ 25-100
KUNIYOSHI, YASUO (1893-1953) AMERICAN
I/ 400-600 P/ 400-37800
KUNTZ, CARL (1770-1830) GERMAN
P/ 800

KUNZIE, DORIS (B. 1910) AMERICAN
P/ 25-100
KUPFERSCHMID, HERMAN (B. 1885) GERMAN
I/ 100-300
KUPKA, FRANTISEK (1871-1957) CZECHOSLOVAKIAN
I/ 300-22000 P/ 400-950 R/ 100-1100
KURTZ, HELMUTH (?) ?
P/ 1000
KURZWEIL, MAXMILIAN (1867-1916) AUSTRIAN
P/ 175-43000 R/ 85-2800
KUSHNER, ROBERT (B. 1949) AMERICAN
I/ 1500 P/ 275-8800

L

LAAGE, WILHELM (B. 1868) GERMAN
R/ 75-1900
LABISSE, FELIX (B. 1905) FRENCH
P/ 45-450
LABORDE, CHARLES (1886-1941) FRENCH
R/ 25-150
LABOUREUR, JEAN-EMILE (1877-1943) FRENCH
I/ 40-8200 P/ 100-500 R/ 75-1900
LACHNIT, WILHELM (B. 1899) GERMAN
I/ 375-750 P/ 800
LADANYI, EMORY (B. 1902) AMERICAN
R/ 25-50
LADENSPELTER, JOHANN (1512-1561) DUTCH
I/ 200-1300
LAHEY, RICHARD F. (B. 1893) AMERICAN
I/ 25-100
LAHS, CURT (?) ?
I/ 250-300 P/ 15-600
LAIRESSE, GERARD DE (1641-1711) FLEMISH
I/ 75-300
LALANNE, MAXIME (1827-1886) FRENCH
I/ 40-450
LALLEMAND, GEORGES (1575-1635) FRENCH
I/ 200-600
LAM, WIFREDO (1902-1982) CUBAN

I/ 75-800 P/ 75-850
LAMBERT, ALFRED (?) ?
 P/ 3100
LAMBERT, M.DE (B. 1873) FRENCH
 P/ 600
LAMOTTE, BERNARD (B.1903) FRENCH
 I/ 30-150
LANA, LODOVICO (1597-1646) ITALIAN
 I/ 250-1000
LANDACRE, PAUL H. (1893-1963) AMERICAN
 R/ 150-1200
LANDECK, ARMIN (1905-1984) AMERICAN
 I/ 150-3500 P/ 200-700
LANDSHUT, MAIR VON (16TH C) GERMAN
 I/ 79000
LANE, FITZ HUGH (1804-1865) AMERICAN
 P/ 3000-12000
LANE, LOIS (B. 1948) AMERICAN
 I/ 225-950
LANE, MIHARU (20TH C) AMERICAN
 P/ 30-90
LANFAIR, HARRIET KEESE (B. 1900) AMERICAN
 P/ 50-150
LANFRANCO, GIOVANNI (1582-1647) ITALIAN
 I/ 200-600
LANG, FRITZ (B. 1877) GERMAN
 P/ 250-300 R/ 150-250
LANGE, OTTO (1879-1944) GERMAN
 I/ 100-2100 R/ 150-7300
LANGMAID, ROWLAND (20TH C) BRITISH
 I/ 225-300
LANSKOY, ANDRE (1902-1976) RUSSIAN/FRENCH
 P/ 75-1100
LAP, ENGELBERT (20TH C) AUSTRIAN
 R/ 50-125
LAPIQUE, CHARLES (B. 1898) FRENCH
 I/ 100-260 P/ 100-600
LARDERA, BERTO (B. 1911) FRENCH
 P/ 250
LARMESSIN, NICOLAS (?) ?
 I/ 250-550
LARSSON, CARL (1853-1919) SWEDISH
 I/ 200-2000 P/ 3000
LARTIGUE, JACQUES (B. 1894) FRENCH

Technique Key

Under each <u>printing technique</u> you may encounter the following types of prints (or combination of processes):

I <u>Intaglio:</u>
- etching
- drypoint
- steel engraving
- stipple engraving
- aquatint
- mezzotint
- soft-ground etching
- crayon manner

P <u>Planographic:</u>
- lithograph
- monotype
- silk-screen
- cliche verre
- serigraph

R <u>Relief:</u>
- wood block
 - woodcut
 - chiaroscuro
 - wood engraving
- linoleum cut (linocut)

P/ 1200
LASANSKY, MAURICIO (B. 1914) AMERICAN
I/ 500-7500
LASKE, OSKAR (1841-1911) AUSTRIAN
I/ 100-550 P/ 100-500
LASKOFF, FRANZ
P/ 700-4400
LASTMAN, PIETER (1583-1633) DUTCH
I/ 600-4900
LATENAY, GASTON DE (1859-1940) FRENCH
I/ 250 P/ 200-700
LAUBER, JOSEPH (B. 1885) AMERICAN
I/ 30-75
LAUBI, HUGO (?) ?
P/ 200-1500
LAUNAY, NICOLAS DE (1739-1792) FRENCH
I/ 125-800
LAURENCIN, MARIE (1883-1956) FRENCH
I/ 75-16500 P/ 75-26100
LAURENS, HENRI (1885-1954) FRENCH
I/ 300-4000 P/ 775-2000 R/ 25-800
LAURENT, ERNEST-JOSEPH (1859-1929) FRENCH
P/ 800
LAURENT, JEAN-ANTOINE (1763-1832) FRENCH
I/ 200
LAUSEN, UWE (B. 1941) ?
P/ 50-400
LAUTENSACK, HANS (1524-1560) GERMAN
I/ 145-8300
LAWRENCE, EDITH (1890-1973) BRITISH
R/ 450
LAWSON, ROBERT (1892-1957) AMERICAN
I/ 50-100
LAZZARI, PIETRO (B. 1898) AMERICAN
I/ 25-100
LAZZELL, BLANCHE (1878-1956) AMERICAN
P/ 990-2900 R/ 275-38500
LE BAS, JACQUES PHILIPPE (1707-1783) FRENCH
I/ 75-250
LE FOLL, ALAIN (1935-1981) FRENCH
P/ 200
LE PAUTRE, JEAN (1618-1682) FRENCH
I/ 150-800
LEANDRE, CHARLES (1862-1930) FRENCH

P/ 125-600
LEBEGUE, LEON (19TH C) FRENCH
P/ 350
LEBRUN, RICO (1900-1964) AMERICAN
P/ 300
LECK, BART VAN DER (1876-1958) DUTCH
P/ 700-2200
LEFEBRE, VALENTIN (1642-1680) FLEMISH
I/ 75
LEFORT, HENRI (B. 1852) FRENCH
I/ 60-175
LEFTROOK, TERRY (20TH C) AMERICAN
I/ 80-150
LEGER, FERNAND (1881-1955) FRENCH
 I/ 200-11000 P/ 25-29000 R/ 1100
LEGRAND, LOUIS AUGUSTE MATHIEU (1863-1951) FRENCH
I/ 25-2500
LEGROS, ALPHONSE (1837-1911) FRENCH
I/ 15-400
LEHEUTRE, GUSTAVE (1861-1932) FRENCH
I/ 50-400
LEHMANN-STEGLITZ (?) ?
P/ 700
LEHMBRUCK, WILHELM (1881-1919) GERMAN
 I/ 150-13000 P/ 150-2300
LEHMDEN, ANTON (B. 1929) AUSTRIAN
I/ 50-375
LEIBIL, WILHELM (1844-1900) GERMAN
I/ 100-2800
LEICH, CHESTER (B. 1889) AMERICAN
I/ 25-100
LEIGH, HOWARD (B. 1896) AMERICAN
P/ 50-100
LEIGHTON, CLARE (1899-1989) AMERICAN
R/ 70-650
LEINBERGER, HANS (16TH C) GERMAN
I/ 2800-3100
LEISTIKOW, WALTER (1865-1908) GERMAN
 I/ 100-1500 P/ 250-5800
LELONG, RENE (19TH/20TH C) FRENCH
P/ 150-1000
LEMKE, HORST (?) ?
 I/ 800-1000 P/ 1000-1200
LEMMEL, CHARLES

P/ 125
LEMMEN, GEORGES (1865-1916) BELGIAN
P/ 200-1500
LENEY, WILLIAM (1769-1831) BRITISH
I/ 400
LENNON, JOHN (20TH C) BRITISH
P/ 500
LENOIR, MARCEL (?) ?
P/ 150-950
LEONART, JOHANN FRIEDRICH (1633-1680) GERMAN
I/ 20-75
LEPARE, GEORGES (1887-1971) FRENCH
P/ 200-1500
LEPERE, AUGUSTE (1849-1918) FRENCH
I/ 50-2200 P/ 150-3100 R/ 100-2200
LEPICIE, NICOLAS BERNARD (1735-1784) FRENCH
I/ 200-600
LEPRINCE, JEAN BAPTISTE (1734-1781) FRENCH
I/ 50-600
LERICHIER, HENRI (20TH C) FRENCH
I/ 30-75
LEROUX, GEORGES (B. 1877) FRENCH
P/ 400-2400
LESSIEUX, LOUIS (?) ?
P/ 1800
LEUPIN, HERBERT (?) ?
P/ 60-800
LEUPPI, LEO PETER (1893-1972) DUTCH
R/ 50-300
LEVER, HAYLEY (1876-1958) AMERICAN
I/ 50-150
LEVINE, JACK (B. 1915) AMERICAN
I/ 75-1800 P/ 50-1100
LEVINE, MARTIN (B. 1941) AMERICAN
I/ 40-200
LEVY, ALPHONSE (1843-1918) FRENCH
P/ 200-1650
LEVY, BEATRICE (1892-1974) AMERICAN
I/ 200
LEWIS, ALLEN (1873-1957) AMERICAN
R/ 30-175
LEWIS, MARTIN (1881-1962) AMERICAN
I/ 200-19800 P/ 1100-8800
LEWITT, SOL (B. 1928) AMERICAN

I/ 25-1700 P/ 75-6000
LEYDEN, LUCAS VAN (1494-1533) FLEMISH
 I/ 50-106000 R/ 180-96000
LEYMARIE, AUGUSTE (19TH/20TH C) FRENCH
 P/ 2000
LHOTE, ANDRE (1885-1962) FRENCH
 I/ 300 P/ 150-1500 R/ 900
LICHTENSTEIN, ROY (B. 1923) AMERICAN
 I/ 1200-7700 P/ 200-82500 R/ 1400-44000
LIEBENWEIN, MAXIMILIEN (1869-1926) AUSTRIAN
 P/ 277-400
LIEBERMANN, MAX (1847-1935) GERMAN
 I/ 50-4200 P/ 50-6300 R/ 30-300
LIEVENS, JAN (1607-1674) DUTCH
 I/ 15-5700
LILLIE, ELLA FILLMORE (B. 1887) AMERICAN
 P/ 25-100
LIMBACH, RUSSELL (B. 1904) AMERICAN
 I/ 35-125 P/ 75-150
LINDENMUTH, TOD (1885-1976) AMERICAN
 R/ 300-2800
LINDNER, RICHARD (1901-1978) AMERICAN
 P/ 175-7200
LINDSAY, NORMAN ALFRED WILLIAMS (1879-1970) AUSTRALIAN
 I/ 500
LINDSTROM, BENGT (B. 1925) SWEDISH
 I/ 100-300 P/ 250-400
LINGEE, CHARLES L. (1748-1819) FRENCH
 I/ 650
LIPCHITZ, JACQUES (1891-1973) FRENCH
 I/ 100-3900 P/ 210-1100
LIPINSKY, LINO S. (B. 1908) AMERICAN
 I/ 75-125
LIPS, JOHANN H. (1758-1817) SWISS
 I/ 100-250
LISSITZKY, EL (1890-1941) RUSSIAN
 P/ 100-62100
LITTLE, PHILIP (1857-1942) AMERICAN
 I/ 75-250
LIVEMONT, PRIVAT (1861-1936) BELGIAN
 P/ 300-5300
LOBEL-RICHE, ALMERY (B. 1880) FRENCH
 I/ 50-500
LOBISSER, SWITBERT (B. 1878) AUSTRIAN

R/ 100-500
LOCHOM, BARTOLOMEUS VAN (B. 1607) DUTCH
I/ 300
LOCKE, CHARLES WHEELER (B. 1899) AMERICAN
I/ 150 P/ 240-450
LOFFLER, BERTHOLD (1874-1960) AUSTRIAN
P/ 300-6300 R/ 1000
LOHSE, RICHARD PAUL (B. 1902) SWISS
P/ 150-750
LOLI, LORENZO (1612-1691) ITALIAN
I/ 40-1200
LONGO, ROBERT (20TH C) AMERICAN
P/ 500-16000
LOO, ANDRE VAN (called CARLE VAN LOO) (1705-1765) FRENCH
I/ 150-600
LOPES-SILVA, LUCIEN (?) ?
P/ 1400
LORANT-HEILBRONN, V.
P/ 880-1000
LORCH, MELCHIOR (1527-1594) DANISH/GERMAN
I/ 400-32000
LORD, ELYSE ASHE (D. 1971) BRITISH
I/ 100-925
LORENZ, CARL (B. 1871) AUSTRIAN
R/ 25-225
LORENZI, GIOVANNI ANTONIO (1665-1740) ITALIAN
I/ 275
LOSQUES, DANIEL DE (1880-1915) FRENCH
P/ 100-1100
LOUPOT, CHARLES (?) ?
P/ 650-10500
LOUTHERBOURG, JACQUES PHILIPP DE (1740-1812) FRENCH
I/ 350
LOUYS, PIERRE (?) ?
P/ 300-2700
LOZOWICK, LOUIS (1893-1973) AMERICAN
P/ 100-18700
LUBELL, WINIFRED M. (20TH C) AMERICAN
R/ 20-50
LUCAS, CHARLES E. (?) ?
P/ 300-2420
LUCE, MAXIMILIEN (1858-1941) FRENCH
I/ 206 P/ 75-5000
LUCIONI, LUIGI (B. 1900) AMERICAN

I/ 50-460
LUGINBUHL, BERNHARD (B. 1929) SWISS
 I/ 200-3000 P/ 100-1300 R/ 125-3200
LUM, BERTHA BOYNTEN (B. 1934) AMERICAN
 R/ 240-660
LUMSDEN, ERNEST STEPHEN (1883-1948) BRITISH
 I/ 50-500
LUNEL, FERDINAND (B. 1857) FRENCH
 P/ 275
LUNOIS, ALEXANDRE (1863-1916) FRENCH
 P/ 25-750
LUPERTZ, MARKUS (?) ?
 I/ 100-590 P/ 60-1200 R/ 500-2900
LURCAT, JEAN (1892-1966) FRENCH
 I/ 50-600 P/ 100-400
LYDIS, MARIETTE RONSBERGER (1894-1970) AMERICAN
 I/ 50-125
LYON, ROLAND (1904-1966) AMERICAN
 R/ 25-100

M

MACARDELL, JAMES (1710-1765) BRITISH
 I/ 300-800
MACCOY, GUY (B. 1904) AMERICAN
 P/ 75-200
MACK, HEINZ (B. 1931) GERMAN
 P/ 100-1800
MACK, WARREN (B. 1896)
 I/ 25-100
MACKE, AUGUST (1887-1914) GERMAN
 R/ 800-4800 P/ 1765
MACKENSEN, FRITZ (B. 1866) GERMAN
 I/ 200-1500
MADRAZO, T.L.DE (?) ?
 P/ 250-1200
MAETZEL, EMIL (?) ?
 I/ 100-550 P/ 90-1000 R/ 390-1400
MAETZEL-JOHANNSEN
 I/ 300-2500 R/ 200-900

Technique Key

Under each <u>printing technique</u> you may encounter the following types of prints (or combination of processes):

I <u>Intaglio:</u>
- etching
- drypoint
- steel engraving
- stipple engraving
- aquatint
- mezzotint
- soft-ground etching
- crayon manner

P <u>Planographic:</u>
- lithograph
- monotype
- silk-screen
- cliche verre
- serigraph

R <u>Relief:</u>
- wood block
 - woodcut
 - chiaroscuro
 - wood engraving
- linoleum cut (linocut)

MAGGIOTTO, FRANCESCO (1750-1805) ITALIAN
 I/ 250
MAGNELLI, ALBERTO (1888-1971) ITALIAN
 P/ 100-600 R/ 200
MAGRITTE, RENE (1898-1967) BELGIAN
 I/ 200-10500 P/ 150-11000
MAHLER, HEINRICH (?) ?
 P/ 1000
MAIAKOVSKY, V. (?) ?
 P/ 225-1400
MAILLET, JACQUES L.(1823-1895) FRENCH
 I/ 100-300
MAILLOL, ARISTIDE (1861-1944) FRENCH
 I/ 100-1300 P/ 30-4000 R/ 25-11000
MAJOR, ISAAK (1576-1630) GERMAN
 I/ 900
MAKI, HAKU (20TH C) JAPANESE
 P/ 60-165
MAKS, CORNELIS JOHANNES (1876-1965) DUTCH
 P/ 400
MALETZKE, HELMUT (?) ?
 I/ 175 R/ 250
MALEVITCH, KASIMIR (1878-1935) RUSSIAN
 P/ 150-10520 R/ 350-2700
MALZAC, FRANC (?) ?
 P/ 750-900
MAN RAY, (20TH C) AMERICAN
 I/ 50-2600 P/ 50-11000
MANASSER, TOBIAS (?) ?
 I/ 25-400
MANE-KATZ (1894-1962) FRENCH
 125-900
MANESSIER, ALFRED (B. 1911) FRENCH
 I/ 150-600 P/ 50-2400
MANET, EDOUARD (1832-1883) FRENCH
 I/ 25-17000 P/ 600-187000
MANGOLD, BURKHARD (B. 1873) SWISS
 P/ 100-6000
MANGOLD, ROBERT (B. 1937) AMERICAN
 I/ 500-3300 P/ 100-1000
MANGOLD, SILVIA P. (B. 1938) AMERICAN
 I/ 300
MANGUIN, HENRI CHARLES (1874-1943) FRENCH
 I/ 200

MANTEGNA, ANDREA (1431-1506) ITALIAN
I/ 400-413000
MANZU, GIACOMO (B. 1908) ITALIAN
I/ 60-1200 P/ 400-1400
MARA, POL (B. 1920) BELGIAN
P/ 175-850
MARATTA, CARLO (1625-1713) ITALIAN
I/ 125-800
MARC, FRANZ (1880-1916) GERMAN
P/ 2000-35000 R/ 100-42000
MARCA-RELLI, CONRAD (B. 1913) AMERICAN
P/ 100-500
MARCHAND, ANDRE (B. 1907) FRENCH
P/ 110-800
MARCHANT, LEONARD (20TH C) AMERICAN
I/ 50-150
MARCKS, GERHARD (B. 1889) GERMAN
I/ 125-475 P/ 100-1300 R/ 25-3200
MARCOUSSIS, LOUIS (1883-1941) FRENCH
I/ 50-72000
MARDEN, BRICE (B. 1938) AMERICAN
I/ 300-6600 P/ 275-6600
MARGOLIES, SAMUEL (B. 1898) AMERICAN
I/ 75-7700 P/ 50-550
MARGULIES, JOSEPH (1896-1984) AMERICAN
I/ 25-250
MARIANI, POMPEO (1857-1927) ITALIAN
P/ 300-11500 (monotypes only)
MARIESCHI, MICHELE (1710-1743) ITALIAN
I/ 150-6400
MARIN, JOHN (1872-1953) AMERICAN
I/ 200-57000
MARINI, MARINO (1901-1980) ITALIAN
I/ 60-7800 P/ 100-8800
MARISOL, ESCOBAR (B. 1930) AMERICAN
I/ 100-600 P/ 100-1350
MARKHAM, KYRA (1891-1967) AMERICAN
I/ 100-350 P/ 100-3025
MAROT, DANIEL (1663-1752) FRANCO/DUTCH
I/ 50-450
MARQUET, ALBERT (1875-1947) FRENCH
I/ 100-1900 P/ 25-3300 R/ 125-275
MARSH, REGINALD (1898-1954) AMERICAN
I/ 200-22000 P/ 150-3500

MARTIN, CHARLES
P/ 300-1100
MARTIN, HENRI (1860-1936) FRENCH
P/ 250-500
MARTIN, JOHN (1789-1854) BRITISH
I/ 100-1800
MARTINET, FRANCOIS (18TH C) FRENCH
I/ 300-1000
MARTINI, PIETRO A. (1739-1797) ITALIAN
I/ 350-600
MARTSZ, de JONGE JAN (1609-after 1647) DUTCH
I/ 100-400
MARTY, ANDRE E. (1882-1974) FRENCH
P/ 750-1500
MARVAL, JACQUELINE (1866-1932) FRENCH
P/ 200-350
MARYAN, MARYAN P/. B.(1927-1977) AMERICAN
P/ 25-175
MASEREEL, FRANS (1889-1972) BELGIAN
P/ 150-625 R/ 25-1900
MASIELLO, PASQUALE (B. 1912) AMERICAN
I/ 25-100
MASOLLE, HELMER
I/ 800-2000
MASON, RANDALL (?) ?
I/ 300
MASSON, ANDRE (B. 1896) FRENCH
I/ 60-15000 P/ 40-2000
MASTRO-VALERIO, ALESSANDRO (1887-1953) AMERICAN
I/ 250-700
MATALONI, GIOVANNI
P/ 1100-1300
MATANIA, FORTUNINO (B. 1881) ITALIAN
P/ 1600-4200
MATARE, EWALD (1887-1965) GERMAN
R/ 100-17050
MATHAM, ADRIAEN (1599-1660) DUTCH
I/ 600
MATHAM, JACOB (1571-1631) DUTCH
I/ 50-15700
MATHAM, THEODOR (1606-1676) DUTCH
I/ 225-325
MATHIEU, GEORGES (B. 1921) FRENCH
I/ 550

MATISSE, HENRI (1869-1954) FRENCH
 I/ 100-137500 P/ 100-350000 R/ 175-46000
MATTA, ROBERTO ECHAUREN (B. 1912) CHILEAN
 I/ 50-1500 P/ 85-900
MATTER, HERBERT
 P/ 650-1450
MATTHEUER, W.
 R/ 500-1200
MATULKA, JAN (1890-1972) CZECHOSLOVAKIAN/AMERICAN
 I/ 800-1500 P/ 990-1900
MAUFRA, MAXIME EMILE LOUIS (1861-1918) FRENCH
 I/ 220-3500 P/ 2200
MAULBERTSCH, FRANZ ANTON (1742-1796) AUSTRIAN
 I/ 2100
MAUPERCHE, HENRI (1602-1686) FRENCH
 I/ 400-450
MAURIN CHARLES (1856-1914) FRENCH
 I/ 50-1400
MAURONER, FABIO (B. 1884) ?
 I/ 50-100
MAUZAN, ACHILLE
 P/ 175-2500
MAUZEY, MERRITT (1898-1975) AMERICAN
 P/ 50-200
MAX, PETER (B. 1937) GERMAN/AMERICAN
 P/ 120-725
MAXIM, ORA INGE (1895-1982) AMERICAN
 R/ 3900
MAYER, MARTIN (1775-1821) FRENCH
 I/ 100-250 P/ 300
MAYHEW, NELL B. (20TH C) AMERICAN
 I/ 60-175
MAYO, EILEEN (?) ?
 R/ 350
MAZZOLA, FRANCESCO (called IL PARMIGIANIMO) (16TH C) ITALIAN
 I/ 2000-12000
MCALLISTER, ABEL F. (B. 1906) AMERICAN
 P/ 25-100 R/ 25-100
MCBEY, JAMES (1889-1959) BRITISH
 I/ 75-5300
MCCLOY, WILLIAM A. (B. 1913) AMERICAN
 I/ 25-100
MCCORMICK, HOWARD (1875-1943) AMERICAN
 R/ 75-150

MCCORMICK, KATHERINE HOOD (1882-1960) AMERICAN
R/ 1200-2700
MCKINNIE, WENDALL (20TH C) AMERICAN
P/ 25-75
MCLEAN, BRUCE
P/ 300-2800
MCMILLEN, MILDRED (1884-1940) AMERICAN
R/ 350-800
MCNETT, WILLIAM B. (1896-1968) AMERICAN
P/ 25-100
MCNULTY, WILLIAM C. (B. 1889) AMERICAN
I/ 100-660
MCPHERSON, CRAIG (20TH C) AMERICAN
I/ 2800
MECIKALSKI, EUGENE (B. 1927) AMERICAN
R/ 25-100
MECKENEM, ISRAEL VAN (D. 1503) GERMAN
I/ 500-56000
MECKSEPER, FRIEDRICH (B. 1936) GERMAN
I/ 60-3700 P/ 210
MEER, JAN VAN DER (1656-1705) DUTCH
I/ 800
MEESER, LILLIAN BURK (1864-1942) AMERICAN
R/ 400
MEID, HANS (1883-1957) GERMAN
I/ 50-1100 P/ 15-500
MEIDNER, LUDWIG (1884-1966) GERMAN
I/ 55-2208 P/ 40-900
MEIER, MELCHIOR (16TH/17TH C) SWISS
I/ 200-900
MEISTERMANN, GEORG (B. 1911) GERMAN
I/ 500-1400 P/ 30-1220 R/ 500-900
MELLAN, CLAUDE (1598-1688) FRENCH
I/ 150-2200
MELTZER, DORIS (B. 1908) AMERICAN
P/ 25-100
MELZER, MORITZ (B. 1877) GERMAN
I/ 800 P/ 690-3100 R/ 300-1650
MENPES, MORTIMER L. (1860-1938) BRITISH/AUSTRALIAN
I/ 50-1300
MENSE, CARL (1886-1965) GERMAN
I/ 200-450 P/ 100-350
MENZEL, ADOLF FRIEDRICH ERDMANN (1815-1905) GERMAN
I/ 50-550 P/ 25-1400 R/ 25-800

MERCATI, GIOVANNI-BATTISTA (B. 1600) ITALIAN
I/ 625
MERIAN, MATTHAUS (?) ?
I/ 25-3100
MERIDA, CARLOS (1891-1984) MEXICAN
P/ 25-900
MERRICK, RICHARD L. (B. 1903) AMERICAN
I/ 25-100
MERRILL, KATHARINE (B. 1896) AMERICAN
I/ 25-100
MERYON, CHARLES (1821-1868) FRENCH
I/ 100-52470
MESECK, FELIX (B. 1883) GERMAN
I/ 25-75
METIVET, LUCIEN (1863-1930) FRENCH
P/ 200-3600
METLICOVITZ, L.
P/ 150-7700
METZGER, CHARLES
P/ 750-1200
MEUNIER, GEORGES (B. 1869) FRENCH
P/ 100-1900
MEUNIER, HENRI (1873-1922) BELGIAN
I/ 300-350 P/ 450-3100
MEYER, A. J. (19TH C) BRITISH
I/ 15-75
MEYER, FELIX (1653-1713) SWISS
P/ 350
MEYER-AMDEN, OTTO (B. 1885) SWISS
P/ 500-1400
MEYER-BASEL, CARL (1862-1932) SWISS
I/ 123-500 P/ 150
MICHAUX, HENRI (B. 1899) BELGIAN
I/ 650-1300 P/ 125-1400
MICHEL, ROBERT (B. 1897) GERMAN
I/ 800-1500 R/ 1500-3520
MIELE, JAN (1599-1663) FLEMISH
I/ 550-750
MIGNON, JEAN (16TH C) FRENCH
I/ 400-12000
MIKL, JOSEF (B. 1928) AUSTRIAN
P/ 350-450
MILAN, PIERRE (16TH C) FRENCH
I/ 700-7500

Technique Key

Under each <u>printing technique</u> you may encounter the following types of prints (or combination of processes):

I <u>Intaglio:</u>
- etching
- drypoint
- steel engraving
- stipple engraving
- aquatint
- mezzotint
- soft-ground etching
- crayon manner

P <u>Planographic:</u>
- lithograph
- monotype
- silk-screen
- cliche verre
- serigraph

R <u>Relief:</u>
- wood block
 - woodcut
 - chiaroscuro
 - wood engraving
- linoleum cut (linocut)

MILHOLLEN, HIRST D. (B. 1906) AMERICAN
I/ 25-100
MILLAIS, SIR JOHN EVERETT (1829-1896) BRITISH
I/ 100-990
MILLAR, FRED (?) ?
I/ 200
MILLER, HELEN P. (1888-1957) AMERICAN
I/ 25-100
MILLER, KENNETH HAYES (1876-1952) AMERICAN
I/ 125-600
MILLER, LEON GORDON (20TH C) AMERICAN
R/ 50-150
MILLER, RICHARD E. (B. 1875) AMERICAN
I/ 25-75
MILLET, JEAN FRANCOIS (1814-1875) FRENCH
I/ 200-23500 P/ 1100-19800
MILLIERE, MAURICE (B. 1871) FRENCH
I/ 175-12000 P/ 1600
MILSHTEIN, ZWI (B. 1934) ISRAELI
P/ 50-425
MILTON, PETER (B. 1930) AMERICAN
I/ 80-3900
MINAMI, KEIKO (B. 1911) JAPANESE
I/ 100-175
MINAUX, ANDRE (B. 1923) FRENCH
P/ 50-300
MINGUZZI, LUCIANO (B. 1911) ITALIAN
I/ 250-350
MINNE, GEORGE (1866-1941) BELGIAN
P/ 40-800
MINOR, ROBERT (1839-1904) AMERICAN
I/ 10-75
MIRER, RUDOLF
P/ 1700
MIRO, JOAN (1893-1983) SPANISH
I/ 100-165000 P/ 25-99000 R/ 100-5000
MISTI (19TH C) FRENCH
P/ 50-1200
MITELLI, GIUSEPPE 1634-1718) ITALIAN
I/ 325
MITCHELL, MARGUERITE (20TH C) AMERICAN
R/ 50-100
MITSCHKE-COLLANDE, CONSTANTIN VON (B. 1884) GERMAN
P/ 300

MOCK, GLADYS (B. 1892) AMERICAN
I/ 25-100
MODENA, NICOLETTO DA (16TH C) ITALIAN
I/ 500-16000
MODERSOHN-BECKER, PAULA (1876-1907) GERMAN
I/ 1000-11200
MODIGLIANI, AMEDEO (1884-1920) ITALIAN
I/ 300-800
MOFFETT, ROSS E. (B. 1888) AMERICAN
P/ 75-250
MOHLITZ, PHILIPPE (B. 1941)
I/ 125-825
MOHOLY-NAGY, LAZLO (1895-1946) HUNGARIAN/AMERICAN
I/ 1500-3000 P/ 2000-37000 R/ 1000-15400
MOHRBUTTER, ALFRED (1867-1916) GERMAN
P/ 150-800
MOLA, PIER FRANCESCO (1612-1666) ITALIAN
I/ 650-700
MOLENAER, JAN M. (1610-1668) DUTCH
I/ 1900
MOLIJN (MOLYN), PIETER (1595-1661) DUTCH
I/ 100-1200
MOLKENBOER, T.H.A
P/ 400-2400
MOLL, CARL (1861-1945) AUSTRIAN
P/ 500-1100 R/ 50-1200
MOLOCH, B. (1849-1909) FRENCH
P/ 175
MOLZAHN, JOHANNES (1892-1965) GERMAN
p I/ 3476 P/ 2841 R/ 1600-2000
MONK, RICHARD BASIL
R/ 200-400
MONNIER, HENRI DE (1805-1877) FRENCH
P/ 60-2400
MONTAGNA, BENEDETTO (1481-1558) ITALIAN
I/ 150-5400
MONVEL, BERNARD B.
P/ 1100
MOORE, BENSON B. (B. 1882) AMERICAN
I/ 25-100
MOORE, GEORGE BELTON (1805-1875) BRITISH
P/ 250-400
MOORE, HENRY (1898-1986) BRITISH
I/ 200-10000 P/ 30-22000 R/ 1500-15400

MOOS, MAX VON (B. 1903) ?
 I/ 243 P/ 75-450 R/ 165
MORACH, OTTO (1887-1973) SWISS
 P/ 1000-6000
MORAN, PETER (1841-1914) AMERICAN
 I/ 75-300
MORAN, THOMAS (1837-1926) AMERICAN
 I/ 100-3300
MORANDI, GIORGIO (1890-1964) ITALIAN
 I/ 1500-115500
MOREAU, JEAN M.(called MOREAU LE JEUNE) (1741-1814) FRENCH
 I/ 200-1100
MOREAU, LUC-ALBERT (1882-1948) FRENCH
 P/ 50-200
MOREAU, PIERRE LOUIS (B. 1876) FRENCH
 I/ 50
MORELL, PIT (B. 1939) GERMAN
 I/ 157-1500
MORETTI, LUCIEN PHILIPPE (20TH C) FRENCH
 P/ 350-1500
MORGAN, FRANKLIN T. (B. 1883) AMERICAN
 I/ 25-100
MORGAN, NORMA (B. 1928) AMERICAN
 I/ 25-100
MORGNER, WILHELM (1891-1917) GERMAN
 I/ 225-850 R/ 200-6000
MORIN, JEAN (1605-1650) FRENCH
 I/ 125-2500
MORIN, LOUIS (B. 1855) FRENCH
 P/ 400
MORISOT, BERTHE (1841-1895) FRENCH
 I/ 90-950
MORLAND, GEORGE (1763-1804) BRITISH
 I/ 220-800
MORLEY, EUGENE (1909-1953) AMERICAN
 P/ 100-300
MORLEY, MALCOLM (B. 1931) BRITISH/AMERICAN
 I/ 1000-2500 P/ 100-16500
MORO, BATTISTA ANGOLO DEL (1514-1573) ITALIAN
 I/ 725
MORRIS, ROBERT (B. 1931) AMERICAN
 P/ 50-550
MORPER, DANIEL (B. 1937) AMERICAN
 P/ 150-425

MORTENSEN, RICHARD (B. 1910) DANISH
P/ 80-100
MOSER, KOLOMON (1868-1918) AUSTRIAN
P/ 390-22000
MOSES, ED (B. 1926) AMERICAN
P/ 300-1320
MOSKOWITZ, ROBERT (20TH C) AMERICAN
P/ 1320-2500
MOTHERWELL, ROBERT (B. 1915) AMERICAN
I/ 175-26000 P/ 175-63400
MOUEL, EUGENE LE
P/ 200-1200
MOYREAU, JEAN (1690-1762) FRENCH
I/ 200-350
MUCHA, ALPHONSE MARIA (1860-1939) CZECHOSLOVAKIAN
P/ 25-52800
MUCHE, GEORG (B. 1895) GERMAN
I/ 350-2300
MUCK, FRIEDRICH O. (19TH/20TH C) GERMAN
P/ 50-100
MUELLER, HANS A. (1888-1962) AMERICAN
R/ 40-75
MUGGIANI, GIORGIO
P/ 900-2400
MUHLENHAUPT, CURT
I/ 150-275 P/ 100-200 R/ 75-275
MULLER, ALBERT (B. 1884) GERMAN
I/ 300-1900 R/ 600-2000
MULLER, ALFREDO (B. 1869) ITALIAN
I/ 300-500 P/ 200-1000
MULLER, C.O.
P/ 125-200 R/ 1800-3000
MULLER, FRIEDRICH (1782-1816)
I/ 200-700
MULLER, JAN HARMENSZ (1571-1628) DUTCH
I/ 50-9400
MUELLER, OTTO (1874-1930) GERMAN
P/ 60-95500 R/ 600-9500
MULLER, RICHARD (1874-1930) AUSTRIAN
I/ 25-1000 P/ 300
MULLER-LINOW, BRUNO (B. 1925) SWISS
I/ 200-275
MUNAKATA, SHIKO (1903-1975) JAPANESE
R/ 130-132000

MUNCH, EDVARD (1863-1944) NORWEGIAN
 I/ 75-56300 P/ 145-616000 R/ 3600-146000
MUNCH-KHE, WILLI (B. 1885) GERMAN
 I/ 50-250
MUNTER, GABRIELE (1877-1962) GERMAN
 I/ 2500 P/ 380-1200 R/ 3900
MURPHY, ALICE HAROLD (1896-1966) AMERICAN
 P/ 30-150
MURPHY, CATHERINE (B. 1946) AMERICAN
 P/ 100-500
MURRAY, ELIZABETH (B. 1940) AMERICAN
 P/ 380-9000
MUSI, AGOSTINO DEI (1490-1540) ITALIAN
 I/ 250-5600
MUSIC, ZORAN ANTONIO (1909-1952) ITALIAN
 I/ 30-1700 P/ 50-950

N

NAGEL, PIETER (B. 1941) DUTCH
 I/ 70-525 P/ 200-880
NAGELE, REINHOLD (20TH C) ?
 I/ 100-600
NALBANDIAN, KARNIG (B. 1916) AMERICAN
 I/ 25-100
NAMIKI, HAJIME
 R/ 600
NARDOIS, JEAN G.
 I/ 800-1400
NASH, PAUL (1889-1946) BRITISH
 I/ 5200 P/ 550-5300 R/ 100-1100
NASH, WILLARD AYER (1898-1943) AMERICAN
 P/ 175-250
NASON, GERTRUDE (1890-1969) AMERICAN
 R/ 100-250
NASON, THOMAS (1889-1971) AMERICAN
 I/ 75-280 R/ 200-300
NATKIN, ROBERT (B. 1930) AMERICAN
 P/ 100-1200 I/ 1700-1800
NAUEN, HEINRICH (1880-1940) GERMAN

I/ 375-3100
NAUMAN, BRUCE (B. 1941) AMERICAN
 I/ 400-5000 P/ 250-16500
NAUMANN, HERMANN
 I/ 35 P/ 75-9100
NAVARRO, F.DE
 P/ 1300
NAY, ERNST WILHELM (1902-1968) GERMAN
 I/ 30-15600 P/ 175-10100 R/ 200-1100
NEAL, REGINALD (B. 1909) AMERICAN
 P/ 75-150
NEBEL, OTTO (B. 1892) SWISS
 P/ 225 R/ 50-700
NEEFFS, JACOBUS (1610-1660) DUTCH
 I/ 125-250
NEEL, ALICE (1901-1984) AMERICAN
 P/ 300-1800
NERI, MANUEL (B. 1930) AMERICAN
 P/ 800
NESBITT, JACKSON LEE (B. 1913) AMERICAN
 I/ 75-495
NESBITT, LOWELL (B. 1933) AMERICAN
 P/ 50-550
NESCH, ROLF (B. 1893) GERMAN
 I/ 175-33000 P/ 200-9900 R/ 1000-1700
NEUKOMM, FRED
 P/ 800
NEUMANN, HANS (B. 1873) GERMAN
 R/ 200-700
NEVE, FRANS DE (1606-1681) FLEMISH
 I/ 150-200
NEVELSON, LOUISE (1900-1988) AMERICAN
 I/ 500-8250 P/ 50-1725
NEVINSON, CHRISTOPHER RICHARD WYNNE (1889-1946) BRITISH
 I/ 150-10800 P/ 250-9200
NEWMAN, BARNETT (1905-1970) AMERICAN
 I/ 1400-20000 P/ 1500-66000
NEWMAN, JOHN
 P/ 1000-1870
NEWTON, EDITH W. (B. 1878) AMERICAN
 P/ 25-100
NEZIERE, J.DE LA (?) ?
 P/ 325-500
NICHOLS, DALE WILLIAM (B. 1904) AMERICAN

Technique Key

Under each <u>printing technique</u> you may encounter the following types of prints (or combination of processes):

I <u>Intaglio:</u>
- etching
- drypoint
- steel engraving
- stipple engraving
- aquatint
- mezzotint
- soft-ground etching
- crayon manner

P <u>Planographic:</u>
- lithograph
- monotype
- silk-screen
- cliche verre
- serigraph

R <u>Relief:</u>
- wood block
 - woodcut
 - chiaroscuro
 - wood engraving
- linoleum cut (linocut)

P/ 75-330
NICHOLSON, BEN (1894-1982) BRITISH
 I/ 75-8300 R/ 300-9000
NICHOLSON, SIR WILLIAM (1872-1949) BRITISH
 I/ 300 P/ 50-4000 R/ 25-1500
NILSON, JOHANN E. (1799-1867) GERMAN
 I/ 200-250
NISBET, ROBERT HOGG (1879-1961) AMERICAN
 I/ 20-125
NITTIS, GIUSEPPE DE (1846-1884) ITALIAN
 I/ 250
NIZZOLI, MARCELLO
 P/ 250-4000
NODA, TETSUYA (B. 1940) JAPANESE
 R/ 600-700
NOEL, GUY-GERARD
 P/ 900-1800
NOLAND, KENNETH (B. 1924) AMERICAN
 I/ 1600-11000 P/ 400-31000
NOLDE, EMIL (1867-1956) GERMAN
 I/ 300-48000 P/ 175-255000 R/ 100-62700
NOLKEN, FRANZ (B. 1884) GERMAN
 I/ 100-350
NOLPE, PIETER (1613-1652) DUTCH
 I/ 200
NOMELLINI, PLINIO (1866-1943) ITALIAN
 P/ 1200
NORBLIN, STEFAN (B. 1892)
 P/ 600
NORDFELDT, BROR JULIUS O. (1878-1955) AMERICAN
 I/ 150-330 R/ 1100-2600
NOTHNAGEL, JOHANNES ANDREAS BENJAMIN (1729-1804) GERMAN
 I/ 75-200
NOURY, GASTON (B. 1866) FRENCH
 P/ 200
NOVAK, LOUIS (B. 1903) AMERICAN
 R/ 75-300
NOVELLANUS, A. (17TH C) GERMAN
 I/ 500
NUANCE, WALTER (20TH C) AMERICAN
 P/ 50-100
NUTTING, MYRON C. (B. 1890) AMERICAN
 P/ 25-100

O

O'CONNOR, RODERICK (1860-1940) IRISH
 I/ 100-3500
O'GALOP (19TH C) FRENCH
 P/ 225-1400
O'HIGGINS, PABLO (B. 1904) AMERICAN
 P/ 75-175
O'KEEFE, IDA T.E. (B. 1899) AMERICAN
 I/ 100-200
OAKFORD, ELLEN (19TH C) AMERICAN
 I/ 50-150
OBERMEIER, OTTO (B. 1883) GERMAN
 P/ 350-600
OCHOA, R. DE (?) ?
 P/ 250-300
OFFIN, CHARLES Z. (B. 1899) AMERICAN
 I/ 40-100
OGE, E. (19TH C) FRENCH
 P/ 200-1400
OGUISS, TAKANARI (B. 1900) JAPANESE
 P/ 500-2800
OHCHI, HIROSHI
 P/ 700
OLBRICH, JOSEPH M. (1867-1908) AUSTRIAN
 P/ 2100-10000
OLDE, HANS (1855-1917) GERMAN
 I/ 250
OLDENBURG, CLAES THURE (B. 1929) AMERICAN
 I/ 275-71500 P/ 50-20000
OLITSKI, JULES (1922-1964) AMERICAN
 P/ 175-2000
OLIVEIRA, NATHAN (B. 1928) AMERICAN
 I/ 200-900 P/ 200-4000
OLIVER, PETER (1594-1647) BRITISH
 I/ 3300-13000
OLIVIER, FERDINAND J. H. VON (1785-1841) GERMAN
 P/ 600-10100
OLMUTZ, WENZEL VON OLSKY
 I/ 100-2300
ONOFRI, CESARE (1632-1712) ITALIAN
 I/ 600-1200
OPITZ, FRANZ KARL

I/ 250
OPPENHEIM, DENNIS A. (B. 1938) AMERICAN
P/ 50
OPPENHEIM, LOUIS (19TH C) GERMAN
P/ 250-1700
OPPENHEIM, MERET (B. 1913) SWISS
P/ 100-4000
OPPENHEIMER, MAX (called MOPP) (1885-1954) GERMAN
I/ 25-850 P/ 150-2200 R/ 475
OPPLER, ERNST (B. 1869) GERMAN
I/ 25-650 P/ 200-300
ORAZI, MANUEL (19TH/20TH C) FRENCH
P/ 50-28000
ORGAN, BRYAN (B. 1935) BRITISH
P/ 100-500
ORLEY, RICHARD VAN (?) ?
I/ 88-700
ORLIK, EMIL (1879-1932) CZECHOSLOVAKIAN
I/ 90-1300 P/ 25-1100 R/ 100-5000
OROZCO, JOSE CLEMENTE (1883-1949) MEXICAN
I/ 30-1100 P/ 40-7500
ORSI, (?) ?
P/ 500-11000
ORTEGA, JOSE (B. 1940) SPANISH
I/ 75-600
OSIECKI, STEFAN
P/ 450
OSSENBEECK, JAN VAN (1624-1674) DUTCH
I/ 250-1400
OSTADE, ADRIAEN VAN (1610-1679) DUTCH
I/ 25-34600 R/ 40
OSTADE, ISAAC VAN (1621-1649) DUTCH
I/ 725
OSTENDORFER, MARTIN (16TH C) GERMAN
R/ 100-2300
OSTERLIND, ANDERS (1887-1960) FRENCH
I/ 175-400
OSTROWSKY, ABBO (B. 1889) AMERICAN
I/ 70-100
OTTO, HEINRICH
I/ 100-475
OUDRY, JEAN BAPTISTE (1686-1755) FRENCH
I/ 300-1900
OURY, LEON LOUIS (B. 1846) FRENCH

P/ 230-1000
OUTGERSZ, WILLEM
 I/ 425-1200
OVERBECK, FRITZ (1869-1909) GERMAN
 I/ 200-800
OWEN, FREDERICK L. (1869-1959) CANADIAN
 I/ 15-60

P

PAESCHKE, PAUL (B. 1875) GERMAN
 I/ 75-800 P/ 400-1700
PAL (20TH C)
 P/ 75-2400
PALADINO, MIMMO (B. 1948) ITALIAN
 I/ 30-12100 P/ 300-2500 R/ 550-3700
PALAZUELO, PABLO (B. 1916) SPANISH
 I/ 200-300
PALERMO, BLINKY (?) ?
 P/ 350-5300
PALING, RICHARD (B. 1901) GERMAN
 I/ 350
PALM, JOACHIM (?) ?
 I/ 50-125
PALMA, JACOPO (called IL GIOVANE) (1544-1628) ITALIAN
 I/ 50-1800
PALMER, SAMUEL (1805-1881) BRITISH
 I/ 100-11900
PANAMARENKO (B. 1940) BELGIAN
 P/ 275-2000
PANDEREN, EGBERT (1581-1637) DUTCH
 I/ 300
PANKOK, BERNHARD (B. 1872) GERMAN
 P/ 150-425
PANKOK, OTTO (20TH C) ?
 I/ 200-2900 P/ 100-2200 R/ 250-3000
PAOLOZZI, EDUARDO (B. 1924) BRITISH
 I/ 272 P/ 25-575
PAPART, MAX (B. 1911) FRENCH
 I/ 400-800 P/ 100-475

PAPPRILL, HENRY (19TH C) AMERICAN
I/ 3300-9900
PARMIGIANINO, FRANCESCO MAZZOLA (1503-1540) ITALIAN
I/ 200-12000 R/ 6019
PARRISH, CLARA WAEVER (D. 1925) AMERICAN
I/ 40-75
PARRISH, STEPHEN WINDSOR (1846-1938) AMERICAN
I/ 75-500
PARROCEL, CHARLES (1688-1752) FRENCH
I/ 30-1500
PARTRIDGE, ROI (B. 1888) AMERICAN
I/ 100-1500
PARZINGER, HANS
P/ 2400
PASCHKE, ED (B. 1938) AMERICAN
P/ 100-1760
PASCIN, JULES (1885-1930) AMERICAN
I/ 130-2200 P/ 25-900
PASMORE, VICTOR (B. 1908) BRITISH
I/ 175-3300 P/ 100-800
PASSAROTTI, BARTOLOMEO (1529-1592) ITALIAN
I/ 250-5000
PASSE, CRISPIJN VAN DE II (16TH/17TH C) DUTCH
I/ 50-750
PASSE, MAGDALENA DE (1600-1638) DUTCH
I/ 440-850
PASSERI, BERNARDINO (16TH C) ?
I/ 3000
PATEK, AUGUST
P/ 1600
PATER, JEAN BAPTISTE (1695-1736) FRENCH
I/ 275
PATTERSON, MARGARET JORDAN (1867-1950) AMERICAN
R/ 100-2000
PAUL, HERMANN RENE GEORGE (1864-1940) FRENCH
P/ 700-4400
PAUL, PETER (1865-1937) BRITISH
P/ 50-300
PAULI, FRITZ EDUARD (1891-1968) SWISS
I/ 100-900 P/ 319
PAULL, GRACE A. (B. 1898) AMERICAN
P/ 25-100
PAULOZZI, EDUARDO (20TH C) AMERICAN
P/ 80-175

PAULSEN, INGWER (B. 1883) GERMAN
I/ 100-400
PAUNZEN, ARTHUR (B. 1890) AUSTRIAN
I/ 20-80
PAVIL, ELIE ANATOLE (1873-1948) FRENCH
P/ 200-1200
PEALE, CHARLES WILSON (1741-1827) AMERICAN
I/ 8800
PEAN, RENE (20TH C) FRENCH
P/ 200-900
PEARLSTEIN, PHILIP (B. 1924) AMERICAN
I/ 150-9900 P/ 150-5300
PEARS, CHARLES (1873-1958) BRITISH
P/ 500-1800
PEARSON, JOHN (20TH C) AMERICAN
P/ 25-75
PEARSON, RALPH M. (1883-1958) AMERICAN
I/ 25-100
PECHE, DAGOBERT (1887-1923) AUSTRIAN
P/ 200-2000
PECHSTEIN, MAX HERMANN M. (1881-1955) GERMAN
I/ 250-14300 P/ 100-28000 R/ 160-83000
PECK, HENRY J. (1880-1964) AMERICAN
I/ 40-125
PEET, ORVILLE HOUGHTEEN (1884-1968) AMERICAN
I/ 40-100
PEETS, ORVILLE H. (B. 1884-1968) AMERICAN
I/ 25-100
PEIFFER-WATENPHUL, MAX (B. 1896) GERMAN
I/ 30-400 P/ 100-1800
PENCK, A. R. (B. 1939) GERMAN
I/ 25-4600 P/ 60-6200 R/ 800-1200
PENCZ, GEORG (1500-1550) GERMAN
I/ 75-6000
PENFIELD, EDWARD (1866-1925) AMERICAN
P/ 100-7700
PENNELL, JOSEPH (1857-1926) AMERICAN
I/ 25-1300 P/ 50-700
PEPPER, BEVERLY (B. 1924) AMERICAN
P/ 3500
PEPPER, CHARLES HOVEY (1864-1950) AMERICAN
R/ 175-250
PERISSIM, J.J. (?) ?
I/ 950

Technique Key

Under each <u>printing technique</u> you may encounter the following types of prints (or combination of processes):

I <u>Intaglio:</u>

- etching
- drypoint
- steel engraving
- stipple engraving
- aquatint
- mezzotint
- soft-ground etching
- crayon manner

P <u>Planographic:</u>

- lithograph
- monotype
- silk-screen
- cliche verre
- serigraph

R <u>Relief:</u>

- wood block
 - woodcut
 - chiaroscuro
 - wood engraving
- linoleum cut (linocut)

PESCHERET, LEON R. (1892-1961) AMERICAN
 I/ 40-75
PESKE, JEAN (1880-1949) FRENCH
 P/ 5000-7700
PETERDI, GABOR (B. 1915) HUNGARIAN
 I/ 50-400
PETTIJEAN, EDMOND MARIE (1844-1925) FRENCH
 P/ 150-900
PFAFF, HANS (B. 1875) GERMAN
 P/ 800-1900
PHILBRICK, MARGARET E. (B. 1914) AMERICAN
 I/ 25-100
PHILBRICK, OTIS (1888-1973) AMERICAN
 P/ 25-100
PHILIPPI, ROBERT (?) ?
 R/ 25-400
PHILLIPS, MATT (B. 1927) AMERICAN
 P/ 150-600
PHILLIPS, PETER (B. 1939) BRITISH
 P/ 60-400
PHILLIPS, WALTER JOSEPH (1884-1963) CANADIAN
 R/ 300-2400
PIAUBERT, JEAN (B. 1900) FRENCH
 P/ 220-550
PIAZZETTA, GIAMBATTISTA (1682-1754) ITALIAN
 I/ 200-300
PICASSO, PABLO (1881-1973) SPANISH
 I/ 190-1750100 P/ 25-248000 R/ 35-457600
PICCIONI, MATTEO (1615-1671) ITALIAN
 I/ 450
PICKING, H.
 P/ 1700
PIEKERT, MARTIN
 P/ 700
PIENE, OTTO (B. 1928) GERMAN
 P/ 100-540 R/ 500
PIERCE, LEONA (B. 1922) AMERICAN
 R/ 25-100
PIGNON, EDOUARD (B. 1905) FRENCH
 I/ 250-300 P/ 150-400
PIPER, JOHN (B. 1903) BRITISH
 I/ 50-1700 P/ 40-1000
PIRANESI, FRANCESCO (1758-1810) ITALIAN
 I/ 90-800

PIRANESI, GIOVANNI-BATTISTA (1720-1778) ITALIAN
I/ 200-56300
PIRSON, ELMER W. (B. 1888) AMERICAN
P/ 1200
PISSARRO, CAMILLE (1830-1903) FRENCH
I/ 40-72000 P/ 500-89500
PISSARRO, GEORGE HENRI (1871-1961) FRENCH
I/ 400 P/ 300-525
PISSARRO, LUCIEN (1863-1944) FRENCH
P/ 300-1000 R/ 100-1200
PISSARRO, OROVIDA (B. 1893) FRENCH
I/ 100-400 R/ 531
PISTOLETTO, MICHELANGELO (B. 1933) ITALIAN
P/ 475-8000
PITZ, HENRY C. (1895-1976) AMERICAN
P/ 25-100
PIZ, GEORG EMANUEL (?) ?
I/ 1000
PIZA, ARTHUR LUIZ (B. 1928) BRAZILIAN
I/ 100-800
PLANSON, ANDRE (1898-1981) FRENCH
P/ 25-240
PLASSARD, VINCENT (17TH C) FRENCH
I/ 300
PLATSCHEK, HANS (B. 1923) GERMAN
P/ 50-400
PLATTENBERG, MATHIAS VAN (1608-1660) ?
I/ 300-900
PLOOS VAN AMSTEL, C. (1726-1798) DUTCH
I/ 200-2600
PLOWMAN, GEORGE TAYLOR (1869-1932) AMERICAN
I/ 30-150
PLUNNECKE, WILHELM (B. 1894) GERMAN
P/ 25-150
PODESTA, GIOVANNI (1620-1674) ITALIAN
I/ 375-3100
POLANZINI, R. (?) ?
I/ 500
POLIAKOFF, SERGE (1906-1969) FRENCH
I/ 200-11000 P/ 100-14300
POLKE, SIGMAR (B. 1941) GERMAN
P/ 250-5100
POLLAK, MAX (B. 1886) AUSTRIAN
I/ 100-1200

POLLARD, JAMES (1797-1859) BRITISH
 I/ 125-2000
POLLARD, ROBERT (1755-1838) BRITISH
 I/ 500
POLLEY, FREDERICK (1875-1958) AMERICAN
 I/ 30-90
POLLOCK, JACKSON (1912-1956) AMERICAN
 I/ 7700-8800 P/ 800-23100
POLO, LUISA (?) ?
 P/ 550
POLSTER, DORA (B. 1884) GERMAN
 P/ 700
POMODORO, ARNOLDO (B. 1926) ITALIAN
 P/ 125-500
PONT, CHARLES E. (B. 1898) AMERICAN
 R/ 25-100
PONTIUS, PAULUS (1603-1658) FLEMISH
 I/ 200-950
PONTY, MAX (?) ?
 P/ 200-990
POONS, LARRY (B. 1937) AMERICAN
 P/ 220-400
PORTER, FAIRFIELD (1907-1975) AMERICAN
 P/ 55-1400
POTTHOF, HANS (?) ?
 P/ 150-850
POUGNY, JEAN (1894-1956) FRENCH
 P/ 60-3600
POUSSIN, ETIENNE DE (?) ?
 I/ 50
POWER, CYRIL (1875-1951) BRITISH
 P/ 430-2100 R/ 100-12600
POZZATTI, RUDY (B. 1925) AMERICAN
 I/ 75-200
PRAMPOLINI, ENRICO (1894-1956) ITALIAN
 P/ 550-1600
PREETORIUS, EMIL (B. 1883) GERMAN
 P/ 400-2600
PREISS, FRITZ (B. 1883) GERMAN
 P/ 300-350
PREM, HEIMRAD (B. 1934) GERMAN
 P/ 225
PRENDERGAST, MAURICE BRAZIL (1859-1924) AMERICAN
 P/ 55000-182000 (monotypes only)

PRICE, KEN (B. 1935) AMERICAN
P/ 150-1500
PRICE, NICK (?) ?
P/ 850-5900
PRIEST, HARTWELL W. (B. 1901) AMERICAN
I/ 25-100
PRIOR, CHARLES M. (B. 1865) AMERICAN
I/ 25-100
PRIOR, MARNA A. (20TH C) AMERICAN
P/ 10-50
PROCACCINI, CAMILLO (1550-1629) ITALIAN
I/ 200-23000
PROCKTOR, PATRICK (20TH C) BRITISH
I/ 50-550 P/ 70-775
PRUD'HON, PIERRE PAUL (1758-1823) FRENCH
P/ 400-2400
PRUNIERE, J. (1901-1944) FRENCH
P/ 100-300
PUCHINGER, ERWIN (B. 1876) AUSTRIAN
P/ 3000
PUGH, SARAH M. (B. 1891) AMERICAN
P/ 25-100 R/ 25-100
PULLINGER, HERBERT (B. 1878) AMERICAN
I/ 50-125
PURRMANN, HANS (1880-1966) GERMAN
I/ 100-1800 P/ 80-1000 R/ 517
PURVIS, TOM
P/ 800-4000
PYROTH, CHRISTA
I/ 100-500 P/ 175

Q

QUAGLIO, DOMENICO (1786-1837) GERMAN
P/ 90-350
QUAST, PIETER JANSZ (1605-1647) DUTCH
I/ 140-600
QUINTE, LOTHAR (B. 1923) GERMAN
P/ 100-950

R

RABINOVICH, GREGOR (B. 1884) RUSSIAN
I/ 30-300 P/ 25
RABOY, MAC (B. 1914) AMERICAN
R/ 25-100
RAEMAEKERS, LOUIS (1869-1956) DUTCH
P/ 1000-2000
RAETZ, MARKUS (B. 1941) SWISS
I/ 300-500
RAFFAEL, JOSEPH (B. 1933) AMERICAN
P/ 300-3850 R/ 550
RAFFAELLI, JEAN FRANCOIS (1850-1924) FRENCH
I/ 100-2600 P/ 175-300
RAIMONDI, MARCANTONIO (1480-1534) ITALIAN
I/ 50-33000
RAINER, ARNULF (B. 1929) AUSTRIAN
I/ 100-4200 P/ 50-6000
RAMOS, MEL (B. 1935) AMERICAN
P/ 75-2670
RAMSDELL, FRED WINTHROP (1865-1915) AMERICAN
P/ 700-2300
RAMUS, CHARLES F. (B. 1902) AMERICAN
P/ 40-90
RANFT, RICHARD (1862-1931) SWISS
I/ 300-1100
RANSON, PAUL (1864-1909) FRENCH
P/ 275-600
RASMUSSEN, AAGE
P/ 880-1200
RASSENFOSSE, ARMAND (1862-1934) BELGIAN
P/ 50-5300
RATTNER, ABRAHAM (1895-1978) AMERICAN
P/ 60-100
RAUSCHENBERG, ROBERT (B. 1925) AMERICAN
I/ 500-2900 P/ 100-176000
RAVENNA, MARCO DA (DENTE) (D. 1527) ITALIAN
I/ 1000-5200
RAVENSCROFT, ELLEN (1876-1949) AMERICAN
R/ 1300-1900
RAY, MAN (see MAN RAY) AMERICAN
READ, DAVID CHARLES (1790-1851) BRITISH
I/ 15-100

REBEYROLLE, PAUL (B. 1926) FRENCH
P/ 180-200
RECKZIEGEL, ANTON (B. 1865) AUSTRIAN
P/ 275
REDDY, KRISHNA (B. 1925) AMERICAN
I/ 200
REDON, GEORGES (1869-1943) FRENCH
I/ 200 P/ 400-1000
REDON, ODILON (1840-1916) FRENCH
I/ 260-13200 P/ 40-80000
REED, EARL H. (1863-1931) AMERICAN
I/ 25-100
REED, ETHEL (B. 1876) AMERICAN
P/ 300-1700
REEVES, RUTH (B. 1892) AMERICAN
I/ 25
REIBER, RICHARD H. (B. 1912) AMERICAN
I/ 50-125
REICHERT, JOSUA
R/ 225-275
REID, JAMES (B. 1907) AMERICAN
P/ 25-100
REIMER, LUDWIG C.
I/ 600
REINBOLD, ANTON (B. 1881) GERMAN
P/ 1200
REINDEL, WILLIAM G. (1871-1948) AMERICAN
I/ 40-75
REINHARDT, AD (1913-1967) AMERICAN
P/ 100-935
REINHART, JOHANN CHRISTIAN (1761-1847) GERMAN
I/ 100-1400
REMBRANDT, (REMBRANDT HARMENSZ VAN RIJN) (1606-1669) DUTCH
I/ 50-999000
RENAULT, ABEL PIERRE (B. 1903) FRENCH
P/ 225
RENESSE, CONSTANTIJN DANIEL VON (1626-1680) DUTCH
I/ 250-4000
RENI, GUIDO (1575-1642) ITALIAN
I/ 150-3500
RENOIR, PIERRE AUGUSTE (1841-1919) FRENCH
I/ 35-19500 P/ 30-193600
RENOUF, EDDA (B. 1943) MEXICAN/AMERICAN
I/ 100-150

Technique Key

Under each <u>printing technique</u> you may encounter the following types of prints (or combination of processes):

I <u>Intaglio:</u>
- etching
- drypoint
- steel engraving
- stipple engraving
- aquatint
- mezzotint
- soft-ground etching
- crayon manner

P <u>Planographic:</u>
- lithograph
- monotype
- silk-screen
- cliche verre
- serigraph

R <u>Relief:</u>
- wood block
 - woodcut
 - chiaroscuro
 - wood engraving
- linoleum cut (linocut)

RETHEL, ALFRED (1816-1859) GERMAN
R/ 125-2700
REVERDY, GEORGES (16TH C) FRENCH
I/ 3300
REVERE, PAUL (1735-1818) AMERICAN
I/ 8500-110000
REYNARD, GRANT (1887-1968) AMERICAN
I/ 60-150
RHEAD, LOUIS JOHN (1857-1926) AMERICAN
P/ 150-4200
RIBERA, JIUSEPE DE (called LO SPAGNOLETTO) (1591-1652) SPANISH
I/ 200-14000
RIBET, JEAN CONSTANTIN (D. 1858) FRENCH
P/ 800-1980
RICCI, MARCO (1676-1729) ITALIAN
I/ 150-6800
RICHARD, J.C. (B. 1832) SWISS
P/ 300
RICHARDS, CERI (1903-1971) BRITISH
P/ 150-400
RICHARDS, FREDERICK DE BOURG (1822-1903) AMERICAN
I/ 25-100
RICHARDS, WALTER DUBOIS (B. 1907) AMERICAN
R/ 50-125
RICHERT, CHARLES H. (B. 1880) AMERICAN
R/ 15-50
RICHIER, GERMAINE (1904-1959) FRENCH
I/ 25-845
RICHTER, ADRIAN LUDWIG (1803-1884) GERMAN
I/ 80-500
RICHTER, ALADAR (B. 1898) HUNGARIAN
P/ 1700-2000
RICHTER, GERHARD (B. 1932) GERMAN
I/ 1630 P/ 100-11640
RICHTER, HANS (1888-1976) AMERICAN
I/ 115-600 P/ 150-620
RICHTER, LUDWIG (1803-1884) GERMAN
I/ 250-850
RICHTER, LUITPOLD (?) ?
I/ 50
RICK, NUMA
P/ 900
RIDINGER, JOHANN E. (1698-1767) GERMAN
I/ 75-1400

RIFKA, JUDY
 P/ 450
RIGGS, ROBERT (1896-1970) AMERICAN
 P/ 220-6600
RILEY, BRIDGET (B. 1931) BRITISH
 P/ 50-480
RIPLEY, AIDEN LASSELL (1896-1969) AMERICAN
 I/ 100-600
RIQUER, ALEXANDRE (B. 1856) SPANISH
 P/ 650-2000
RIVERA, DIEGO (1886-1957) MEXICAN
 P/ 300-8250 R/ 550
RIVERS, LARRY (B. 1923) AMERICAN
 I/ 6050 P/ 100-17600 R/ 300-6050
RIVIERE, HENRI (1864-1951) FRENCH
 I/ 200-1200 P/ 50-1980 R/ 300-7900
ROBBE, MANUEL (1872-1936) FRENCH
 I/ 50-2900 P/ 400-1700
ROBBINS, FREDERICK (B. 1893) AMERICAN
 I/ 100-150
ROBBINS, FREDERICK GOODRICH (B. 1893) AMERICAN
 I/ 25-100
ROBERTS, DAVID (1796-1864) SCOTTISH
 P/ 100-600
ROBERTS, WILLIAM (B. 1895) BRITISH
 I/ 900
ROBETTA, CRISTOFORO DI MICHELE (1462-1522) ITALIAN
 I/ 400-39800
ROCHE, JOEL (?) ?
 I/ 25
ROCHE, M. PAUL (B. 1885) AMERICAN
 I/ 25-100
ROCHE, PIERRE (1855-1922) FRENCH
 P/ 600-800
ROCHEGROSSE, GEORGES ANTOINE (1859-1938) FRENCH
 P/ 140-1200
ROCHER, EDMOND A. (B. 1873) FRENCH
 P/ 350-600
ROCKBURNE, DOROTHEA (20TH C) AMERICAN
 I/ 825-1800
RODCHENKO, ALEXANDER (1891-1956) RUSSIAN
 P/ 500-3200 R/ 400-1100
RODEL, KARL (1841-1909) DUTCH
 P/ 200-300

RODERMONDT, PIETER (?) ?
 I/ 150-400
RODIN, AUGUSTE (1840-1917) FRENCH
 I/ 150-10000 P/ 225-1200
ROEDEL, ? (1859-1900) FRENCH
 P/ 200-2500
ROEDER, EMY (1890-1917) GERMAN
 P/ 100-945
ROGANEAU, FRANCOIS (1883-1974) FRENCH
 P/ 1200
ROGHMAN, ROELANT (1597-1686) DUTCH
 I/ 200-1700
ROHL, PETER (B. 1890) GERMAN
 R/ 300-1500
ROHLAND, CAROLINE S. (B. 1885) AMERICAN
 P/ 25-100
ROHLFS, CHRISTIAN (1849-1938) GERMAN
 P/ 400-2300 R/ 175-12100
ROHRICHT, WOLF (B. 1886) GERMAN
 P/ 175-200
ROHSE, OTTO (B. 1925) GERMAN
 I/ 250-300
ROLGAKSKI, WALTER (B. 1923) AMERICAN
 I/ 50-150
ROLLINSON, WILLIAM (1762-1842) BRITISH
 I/ 700
ROMANO, CLARE (B. 1922) AMERICAN
 P/ 75-200
ROMANO, UMBERTO (B. 1905) AMERICAN
 I/ 40-100 P/ 50-200
ROOS, JOHANN HEINRICH (1631-1685) GERMAN
 I/ 250-750
ROOS, JOSEPH (1726-1805) GERMAN
 I/ 50-600
ROOT, JOAN (20TH C) AMERICAN
 P/ 20-75
ROPS, FELICIEN JOSEPH VICTOR (1833-1898) BELGIAN
 I/ 30-3700 P/ 75-800
ROSA, SALVATOR (1615-1673) ITALIAN
 I/ 100-7600
ROSENBERG, HENRY MORTIKAR (1858-1947) AMERICAN
 P/ 225-400
ROSENBERG, LOUIS CONRAD (1890-1983) AMERICAN
 I/ 75-150

ROSENQUIST, JAMES (B. 1933) AMERICAN
I/ 520-6300 P/ 100-46750
ROSS, CHARLES (B. 1937) AMERICAN
P/ 500
ROSS, PIERRE S. (B. 1907) AMERICAN
P/ 25-100
ROSSI, GIROLAMO DE (active 1632-1664) ITALIAN
I/ 300
ROSSING, KARL (B. 1897) AUSTRIAN
I/ 250 R/ 150-1000
ROSSINI, LUIGI (1790-1857) ITALIAN
I/ 100-700
ROT, DIETER (B. 1930) GERMAN
I/ 80-800 P/ 50-5000
ROTA, MARTINO (1520-1583) ITALIAN
I/ 300-2100
ROTARI, PIETRO ANTONIO (1707-1762) ITALIAN
I/ 400-655
ROTH, ERNEST DAVID (1879-1964) AMERICAN
I/ 30-475
ROTHENBERG, SUSAN (B. 1945) AMERICAN
I/ 1900-7700 P/ 550-46200 R/ 1300-10000
ROTHENSTEIN, SIR WILLIAM (1872-1945) BRITISH
P/ 100-400
ROUAULT, GEORGES (1871-1958) FRENCH
I/ 75-58000 P/ 200-35000
ROUBILLE, AUGUSTE (1872-1955) FRENCH
P/ 500-4400
ROUGEMONT, (B. 1935) FRENCH
1900-2900
ROUHIER, LOUIS (17TH C) FRENCH
I/ 200-950
ROUSSEAU, HENRI (1844-1910) FRENCH
P/ 2200-4200
ROUSSEAU, ETIENNE PIERRE THEODORE (1812-1867) FRENCH
I/ 25-2100
ROUSSEL, KER XAVIER (1867-1944) FRENCH
I/ 800-1200 P/ 100-9350
ROUSSEL, THEODORE (1847-1926) BRITISH
I/ 100-6000
ROUSSELET, GILLES (1610-1686) FRENCH
I/ 1000
ROWLANDSON, THOMAS (1756-1827) BRITISH
I/ 25-4050

ROZANOVA, OLGA W.
P/ 550-1700 R/ 1200-4000
RUBENS, SIR PETER PAUL (1577-1640) FLEMISH
I/ 2800-4400
RUBIN, REUVEN (1893-1974) ISRAELI
P/ 200-800
RUDOLPH, ALFRED (1881-1942) AMERICAN
I/ 50-125
RUGENDAS, GEORGE PHILIPP (1666-1742) GERMAN
I/ 25-800
RUIJSCHER, JOHANNES (1625-1675) GERMAN
I/ 100-1600
RUISDAEL, JACOB VAN (1628-1682) DUTCH
I/ 250-264000
RUNGE, PHILIPP OTTO (1777-1810) GERMAN
I/ 2500-6500
RUNGIUS, CARL (1869-1959) AMERICAN
I/ 100-1900
RUPERT, PRINCE (1619-1682) GERMAN
I/ 6000-91000
RUSCHA, EDWARD (B. 1937) AMERICAN
I/ 990-63250 P/ 75-63250
RUZICKA, RUDOLPH (B. 1883) AMERICAN
R/ 60-500
RYAN, ANNE (1889-1954) AMERICAN
I/ 600 R/ 175-400
RYDER, CHAUNCY FOSTER (1868-1949) AMERICAN
I/ 50-200
RYERSON, MARGERY AUSTEN (B. 1886) AMERICAN
I/ 100-350
RYMAN, ROBERT (B. 1930) AMERICAN
I/ 625-7425
RYSSEL, PAUL VAN (?) ?
I/ 150-2500
RYSSELBERGHE, THEO VAN (1862-1926) BELGIAN
I/ 100-5100 P/ 100-3800

S

SABATINI, LORENZO (?) ITALIAN
 I/ 5700
SABATIER, LEON (1891-1965) FRENCH
 P/ 400
SACCHI, CARLO (1616-1706) ITALIAN
 I/ 1000-5700
SADELER, AEGIDIUS (1570-1629)
 I/ 100-2100
SADELER, JOHANNES (D. 1665) FLEMISH
 I/ 50-2400
SADKOWSKI, ALEX (19TH/20TH C) AUSTRIAN
 I/ 75-350 P/ 50
SAENREDAM, JOAN (JAN) (1565-1607) DUTCH
 I/ 25-4600
SAENREDAM, PIETER (1597-1665) DUTCH
 I/ 150-800
SAFTLEVEN, HERMAN (II) (1609-1685) DUTCH
 I/ 90-1000
SAINT AUBIN, GABRIEL DE (1724-1780) FRENCH
 I/ 250-14000
SAINT PHALLE, NIKI DE (B. 1930) FRENCH
 P/ 150-1900
SAINT-NON, ABBE DE (?) ?
 I/ 100-1000
SAITO, YOSHISHIGE (B. 1904) JAPANESE
 R/ 60-770
SALA, PAOLO (1859-1924) ITALIAN
 P/ 350
SALIGER, IVO (B. 1894) AUSTRIAN
 I/ 75-1200
SALIMBENI, VENTURA (1568-1613) ITALIAN
 I/ 150-1300
SALLAERT, ANTHONIS (1590-1657) FLEMISH
 R/ 850
SALLE, DAVID (B. 1952) AMERICAN
 I/ 1000-3300 P/ 600-5000 R/ 850-3575
SALTONSTALL, ELIZABETH (1900-1990) AMERICAN
 P/ 50-125
SANTIS, ORAZIO DE (B. 1568) ITALIAN
 I/ 425-1600
SANTOMASO, GIUSEPPE (B. 1907) ITALIAN
 I/ 30-1200 P/ 50-1100
SASSONE, MARCO (20TH C) ITALIAN
 P/ 75-500

Technique Key

Under each <u>printing technique</u> you may encounter the following types of prints (or combination of processes):

I Intaglio:

- etching
- drypoint
- steel engraving
- stipple engraving
- aquatint
- mezzotint
- soft-ground etching
- crayon manner

P Planographic:

- lithograph
- monotype
- silk-screen
- cliche verre
- serigraph

R Relief:

- wood block
 - woodcut
 - chiaroscuro
 - wood engraving
- linoleum cut (linocut)

SAURA, ANTONIO (B. 1930) SPANISH
P/ 200-500
SAUVAGE, SYLVAIN (1888-1948) FRENCH
I/ 175
SAVER, LEROY D. (B. 1894) AMERICAN
R/ 25-100
SAVERIJ, JACOB I (17TH C) ?
I/ 450-6000
SAVIGNAC, RAYMOND (B. 1908) FRENCH
P/ 200-1500
SCANGA, ITALO
P/ 200-1300
SCARSELLO, GIROLAMO (17TH C) ITALIAN
I/ 100-650
SCHAD, CHRISTIAN (B. 1894) GERMAN
I/ 100-600 R/ 50-4800 P/ 150-2000
SCHAEFLER, FRITZ (B. 1888) GERMAN
I/ 200-800 R/ 25-600
SCHANKER, LOUIS (1903-1981) AMERICAN
P/ 200-800 R/ 450-3850
SCHARF, KENNY (?) ?
P/ 550
SCHARF, RALPH HAMMER (20TH C) AMERICAN
I/ 15-75
SCHARFF, EDWIN (1887-1955) GERMAN
I/ 150-400 P/ 225-450
SCHARL, JOSEF (1896-1954) GERMAN/AMERICAN
I/ 200-850 P/ 2000 R/ 200-828
SCHAUFFELEIN, HANS LEONARD (1480-1540) GERMAN
R/ 175-2000
SCHENAU, JOHANN ELEAZAR (1737-1806) GERMAN
I/ 550
SCHENK, PIETER (18TH C) DUTCH
I/ 200-750
SCHEURICH, PAUL (B. 1883) AMERICAN
I/ 250 P/ 150-1700
SCHEYNDEL, GILLIS VON (17TH C) DUTCH
I/ 150-1400
SCHIAMINOSSI, RAFFAELLO (1529-1622) ITALIAN
I/ 200-1700
SCHIAVONE, ANDREA MELDOLLA (16TH C) ITALIAN
I/ 400-6200
SCHIELE, EGON (1890-1918) AUSTRIAN
I/ 600-31800 P/ 350-25225

SCHIESTL, MATTHAUS (B. 1869) AUSTRIAN
 P/ 125-450
SCHIESTL, RUDOLF (1878-1931) GERMAN
 I/ 125-675 P/ 400-860 R/ 150-800
SCHILBACH, JOHANN (D. 1760) GERMAN
 I/ 275
SCHINDELER, A.
 P/ 2200-4900
SCHLEMMER, OSKAR (1888-1943) GERMAN
 I/ 2793 P/ 1100-13000
SCHLICHTER, RUDOLF (1890-1955) GERMAN
 I/ 175-800 P/ 229-1500
SCHLIPPENBACH, PAUL (1869-1933) GERMAN
 I/ 50
SCHLOTTER, EBERHARD (B. 1921) GERMAN
 I/ 38-650 P/ 75
SCHMIDT, GEORG F. (1712-1775) GERMAN
 I/ 50-550
SCHMIDT, MARTIN (1718-1801) GERMAN
 I/ 300-1600
SCHMIDT-ROTTLUFF, KARL (1884-1976) GERMAN
 I/ 450-20250 P/ 100-52400 R/ 100-26300
SCHMIED, FRANCOIS LOUIS (1873-1941) SWISS
 P/ 75-1000
SCHMOLL, KARL V.E. (B. 1879) AUSTRIAN
 P/ 450 R/ 150-350
SCHMURR, WILHELM (B. 1878) GERMAN
 P/ 350
SCHMUTZER, FERDINAND (1870-1928) AUSTRIAN
 I/ 75-600 P/ 300
SCHMUTZER, JAKOB (JACOB) (1733-1811) AUSTRIAN
 I/ 1000-1200
SCHNABEL, JULIAN (B. 1951) AMERICAN
 I/ 500-34100
SCHNARRENBERGER, WILHELM (B. 1892) GERMAN
 P/ 250-2300 R/ 200-300
SCHNEIDER, OTTO (1875-1946) AMERICAN
 I/ 50-125
SCHNYDER, ALBERT (B. 1898) GERMAN
 P/ 200-1300
SCHOLDER, FRITZ (B. 1937) AMERICAN
 P/ 300-1000
SCHOLZ, GEORG (?) ?
 P/ 1100-2300

SCHON, ERHARD (16TH C) GERMAN
R/ 200-3300
SCHONGAUER, MARTIN (1445-1491) GERMAN
I/ 210-258500
SCHRAG, KARL (B. 1912) AMERICAN
P/ 75-475
SCHREIBER, GEORGE (B. 1904) AMERICAN
P/ 30-335
SCHREYER, LOTHAR (1886-1966) GERMAN
P/ 750-4000 R/ 800-1500
SCHRIMPF, GEORG (1889-1938) GERMAN
P/ 25-2600 R/ 125-2000
SCHRODER, SONNENSTERA (B. 1892) GERMAN
P/ 100-750
SCHRODTER, ADOLF (1805-1875) GERMAN
I/ 250-300
SCHUBERT, OTTO (B. 1892) GERMAN
I/ 25-175
SCHULTZ-WETTEL, F. (B. 1872) FRENCH
P/ 1000
SCHULTZE, BERNARD (B. 1915) GERMAN
I/ 50-1300 P/ 50-150
SCHUMACHER, EMIL (B. 1912) GERMAN
I/ 60-6100 P/ 227-890 R/ 560-1250
SCHUT, CORNELIS (1597-1655) FLEMISH
I/ 100-500
SCHUT, PIETER H. (1619-1660) DUTCH
I/ 175
SCHUTZ, ANTON (1894-1977) AMERICAN
I/ 75-440
SCHUZ, CHRISTIAN G. (?) ?
I/ 600
SCHWESIG, KARL (B. 1898) GERMAN
I/ 250 R/ 50
SCHWIMBECK, FRITZ (B. 1889) GERMAN
I/ 50-75
SCHWITTERS, KURT (1887-1948) GERMAN
P/ 350-14000 R/ 150-300
SCLOPIS, IGNAZIO (18TH C) ?
I/ 350-2500
SCOTIN, GERARD JEAN BAPTISTE (B. 1698) FRENCH
I/ 200-500
SCOTT, WILLIAM (B. 1913) BRITISH
P/ 150-1600

SCULLY, SEAN (B. 1946) BRITISH
 I/ 5500-10450 R/ 1400-18000
SCULTORI, DIANA (1530-1585) ITALIAN
 I/ 75-2600
SCULTORI, GIOVANNI-BATTISTA (1503-1575) ITALIAN
 I/ 200-3200
SEARLE, RONALD (B. 1920) BRITISH
 P/ 125-350
SEBILLE, ALBERT (19TH C) FRENCH
 P/ 335-1000
SECUNDA, ARTHUR (B. 1927) AMERICAN
 P/ 400
SEEWALD, RICHARD (1889-1976) GERMAN
 I/ 100-450 P/ 50-800 R/ 100-1200
SEGAL, GEORGE (B. 1924) AMERICAN
 P/ 275-3900
SEGALL, LASAR
 I/ 500-800 P/ 200-850 R/ 300-950
SEGANTINI, GOTTARDO (B. 1882) ITALIAN
 I/ 100-200
SEGUIN, ARMAND (1869-1903) FRENCH
 I/ 200-8000
SEITZ, GUSTAV (B. 1908) GERMAN
 P/ 125-275
SEIWERT, FRANZ W. (1894-1933) GERMAN
 R/ 200-2600
SELIGMANN, KURT (1900-1962) SWISS/AMERICAN
 I/ 250-1600 P/ 200-2200
SEM, GOURSAT (1863-1934) FRENCH
 P/ 150-1300
SEMOLEI, G.B.F. (?) ?
 I/ 1200-5000
SEPO, SEVERO POZZATI (B. 1895) ITALIAN
 P/ 300-1000
SEROV, VALENTIN (1865-1911) RUSSIAN
 P/ 7000
SERRA, RICHARD (B. 1938) AMERICAN
 P/ 800-22000
SERVEAU, CLEMENT (1886-1972) FRENCH
 R/ 200
SERWOUTERS, PIETER (1586-1657) FLEMISH
 I/ 500-750
SEUPHOR, MICHEL (B. 1901) FRENCH
 P/ 300

SEVERINI, GINO (1883-1966) ITALIAN
 I/ 800 P/ 200-4000 R/ 1300-4800
SEYMOUR, RALPH F. (B. 1876) AMERICAN
 I/ 25-100
SHAHN, BEN (1898-1969) AMERICAN
 P/ 60-8800
SHANNON, CHARLES HAZELWOOD (1863-1937) BRITISH
 P/ 100-150
SHAPIRO, JOEL (B. 1941) AMERICAN
 P/ 250-1100
SHAPIRO, SHMUEL (20TH C) ?
 P/ 175-300
SHAW, ROBERT (1859-1912) AMERICAN
 I/ 20-80
SHEELER, CHARLES (1883-1965) AMERICAN
 P/ 9300-33000
SHEETS, MILLARD (B. 1907) AMERICAN
 I/ 350 P/ 100-1700
SHEPPERSON, CLAUDE ALLIN (1867-1921) BRITISH
 P/ 50-150
SHERMAN, WELBY (19TH/20TH C)
 I/ 500-5000
SHIELDS, ALAN (B. 1944) AMERICAN
 I/ 880 P/ 700-1500
SHOESMITH, KENNETH
 P/ 350-1600
SHOKLER, HARRY (1896-1978) AMERICAN
 P/ 50-550
SHORT, FRANK (1857-1945) BRITISH
 I/ 75-525 P/ 75-300
SHUNNEY, A. (20TH C) AMERICAN
 R/ 75-250
SICHEM, CHRISTOFFEL VAN (1546-1624) DUTCH
 R/ 400-1300
SICKERT, WALTER RICHARD (1860-1942) BRITISH
 I/ 100-1900
SIDANER, HENRI-EUGENE LE (19TH/20TH C) FRENCH
 P/ 50-125
SIECK, RUDOLF (B. 1877) GERMAN
 I/ 100-1200 P/ 150-300
SIGNAC, PAUL (1863-1935) FRENCH
 I/ 75-11000 P/ 200-50000
SILVESTRE, ISRAEL (1621-1691) FRENCH
 I/ 100-1100

SIMAY, IMRE (B. 1874) HUNGARIAN
P/ 4000
SIMMONS, WILLIAM (1884-1949) AMERICAN
I/ 25-100
SIMON, GRANT M. (B. 1887) AMERICAN
P/ 25-100
SIMON, HOWARD (B. 1903) AMERICAN
R/ 50-125
SIMON, T.F. (1877-1942) CZECHOSLOVAKIAN
I/ 75-495 P/ 275
SIMPSON, JACKSON (20TH C) AMERICAN
I/ 30-85
SINDELAER, CHARLES J. (20TH C) AMERICAN
I/ 100-375
SINGIER, GUSTAVE (1909-1984) FRENCH
I/ 100-600 P/ 40-700
SINTENIS, RENEE (1888-1965) GERMAN
I/ 25-500
SIQUEIROS, DAVID ALFARO (1896-1964) MEXICAN
P/ 125-2000 R/ 200
SIRANI, ELISABETTA (1638-1665) ITALIAN
I/ 175-425
SIRANI, GIOVANNI ANDREA (1610-1670) ITALIAN
I/ 200-325
SISLEY, ALFRED (1839-1899) FRENCH
I/ 150-1000 P/ 250-18000
SJOLLEMA, JOHAN S. (?) ?
P/ 400-6000
SKARBINA, FRANZ (1849-1910) GERMAN
P/ 150-1400
SKIPPE, JOHN (1741-1811) BRITISH
R/ 50-150
SLEVOGT, MAX (1868-1932) GERMAN
I/ 75-1300 P/ 25-2500 R/ 25-50
SLOAN, BLANDING (?) ?
I/ 20-9000
SLOAN, JOHN (1871-1951) AMERICAN
I/ 75-12100 P/ 2800 R/ 900-1500
SLOCOMBE, GEORGE (19TH/20TH C) AMERICAN
I/ 40-80
SLOUN, FRANK J. VAN (1879-1938) AMERICAN
P/ 30-150
SLUYTERS, JAN (1881-1957) DUTCH
P/ 200-4400

Technique Key

Under each <u>printing technique</u> you may encounter the following types of prints (or combination of processes):

I <u>Intaglio:</u>
- etching
- drypoint
- steel engraving
- stipple engraving
- aquatint
- mezzotint
- soft-ground etching
- crayon manner

P <u>Planographic:</u>
- lithograph
- monotype
- silk-screen
- cliche verre
- serigraph

R <u>Relief:</u>
- wood block
 - woodcut
 - chiaroscuro
 - wood engraving
- linoleum cut (linocut)

SMILLIE, JAMES D. (1833-1909) AMERICAN
I/ 75-300
SMITH, JOHN RAPHAEL (1752-1812) BRITISH
I/ 100-725
SMITH, JULES ANDRE (1880-1959) AMERICAN
I/ 30-100
SMITH, LAWRENCE BEALL (B. 1902) AMERICAN
P/ 60-385
SMITH, RICHARD (B. 1931) BRITISH
I/ 1709 P/ 50-450
SMITH, WILLIAM COLLINGWOOD (1815-1887) BRITISH
I/ 1400
SNYDER, JOAN (B. 1940) AMERICAN
P/ 400
SODERBERG, YNGVE EDWARD (1896-1971) AMERICAN
I/ 75-200
SOLIS, VIRGIL (1551-1562) BRITISH
I/ 50-6100 R/ 200-600
SOLTMANN, HANS (B. 1876) ?
P/ 50-80
SOMER, JAN VAN (1645-1699) DUTCH
I/ 800-1200
SOMM, HENRI (1844-1907) FRENCH
I/ 500
SOMMER, WILLIAM (1870-1949) AMERICAN
P/ 50-150
SOMPEL, PIETER VAN (1600-1643) FLEMISH
I/ 200-400
SONDERBORG, K.R/.H. (B. 1923) GERMAN
I/ 180-2000 P/ 25-1500
SORGE, PETER (B. 1937) GERMAN
I/ 50-175
SORMAN, STEVEN (B. 1948) AMERICAN
I/ 1000-2000 P/ 400-2600
SOTO, JESUS RAPHAEL (B. 1923) VENEZUELAN
P/ 200-600
SOULAGES, PIERRE (B. 1919) FRENCH
I/ 50-4000 P/ 70-2600
SOULAS, LOUIS JOSEPH (1905-1954) FRENCH
I/ 150-300
SOYER, ISSAC (B. 1907) AMERICAN
P/ 150-350
SOYER, MOSES (1899-1974) RUSSIAN/AMERICAN
P/ 150-400

SOYER, RAPHAEL (1899-1987) AMERICAN
 I/ 50-1200 P/ 50-3800
SPARKS, JOSEPH (B. 1896) AMERICAN
 P/ 25-100
SPENCER, STANLEY (1891-1959) BRITISH
 P/ 100-600
SPRANGER, BARTHOLOMAEUS (1546-1611) GERMAN
 I/ 730-38000
SPRING, JOHANN (18TH/19TH C) RUSSIAN
 P/ 550-1650
SPRINGINKLEE, HANS (16TH C) GERMAN
 R/ 200-2000
SPRUANCE, BENTON M. (1904-1962) AMERICAN
 P/ 75-14850 R/ 440
STADLER, ANSELM
 R/ 200-330
STADLER, TONI (or ANTON VAN) (1850-1917) GERMAN
 P/ 60-250
STAEGER, FERDINAND (B. 1880) GERMAN
 I/ 50-350
STAEL, NICOLAS DE (1913-1955) FRENCH
 I/ 300-4600 P/ 770-27000 R/ 150-1185
STAHL, E. LEO
 P/ 1300
STALBEMT, ADRIAEN VAN (1580-1662) FLEMISH
 I/ 700
STANEK, EMMANUEL (1862-1920) AUSTRIAN
 P/ 350
STAUFFER-BERN, KARL (1857-1891) SWISS
 I/ 100-1100
STEFFEN, BERNARD JOSEPH (B. 1907) AMERICAN
 P/ 100-360
STEFULA, GEORG (B. 1913) GERMAN
 P/ 150
STEIFEL, ERHARD (B. 1940) SWISS
 P/ 350
STEIN, V. (?) ?
 P/ 700-2000
STEINBERG, SAUL (B. 1914) AMERICAN
 I/ 800 P/ 100-11000
STEINER, BERND (?) ?
 P/ 100-2000
STEINER, HEINRICH
 P/ 1000

STEINER-PRAG, HUGO (1880-1945) AUSTRIAN
P/ 25-150
STEINHARDT, JAKOB (1887-1968) ISRAELI
I/ 250-400 R/ 200-1100 P/ 1100
STEINLEN, THEOPHILE ALEXANDRE (1859-1923) SWISS/FRENCH
I/ 100-5730 P/ 25-29000
STEIR, PAT (B. 1938) AMERICAN
I/ 200-2800 R/ 500
STELLA, CLAUDINE B. (1636-1697) FRENCH
I/ 25
STELLA, FRANK (B. 1936) AMERICAN
I/ 2900-154000 P/ 200-79200 R/ 29920-71500
STELLA, JACQUES (1596-1657) FRENCH
I/ 1200-1600
STEPHANE, MICIUS (B. 1912) HAITIAN
P/ 990-1100
STERL, ROBERT HERMANN (1867-1932) GERMAN
P/ 276-500
STERN, ALEXANDER (?) ?
I/ 25-80
STERN, ERNST (B. 1876) GERMAN
P/ 50
STERNBERG, HARRY (B. 1904) AMERICAN
I/ 130-1000 P/ 375-440
STERNER, ALBERT EDWARD (1863-1946) AMERICAN
I/ 70-100 P/ 100-2500
STETSON, CHARLES WALTER (1858-1911) AMERICAN
I/ 40-100
STEVENS, MAY (B. 1924) AMERICAN
P/ 150
STOECKLIN, NIKLAUS (B. 1896) SWISS
P/ 300-1500
STOHR, ERNST (1865-1917) AUSTRIAN
R/ 350
STOHRER, WALTER
I/ 125-1300 P/ 200-650
STONER, JOHN LAWRENCE (B. 1906) AMERICAN
P/ 3400
STOOP, DIRK (1610-1681) DUTCH
I/ 75-550
STOYANOVITZ, D. (?) ?
P/ 2100
STRANG, WILLIAM (1859-1921) SCOTTISH
I/ 50-350

STRAUBE, WILLIAM (B. 1871) GERMAN
P/ 200-300
STRETTI-ZAMPONI, J. (B. 1882) ?
P/ 75-150
STRICKLAND, WILLIAM (?) ?
I/ 500
STRUCK, HERMAN (1887-1954) AMERICAN
I/ 25-1100 P/ 50
STUBBS, GEORGE TOWNLEY (1724-1806) BRITISH
I/ 300-9500
STUCK, FRANZ VON (1863-1928) GERMAN
I/ 150-850 P/ 600-1700
STURGES, DWIGHT C. (1874-1940) AMERICAN
I/ 25-80
SUAVIUS, LAMBERT (16TH C) ?
I/ 3900
SUBLEYRAS, PIERRE HUBERT (1699-1749) FRENCH
I/ 200-1700
SUGAI, KUMI (B. 1919) JAPANESE
I/ 1000-1650 P/ 50-1800
SULTAN, DONALD (B. 1951) AMERICAN
I/ 550-44000 P/ 2400-7700 R/ 2750-4180
SUMMERS, CAROL (B. 1925) AMERICAN
P/ 275-500 R/ 50-1400
SUNYOL, ? (?) ?
P/ 350-800
SURENDORF, CHARLES FREDERICK (B. 1906) AMERICAN
R/ 70-300
SURVAGE, LEOPOLD (1879-1968) FRENCH
I/ 140-350 P/ 150-750 R/ 185-350
SUTHERLAND, GRAHAM (1903-1980) BRITISH
I/ 250-4300 P/ 75-1580
SUTTERLIN, LUDWIG (1865-1917) GERMAN
P/ 130-600
SUTTON, RUTH H. (1898-1960) AMERICAN
P/ 25-100 R/ 25-100
SUYDERHOEF, JONAS (1613-1686) DUTCH
I/ 200-500
SWANEVELT, HERMAN VAN (1500-1665) DUTCH
I/ 200-500
SWANN, DON (B. 1889) AMERICAN
I/ 40-90
SWART, JAN VAN G. (16TH C) DUTCH
R/ 2700-31005

SWEELINK, GERRIT PIETERSZ (B. 1566) DUTCH
 I/ 7700

T

TAIT, AGNES (B. 1897) AMERICAN
 P/ 50-100
TAL COAT, PIERRE (B. 1905) FRENCH
 P/ 80-650
TAMAGNO (?) ?
 P/ 150-2000
TAMAYO, RUFINO (B. 1899) MEXICAN
 I/ 500-2500 P/ 50-4040
TANCONVILLE
 P/ 200-600
TANGUY, YVES (1900-1955) FRENCH/AMERICAN
 I/ 400-21400
TANNING, DOROTHEA (B. 1912) AMERICAN
 I/ 20-125 P/ 200-450
TAPIES, ANTONIO (B. 1923) SPANISH
 I/ 250-17910 P/ 75-59700
TAPPERT, GEORG (1880-1957) GERMAN
 I/ 150-2350 P/ 200-500 R/ 50-3000
TAUZIN, LOUIS (19TH C) FRENCH
 P/ 1200-1540
TAYLOR, ANNA HEYWARD (1879-1956) AMERICAN
 R/ 150-425
TAYLOR, EDWARD DEWITT (B. 1871) AMERICAN
 I/ 75-125
TAYLOR, FRED (B. 1875) BRITISH
 P/ 730-3100
TAYLOR, PRENTISS (B. 1907) AMERICAN
 P/ 25-350
TELAKOWSKA, WANDA (20TH C) AMERICAN
 R/ 250
TENIERS, DAVID (THE ELDER) (1582-1649) FLEMISH
 I/ 400
TERAOKA, MASAMI (B. 1936) AMERICAN
 P/ 150-400
TERECHKOVITCH, KONSTANTIN (KOSTIA) (1902-1978) RUSSIAN/FRENCH

P/ 80-1200
TERZI, ALEARDO (B. 1870) ITALIAN
P/ 900-3300
TESTA, PIETRO (1611-1650) ITALIAN
I/ 100-1500
TEUBER, HERMANN (?) ?
I/ 75-400 P/ 75-200
THAL, SAM (1903-1964) AMERICAN
I/ 40-100
THAULOW, FRITZ (1847-1906) NORWEGIAN
I/ 100-5460 P/ 5200
THEODOROS, (B. 1931) GREEK
P/ 900-1200
THEW, ROBERT (1758-1802) BRITISH
I/ 400-1000
THIEBAUD, WAYNE (B. 1920) AMERICAN
I/ 400-39600 P/ 200-23100 R/ 1800-31680
THIELE, J. F. ALEXANDER (1747-1803) GERMAN
I/ 250-400
THIELER, FRED (B. 1916) GERMAN
I/ 524 P/ 100-3400
THIEMANN, CARL (B. 1881) AUSTRIAN
I/ 200 R/ 25-1900
THIRIAT, HENRI (19TH C) FRENCH
P/ 700-3200
THOMA, HANS (1839-1924) GERMAN
I/ 25-1500 P/ 25-2300
THOMAS, HENRY JOSEPH (1878-1972) BELGIAN
P/ 900-2420
THOMAS, WALTER (?) ?
P/ 300-1800
THOMKINS, ANDRE (B. 1930) SWISS
I/ 180-1300 P/ 150-2025
THOMPSON, JEROME B. (1814-1886) AMERICAN
I/ 4225 P/ 200-250
THOMSON, ALFRED (B. 1895) BRITISH
P/ 4000
THOR, WALTER (1870-1929) GERMAN
P/ 275-1800
THORN PRIKKER, JAN (1868-1932) DUTCH
P/ 350-800
THORNE, DIANA (B. 1895) AMERICAN
I/ 25-80
THORNTON, DR. (?) ?

Technique Key

Under each <u>printing technique</u> you may encounter the following types of prints (or combination of processes):

I <u>Intaglio:</u>

- etching
- drypoint
- steel engraving
- stipple engraving
- aquatint
- mezzotint
- soft-ground etching
- crayon manner

P <u>Planographic:</u>

- lithograph
- monotype
- silk-screen
- cliche verre
- serigraph

R <u>Relief:</u>

- wood block
 - woodcut
 - chiaroscuro
 - wood engraving
- linoleum cut (linocut)

I/ 1400-3900
TICHON, CHARLES
P/ 250-600
TIEPOLO, GIOVANNI BATTISTA (1696-1770) ITALIAN
I/ 300-46000
TIEPOLO, GIOVANNI DOMENICO (1727-1804) ITALIAN
I/ 125-14160
TIEPOLO, LORENZO (1736-1776) ITALIAN
I/ 350-10620
TILLYER, WILLIAM (B. 1938) BRITISH
P/ 50-360
TILSON, JOE (B. 1928) BRITISH
I/ 150-2000 P/ 50-1200
TING, WALASSE (B. 1929) AMERICAN
P/ 150-650
TINGUELY, JEAN (B. 1925) SWISS
I/ 200-10100 P/ 200-10620 R/ 1285
TINTI, LORENZO (1626-1672) ITALIAN
I/ 300
TIRABOSCO, GIUSEPPE (19TH C) ITALIAN
I/ 500
TISCHBEIN, JOHANN HEINRICH (1722-1789) GERMAN
I/ 100-1700
TISSOT, JAMES JACQUES JOSEPH (1836-1902) FRENCH
I/ 150-45000
TITTLE, WALTER ERNEST (1883-1960) AMERICAN
I/ 25-1100
TOBEY, MARK (1890-1976) AMERICAN
I/ 150-2500 P/ 75-16000
TOBIASSE, THEO (B. 1927) ISRAELI/FRENCH
P/ 100-1900
TODD, A.R. MIDDLETON (B. 1891) BRITISH
I/ 25-100
TOLEDO, FRANCISCO (B. 1940) MEXICAN
I/ 150-1300
TOLMAN, STACY (1860-1935) AMERICAN
I/ 50-100
TOOKER, GEORGE (B. 1920) AMERICAN
I/ 150-300 P/ 300-1300
TOOROP, JAN (1858-1928) DUTCH
I/ 150-4500 P/ 75-26400 R/ 450-4600
TOPP, ARNOLD (1887-1960) ?
R/ 200-550
TORLAKSON, JIM (B. 1951) AMERICAN

I/ 300-400
TORRI, FLAMINIO (1621-1661) ITALIAN
 I/ 400
TOULOUSE-LAUTREC, HENRI DE (1864-1901) FRENCH
 I/ 200-12000 P/ 100-357500
TOUSSAINT, FERNAND (1873-1955) BELGIAN
 P/ 700-22000
TRAPP, WILLY (1735-1813) GERMAN
 P/ 750-1000
TRAUTMANN, JOHANN (1713-1769) GERMAN
 I/ 250-600
TRAVIES, EDOUARD (B. 1809) FRENCH
 P/ 350-3500
TRAVIS, PAUL B. (B. 1891) AMERICAN
 P/ 40-100
TREMOIS, PIERRE YVES (B. 1921) FRENCH
 I/ 25-1000 P/ 350-400
TRENTA, ANTONIO DA (16TH C) ITALIAN
 R/ 200-8100
TRIER, HANN (B. 1915) GERMAN
 I/ 75-700 P/ 50-200
TRINQUIER-TRIANON
 P/ 250-4400
TROGER, PAUL (1698-1762) AUSTRIAN
 I/ 250-1700
TROKES, HEINZ (B. 1913) GERMAN
 I/ 50-500 P/ 25-1500
TROMKA, ABRAM (1896-1954) AMERICAN
 P/ 75-150
TROVA, ERNEST (B. 1927) AMERICAN
 P/ 100-1150
TROWBRIDGE, VAUGHN (B. 1869) AMERICAN
 I/ 50-125
TRUBNER, WILHELM (1851-1917) GERMAN
 I/ 125
TRUE, DAVID (B. 1942) AMERICAN ?
 I/ 2400
TSCHUDI, LILL (B. 1901) BRITISH
 R/ 275-4547
TSCHUMI, OTTO (B. 1904) SWISS
 P/ 100-350 R/ 200-1200
TUBKE, WERNER (B. 1929) ?
 I/ 100-400 P/ 75-490
TUCKER, WILLIAM (B. 1935)

P/ 2200
TUNNICLIFFE, CHARLES (1901-1978) BRITISH
 I/ 150-800 R/ 751
TURNER, DON LA VIERE (B. 1929) AMERICAN
 I/ 25-100 R/ 25-100
TURNER, JOSEPH MALLORD WILLIAM (1775-1851) BRITISH
 I/ 150-4700
TURNER, JULIUS C. (?) ?
 I/ 250-300
TURRELL, JAMES (B. 1943) AMERICAN
 I/ 900
TUTTLE, HENRI E. (1890-1946) AMERICAN
 I/ 25-100
TUTTLE, RICHARD (B. 1941) AMERICAN
 P/ 300-2530
TWACHTMAN, JOHN HENRY (1853-1902) AMERICAN
 I/ 200-1500
TWOMBLY, CY (B. 1929) AMERICAN
 I/ 1400-63250 P/ 200-18700 R/ 10000
TWORKOV, JACK (B. 1900) AMERICAN
 P/ 75-225
TYTELL, LOUIS (B. 1913) AMERICAN
 R/ 25-100

U

UBAC, RAOUL (B. 1910) BELGIAN/FRENCH
 I/ 175-450 P/ 50-450
UBBELOHDE, OTTO (1867-1922) GERMAN
 I/ 125-850 P/ 225-420
UDEN, LUCAS VAN (1595-1672) FLEMISH
 I/ 170-3100
UECKER, GUNTHER (B. 1930) GERMAN
 I/ 220 P/ 100-1100 R/ 230-500
UHDEN, MARIA (1892-1918)) GERMAN
 R/ 175-750
UHLICH, FRITZ (1682-1741) GERMAN
 P/ 800
UHLIG, MAX (?) ?
 I/ 75-345 P/ 100-1100

UHLMANN, HANS (B. 1900) GERMAN
P/ 125-225
ULREICH, NURA WOODSON (D. 1950) AMERICAN
P/ 75-150
UMBACH, JONAS (1624-1693) GERMAN
I/ 25-600
UNGER, HANS (1872-1936) BRITISH
P/ 550-1400
UNOLD, MAX (B. 1885) GERMAN
P/ 200-400 R/ 25-400
URUSHIBARA, YOSHIJURO (1880-1953) JAPANESE
R/ 145-900
URY, LESSER (1861-1931) GERMAN
I/ 150-4400 P/ 200-4700
UTRILLO, MAURICE (1883-1955) FRENCH
I/ 600-6700 P/ 75-16000
UYTTENBROECK, MOSES VAN (1590-1648) DUTCH
I/ 24-1200

V

VADASZ, ENDRE (B. 1901) HUNGARIAN
I/ 30-100
VAILLANT, WALLERANT (1623-1677) DUTCH
I/ 200-4000
VALADON, SUZANNE (1865-1938) FRENCH
I/ 50-10000 P/ 175-1980
VALCK, GERARD (1651-1726) DUTCH
I/ 380-500
VALENTINIS, SABASTIANO DE (16TH C) ITALIAN
I/ 6200
VALERIO, R. DE (20TH C) AMERICAN
P/ 300-4600
VALLET, EDOUARD (1876-1929) SWISS
I/ 275-1000
VALLOTTON, FELIX (1865-1925) SWISS
P/ 40-4600 R/ 25-21000
VALTAT, LOUIS (1869-1952) FRENCH
I/ 180-1500 R/ 550-3000
VAN SOELEN, THEODORE (1890-1964) AMERICAN

P/ 25-100
VANNI, FRANCESCO (1563-1610) ITALIAN
I/ 800-4200 R/ 630
VANNI, GIOVANNI-BATTISTA (1599-1660) ITALIAN
I/ 500-1100
VARLIN, WILLY GUGGENHEIM (B. 1900) SWISS
P/ 150-1300
VASARELY, VICTOR (B. 1908) FRENCH
I/ 25-750 P/ 50-6000
VASI, GIUSEPPE (1710-1782) ITALIAN
I/ 100-7400
VASSILIEFF, MARIE (1884-1957) RUSSIAN
P/ 500
VELDE, ADRIAN VAN DE (1636-1672) DUTCH
I/ 1500-1600
VELDE, BRAM VAN (B. 1910) DUTCH
P/ 50-2424
VELDE, ESAIAS VAN DE (THE ELDER) (1590-1630) DUTCH
I/ 500-6200
VELDE, HENRI VAN DE (1863-1957) DUTCH
P/ 200-1100
VELDE, JAN VAN DE (1593-1641) DUTCH
I/ 150-5000
VELICKOVIC, VLADIMIR (B. 1935) YUGOSLAVIAN
I/ 118 P/ 200-400
VELLERT, DIRK (1511-1544) DUTCH
I/ 1000-115000
VENEZIANO, AGOSTINO (1490-1536) ITALIAN ?
I/ 75-13000
VENEZIANO, CARLO (?) ?
I/ 200
VENNEKAMP, JOHANNES (B. 1935) ?
I/ 50-200
VERBEECK, PIETER C. (17TH C) DUTCH
I/ 560-1700
VERBOOM, ADRIAEN HENDRIKSZ (1628-1670) DUTCH
I/ 100-550
VERDET, ANDRE (B. 1913) FRENCH
P/ 800
VERKOLJE, JAN (B. 1650) DUTCH
I/ 400-1300
VERLINDE, CLAUDE
P/ 275-350
VERNER, ELIZABETH O'NEILL (B. 1884) AMERICAN

I/ 275-350
VERNET, EMILE JEAN HORACE (called HORACE) (1789-1863) FRENCH
 I/ 1800 P/ 175-800
VERONESI, LUIGI (B. 1908) ITALIAN
 R/ 250
VERTES, LOUIS
 P/ 150-1400
VERTES, MARCEL (1895-1961) FRENCH
 I/ 100-500 P/ 50-1700
VICENTINO, GIUSEPPE
 R/ 650-800
VICENTINO, NICCOLO (16TH C) ITALIAN
 R/ 285-13000
VICO, ENEA (1523-1567) ITALIAN
 I/ 25-6500
VIDAL, EMILE
 P/ 300-600
VIERA DA SILVA, MARIA ELENA (B. 1908) FRENCH
 I/ 200-525 P/ 125-1200
VIKTORIN, RAINER (20TH C) ?
 I/ 400-1000
VILA, EMILIO
 P/ 200-2500
VILLA, ALEARDO (1865-1906) ITALIAN
 P/ 650-1500
VILLA, HERNANDO GONZALLO (1881-1952) AMERICAN
 P/ 800
VILLAMENA, FRANCISCO (1566-1624) ITALIAN
 I/ 800
VILLEMOT, BERNARD (B. 1911) FRENCH
 P/ 150-1500
VILLON, JACQUES (1875-1963) FRENCH
 I/ 25-72000 P/ 35-41250
VILLOT, C.
 P/ 200
VINCENT, RENE (1879-1936) FRENCH
 P/ 150-11000
VINCKBOONS, DAVID (1576-1629) FRENCH
 I/ 250-2500
VINKELES, REINIER (1741-1816) DUTCH
 I/ 375-1000
VION, R. (20TH C) FRENCH
 P/ 175-1200
VISENTINI, ANTONIO (1688-1782) ITALIAN

Technique Key

Under each <u>printing technique</u> you may encounter the following types of prints (or combination of processes):

I <u>Intaglio:</u>

- etching
- drypoint
- steel engraving
- stipple engraving
- aquatint
- mezzotint
- soft-ground etching
- crayon manner

P <u>Planographic:</u>

- lithograph
- monotype
- silk-screen
- cliche verre
- serigraph

R <u>Relief:</u>

- wood block
 - woodcut
 - chiaroscuro
 - wood engraving
- linoleum cut (linocut)

I/ 200-1100
VISSCHER, CLAES (1587-1652) DUTCH
 I/ 50-500
VISSCHER, CORNELIS (1629-1658) DUTCH
 I/ 75-2300
VIVANT-DENON, D. (1747-1826) FRENCH
 I/ 25
VLAMINCK, MAURICE DE (1876-1958) FRENCH
 I/ 100-6075 P/ 50-8200 R/ 100-8800
VLIEGER, SIMON DE (1600-1663) DUTCH
 I/ 150-7000
VLIET, JAN JORIS (B. 1610) DUTCH
 I/ 25-2400
VLYMEN, B.V. (?) ?
 P/ 400-800
VOGEL, BERNHARD (1683-1737) GERMAN
 I/ 250
VOGELER, HEINRICH (1872-1942) GERMAN
 I/ 40-7400
VOLKMANN, HANS R. (1860-1927) GERMAN
 I/ 100-240 P/ 50-325
VOLKMAR, CHARLES (1841-1914) AMERIACAN
 I/ 25-100
VOLL, CHRISTOPH (1897-1939) GERMAN
 I/ 300-425 R/ 550-1000
VOORHEES, CLARK G. (1871-1933) AMERICAN
 I/ 20-100
VORDEMBERGE-GILDEWART, FRIEDRICH (1899-1963) GERMAN/DUTCH
 P/ 100-350
VORSTERMANN, LUCAS II (1624-1667) FLEMISH
 I/ 150-828
VOSTELL, WOLF (B. 1932) GERMAN
 P/ 100-760
VOYEZ, FRANCOIS (1746-1805) FRENCH
 I/ 350-400
VUIBERT, REMI (1600-1651) FRENCH
 I/ 150-400
VUILLARD, EDOUARD (1868-1940) FRENCH
 I/ 50-1600 P/ 35-59400

W

WACIK, FRANZ (1883-1938) AUSTRIAN
P/ 250
WADSWORTH, EDWARD (1889-1949) BRITISH
I/ 500-3200 P/ 300-2500 R/ 500-11000
WAEL, JAN BAPTIST DE (17TH C) DUTCH
I/ 50
WAES, AERT VAN (1620-1664) DUTCH
I/ 1400-2100
WAHLSTEDT, WALTER (B. 1898) GERMAN
P/ 500-1900 R/ 150-500
WALCOTT, WILLIAM (1874-1943) BRITISH
I/ 50-150
WALKOWITZ, ABRAHAM (1878-1965) AMERICAN
I/ 275 P/ 200-18000
WALSER, KARL (B. 1877) SWISS
I/ 25-75 P/ 25
WARD, WILLIAM (1766-1826) BRITISH
I/ 75-900
WARHOL, ANDY (1928-1987) AMERICAN
P/ 30-143000
WASKE, ERICH (B. 1889) GERMAN
P/ 75-250
WATERLOO, ANTHONIE (1610-1690) DUTCH
I/ 25-21300
WATSON, ADELE (1873-1947) AMERICAN
P/ 25-100
WATSON, ERNEST W. (B. 1884) AMERICAN
R/ 100-385
WATSON, EVA AULD (20TH C) AMERICAN
R/ 100-325
WATSON, JAMES (1740-1790) BRITISH
I/ 100-400
WATTEAU, JEAN ANTOINE (1684-1721) FRENCH
I/ 50-12200
WAUMANS, COENRAD (B. 1619) FLEMISH
I/ 150
WEBB, A.C. (B. 1888) AMERICAN
I/ 25-660
WEBB, JOSEPH (1908-1962) BRITISH
I/ 200-900
WEBER, ALBERT PAUL (B. 1893) AMERICAN

P/ 25-2800 R/ 100-625
WEBER, MAX (1881-1961) AMERICAN
 P/ 200-1300 R/ 200-600
WEBSTER, HERMAN ARMOUR (1878-1970) AMERICAN
 I/ 40-100
WECHTLIN, HANS (EARLY 16TH C) GERMAN
 R/ 350-2500
WEHLE, HEINRICH (1778-1805) GERMAN
 I/ 800
WEIDENAAR, REYNOLD (1915-1985) AMERICAN
 I/ 70-715
WEIDNER, ROSWELL T. (B. 1911) AMERICAN
 P/ 25-100
WEILUC, ? (19TH C) FRENCH
 P/ 500-6100
WEINER, HANS (1575-1620) GERMAN
 I/ 300-2650
WEINRICH, AGNES (1873-1946) AMERICAN
 R/ 500-3500
WEIROTTER, FRANZ (1730-1771) AUSTRIAN
 I/ 25-350
WEISGERBER, ALBERT (1878-1915) GERMAN
 I/ 150-500
WEISKONIG, WERNER
 P/ 400-700
WEISS, EMIL RUDOLF (B. 1875)
 R/ 200-450
WELLIVER, NEIL (B. 1929) AMERICAN
 I/ 350-1200 P/ 650-900
WELTI, ALBERT (1862-1912) SWISS
 I/ 75-880
WENGENROTH, STOW (1906-1977) AMERICAN
 P/ 175-9900
WERKMEISTER, W. (?) ?
 I/ 100-250
WERNER, THEODOR (1886-1968) GERMAN
 P/ 100-280
WESLEY, JOHN (B. 1928) AMERICAN
 P/ 150-250
WESSELMANN, TOM (B. 1931) AMERICAN
 I/ 150-4500 P/ 170-19800 R/ 500-2200
WEST, BENJAMIN (1738-1820) AMERICAN
 I/ 70-400 P/ 650-5900
WEST, LEVON (1900-1968) AMERICAN

I/ 110-500
WESTPFAL, CONRAD (B. 1891) GERMAN
P/ 200-600 R/ 200-950
WETHERILL, ELISHA K. K. (1874-1929) AMERICAN
I/ 25-100
WETLI, HUGO (20TH C) ?
P/ 100-710
WEWERKA, STEFAN
I/ 50-550 P/ 200
WHISTLER, JAMES ABBOTT MCNEILL (1834-1903) AMERICAN
I/ 100-52800 P/ 150-79750
WHITE, CHARLES W. (1918-1980) AMERICAN
P/ 200
WHITEHEAD, BUELL (20TH C) AMERICAN
P/ 200-300
WIDHOPFF, D.O. (1867-1933) FRENCH
P/ 350
WIEGERS, JAN (B. 1893) DUTCH
I/ 750-1200 P/ 250 R/ 200-2000
WIERIX, HIERONYMUS (1553-1619) FLEMISH
I/ 50-5100
WIERIX, JOHANNES (B. 1549) FLEMISH
I/ 50-300
WILCOX, FRANK (1887-1964) AMERICAN
I/ 75-150
WILCOX, LOIS (B. 1889) AMERICAN
P/ 25-100
WILDMAN, MARY F. (B. 1899) AMERICAN
I/ 25-75
WILEY, WILLIAM T. (B. 1937) AMERICAN
I/ 100-1800 P/ 200-900 R/ 1200-3000
WILLE, JOHANN GEORG (1715-1808) GERMAN
I/ 30-400
WILLETTE, ADOLPHE-LEON (1857-1926) FRENCH
P/ 190-750
WILLIAMS, JOHN (20TH C) AMERICAN
I/ 50-100
WILLIAMS, WALTER (1835-1906) BRITISH
R/ 100
WILLMANN, MICHAEL (1630-1706) GERMAN
I/ 200-1100
WILSON, BENJAMIN (1721-1788) BRITISH
I/ 400
WILSON, C. Y. A. (20TH C) AMERICAN

I/ 25-80
WILSON, EDWARD A. (1886-1970) AMERICAN
P/ 50-300
WILSON, JOHN (B. 1922) AMERICAN
P/ 100-550
WILSON, ROBERT BURNS (1851-1916) AMERICAN
P/ 200-690
WILTZ, ARNOLD (B. 1889) AMERICAN
I/ 75-150 P/ 30-75
WIMMER, PAULA
R/ 25-600
WINCKLE, F. (B. 1766) AUSTRIAN
P/ 600
WINKLER, JOHN W. (1890-1979) AMERICAN
I/ 75-500
WINNER, GERD (B. 1936) GERMAN
P/ 150-2000
WINNEWISSER, ROLF (B. 1949) SWISS
R/ 100
WINSLOW, HENRY (1874-1955) AMERICAN
I/ 25-100
WINTER, FRITZ (1905-1978) GERMAN
I/ 100-2400 P/ 100-2050
WINTERS, TERRY (20TH C) AMERICAN
P/ 385-25300
WIRSCHING, OTTO (1889-1919) GERMAN
R/ 25
WITHERSTINE, DONALD (1896-1961) AMERICAN
R/ 20-75
WOEHRMAN, RALPH
I/ 50-275
WOELFFER, EMERSON
P/ 350
WOLF, HENRY (1852-1916) AMERICAN
I/ 30-75
WOLFGANG, GUSTAV A. (1692-1775) GERMAN
I/ 400
WOLFGANG, JOHANN G. (1662-1744) GERMAN
I/ 275
WOLFSFELD, ERICH (B. 1884)
I/ 300
WOLFSON, WILLIAM (B. 1894) AMERICAN
P/ 1100
WOLGEMUT, MICHAEL (1434-1519) GERMAN

R/ 250-800
WOLLHEIM, GERT H. (?) ?
 I/ 950 R/ 200-600
WOLS, (ALFRED O. W. S.) (1913-1951) GERMAN
 I/ 150-600
WOMRATH, ANDREW (B. 1869) AMERICAN
 I/ 500 P/ 200-1000
WOOD, GRANT (1891-1942) AMERICAN
 P/ 400-6600
WOOD, STANLEY (B. 1894) AMERICAN
 I/ 25-100
WOODBURY, CHARLES HERBERT (1864-1940) AMERICAN
 I/ 80-450
WOODWARD, ELLSWORTH (1861-1939) AMERICAN
 I/ 25-100
WOOLF, SAMUEL J. (1880-1948) AMERICAN
 P/ 80-175
WORN, WALTER (?) ?
 P/ 100-400 R/ 50-600
WOTRUBA, FRITZ (1907-1975) GERMAN
 I/ 75-125 P/ 50-1800
WRIGHT, REDMOND S. (B. 1903) AMERICAN
 I/ 25-100
WRIGHT, STANTON M. (20TH C) AMERICAN
 R/ 100-500
WUCHERER, FRITZ (B. 1873) SWISS
 I/ 100-1200 P/ 100-3400
WUNDERLICH, PAUL (B. 1927) GERMAN
 I/ 100-1200 P/ 25-3300 R/ 230-475
WUSTEN, JOHANNES
 I/ 275-525
WYCK, THOMAS (1616-1677) DUTCH
 I/ 100-250
WYETH, JAMES (B. 1946) AMERICAN
 I/ 500-3300
WYLLIE, WILLIAM LIONEL (1851-1931) BRITISH
 I/ 50-850
WYNGAERDE, FRANS (1614-1669) FLEMISH
 I/ 690-950
WYNMAN, WIM (B. 1897) DUTCH
 P/ 1700
WYSS, FRANZ ANATOL (?) ?
 I/ 100-550

Technique Key

Under each <u>printing technique</u> you may encounter the following types of prints (or combination of processes):

I <u>Intaglio:</u>
- etching
- drypoint
- steel engraving
- stipple engraving
- aquatint
- mezzotint
- soft-ground etching
- crayon manner

P <u>Planographic:</u>
- lithograph
- monotype
- silk-screen
- cliche verre
- serigraph

R <u>Relief:</u>
- wood block
 - woodcut
 - chiaroscuro
 - wood engraving
- linoleum cut (linocut)

Y

YLEN, JEAN D' (?) ?
P/ 350-1200
YONGHE, JOHN DE (1856-1917) AMERICAN
P/ 300-900
YOSHIDA, HIROSHI (B. 1876) JAPANESE
R/ 100-11000
YOUNG, CHARLES JAC (1880-1940) AMERICAN
I/ 20-90
YOUNGERMAN, JACK (B. 1926) AMERICAN
P/ 75-650
YUNKERS, ADJA (B. 1900) LATVIAN/AMERICAN
P/ 70-770

Z

ZABOLY, BELA (B. 1910) AMERICAN
I/ 30-90
ZADKINE, OSSIP (1890-1967) RUSSIAN/FRENCH
I/ 30-600 P/ 25-1300 R/ 700
ZAKANITCH, ROBERT (B. 1935) AMERICAN
P/ 200-450
ZANETTI, ANTONIO MARIA (1680-1757) ITALIAN
R/ 150-3300
ZAO-WOU-KI (1921-1964) CHINESE/FRENCH
I/ 125-1450 P/ 100-1100
ZAZINGER, M. (1720-1789) SPANISH
I/ 1700
ZEEMAN, REINIER (1623-1667) DUTCH
I/ 100-1000
ZENDER, RUDOLF (20TH C) SWISS
P/ 250-325
ZIEGLER, RICHARD (B. 1901) GERMAN
P/ 500
ZIETARA, WALENTY (?) ?
P/ 200-1500
ZIGLDRUM, FRED A. (?) ?
I/ 150-300

ZILLE, HEINRICH (1858-1929) GERMAN
 I/ 100-2200 P/ 100-6000
ZIMBAL, JOHANN (?) ?
 I/ 500-2600 P/ 194
ZIMMER, HANS PETER (B. 1936) GERMAN
 I/ 75-1900
ZIMMERMANN, MAC (B. 1912) GERMAN
 I/ 50-1100 P/ 50-550
ZINGG, ADRIAN (1934-1816) SWISS
 I/ 150-500
ZOCCHI, GIUSEPPE (1711-1767) ITALIAN
 I/ 560-1950
ZOIR, EMIL (B. 1867) SWEDISH
 I/ 15-50
ZORN, ANDERS (1860-1920) SWEDISH]
 I/ 50-17000
ZUCCARELLI, FRANCESCO (1701-1788) ITALIAN
 I/ 250-1130
ZUCCHI, LORENZO (1704-1779) ITALIAN
 I/ 200
ZUCKER, JOSEPH (B. 1941) AMERICAN
 I/ 100
ZULOW, FRANZ VON (1883-1963) AUSTRIAN
 P/ 50-1900
ZUNDT, MATTHIAS (1498-1572) GERMAN
 I/ 300
ZUNIGA, FRANCISCO (B. 1913) MEXICAN
 P/ 275-3300

Artists in Dealer Catalogs

The following is an alphabetical list of over 340 artists whose prints infrequently turn up at auction, or, prints by these artists appear in "group" lots. (Auction houses will sometimes group together several inexpensive works to make up a sufficient dollar value.) As a result, these lesser-known artists will not have any individual track record at auction and consequently, they will not appear in the main alphabetical section of this guide.

The list emphasizes American, English, and French artists who produced prints primarily from 1860 to 1960. The price range given represents where roughly 75% of an artist's works fall, price wise, based on a broad survey of numerous dealer catalogs.

The printing technique listed (i.e., I, P, or R) is the technique for which he/she is best known. An asterisk (*) after a price range indicates that prints by this artist are rare!

ABELES, SIGMUND (B. 1934) AMERICAN
 I/ 100-500 P/ 100-500
ADAMS, CLINTON (B. 1918) AMERICAN
 P/ 100-300
ADDAMS, CLIFFORD (1876-1942) AMERICAN
 I/ 100-300
ALDRIN, ANDERS (1889-1970) SWEDISH/AMERICAN
 R/ 300-650
ANDERSON, CARLOS (20TH C) AMERICAN
 P/ 100-400
ANDRUS, VERA (1896-1979) AMERICAN
 P/ 200-500
ARNOLD, GRANT (B. 1904) AMERICAN
 P/ 100-300
AUERBACH-LEVY, WILLIAM (1889-1964) AMERICAN
 I/ 150-450
AULT, GEORGE C. (1891-1948) AMERICAN
 P/ 500-1500* R/ 500-3500*
AUSTIN, ROBERT (1895-1973) BRITISH
 I/ 250-650

B

BACHER, OTTO (1856-1909) AMERICAN
I 200-600
BAERTSOEN, ALBERT (1866-1922) BELGIAN
I/ 100-300
BANTING, JOHN (1902-1972) BRITISH
P/ 500-1000
BARKER, ALBERT (1874-1947) AMERICAN
P/ 100-600
BARKER, THOMAS (OF BATH) (1769-1847) BRITISH
P/ 400-700
BARLOW, LOU (B. 1908) AMERICAN
R/ 100-500
BARRETT, LAWRENCE (B. 1897) AMERICAN
P/ 100-300
BARTLETT, IVAN (B. 1915) AMERICAN
R/ 50-150
BASKETT, CHARLES H. (1872-1953) BRITISH
I/ 100-300
BEAL, GIFFORD (1879-1956) AMERICAN
I/ 100-300
BECKER, FREDERICK (B. 1913) AMERICAN
I/ 400-800
BELL, CECIL C. (1906-1970) AMERICAN
P/ 200-800
BELLEROCHE, ALBERT (1864-1944) FRENCH
P/ 500-3000
BERMAN, EUGENE (1899-1972) AMERICAN
P/ 300-600
BIBEL, LEON (B. 1912) AMERICAN
P/ 250-800
BICKNELL, ALBION H. (1837-1915) AMERICAN
P/ 500-2500 (monotypes only)
BIELER, ANDRE (B. 1896) SWISS/CANADIAN
R/ 400-800
BLACKBURN, MORRIS (B. 1902) AMERICAN
R/ 400-750
BLACKBURN, ROBERT (B. 1920) AMERICAN
I/ 300-700 P/ 300-700
BLANCH, ARNOLD (1896-1968) AMERICAN
P/ 150-350
BLATHERWICK, LILY (1859-1934) BRITISH

P/ 100-300

BLERY, EUGENE (1805-1887) FRENCH
I/ 100-1000

BLOCH, JULIUS (1888-1966) AMERICAN
P/ 150-300

BLUM, ROBERT F. (1857-1903) AMERICAN
I/ 150-500

BLUMENSCHEIN, HELEN G. (B. 1909) AMERICAN
P/ 150-300

BOCCIONI, UMBERTO (1882-1916) AMERICAN
P/ 150-350

BOONE, CORA (1865-1953) AMERICAN
R/ 300-600

BORMANN, EMMA (B. 1887) GERMAN
R/ 150-350

BOTHWELL, DORR (B. 1902)
P/ 350-750

BOTKE, CORNELIUS (1887-1954) AMERICAN
I/ 200-300 R/ 300-800

BOTKE, JESSIE ARMS (1883-1971) AMERICAN
R/ 250-600

BOURGEOIS, LOUISE (B. 1911) AMERICAN
I/ 1500-3500*

BOYS, THOMAS SHOTTER (1803-1874) BRITISH
P/ 200-750

BRODSKY, HARRY (20TH C) AMERICAN
P/ 250-500

BRODZKY, HORACE (1885-1969) BRITISH
R/ 350-750

BROOK, ALEXANDER (1898-1980) AMERICAN
P/ 150-250

BROWN, JOHN GEORGE (1831-1913) AMERICAN
I/ 150-650

BROWN, SYD (B. 1907) AMERICAN
P/ 100-400

BRUSSEL-SMITH, BERNARD (B. 1914) AMERICAN
R/ 100-400

BRY, EDITH (B. 1898) AMERICAN
P/ 50-200

BUCKLAND-WRIGHT, JOHN (1897-1954) BRITISH
I/ 150-350

BUFF, CONRAD (1886-1975) AMERICAN
P/ 2-500

BUMBECK, DAVID (B. 1940) AMERICAN

I/ 100-500
BURKHARDT, HANS (B. 1904) AMERICAN
P/ 500-1500*
BUTCHER, ENID (20TH C) BRITISH
I/ 50-150

C

CALAME, ALEXANDRE (1810-1864) FRENCH
P/ 50-250
CALAPAI, LETTERIO (B. 1902) AMERICAN
I/ 250-850
CALVERT, EDWARD (1799-1883) BRITISH
R/ 400-1200
CAMERON, KATE (1874-19615) BRITISH
I/ 100-300
CARROLL, JOHN (1892-1959) AMERICAN
P/ 100-200
CARTER, FREDERICK (1885-1967) BRITISH
I/ 50-500
CHAFFEE, ADA GILMOUR (1883-1955) AMERICAN
R/ 1500-5000*
CHAFFEE, OLIVER NEWBURY JR. (1881-1944) AMERICAN
R/ 750-2000*
CHARPENTIER, ALEXANDRE (1875-1963) FRENCH
P/ 400-850
CHASE, W. CORWIN (1897-1988) AMERICAN
R/ 300-850
CHESNEY, LEE R. (B. 1920) AMERICAN
I/ 200-400
CHEYNE, IAN (1895-1955) SCOTTISH
R/ 350-750
CHURCH, FREDERICK STUART (1842-1924) AMERICAN
I/ 100-300
CLARK, ROLAND (1874-1957) AMERICAN
I/ 200-750
COHN, MAX ARTHUR (B. 1908) AMERICAN
P/ 200-400
COLE, J. FOXCROFT (1837-1892) AMERICAN
I/ 150-300

Technique Key

Under each <u>printing technique</u> you may encounter the following types of prints (or combination of processes):

I <u>Intaglio:</u>

- etching
- drypoint
- steel engraving
- stipple engraving
- aquatint
- mezzotint
- soft-ground etching
- crayon manner

P <u>Planographic:</u>

- lithograph
- monotype
- silk-screen
- cliche verre
- serigraph

R <u>Relief:</u>

- wood block
 - woodcut
 - chiaroscuro
 - wood engraving
- linoleum cut (linocut)

COLE, TIMOTHY (1852-1931) AMERICAN
R/ 50-150
COLMAN, SAMUEL (1832-1920) AMERICAN
I/ 100-500
CONSTANT, GEORGE (B. 1892) AMERICAN
I/ 50-250
COPE, CHARLES (1811-1890) BRITISH
I/ 150-300
COTMAN, JOHN SELL (1782-1842) BRITISH
I/ 250-500
COWERN, RAYMOND (B. 1913) BRITISH
I/ 50-150
CRANE, ALAN (1901-1969) AMERICAN
P/ 100-250
CRESWICK, THOMAS (1811-1869) BRITISH
I/ 150-300
CROME, JOHN (1768-1821) BRITISH
I/ 200-800

D

DAGLISH, ERIC (1894-1966) BRITISH
R/ 50-150
DAWSON, NELSON (1859-1941) BRITISH
I/ 100-250
DAY, RICHARD (1896-1972)
P/ 200-500
DAY, WORDEN (1916-1986) AMERICAN
R/ 400-1000
DECKER, ALBERT (B. 1919) AMERICAN
P/ 100-300
DEHAAS, MAURITZ FREDERICK HENDRIK (1832-1895)
DUTCH/AMERICAN
I/ 75-250
DEHNER, DOROTHY (B. 1901) AMERICAN
I/ 400-800
DESMAZIERES, ERIK (B. 1948) FRENCH
I/ 500-1500
DEVERIA, ACHILLE (1800-1857) FRENCH
P/ 200-500

DEWOLF, WALLACE (1854-1930) AMERICAN
 I/ 50-150
DIELMAN, FREDERICK (1847-1935) AMERICAN
 I/ 50-300
DOI, ISAMI (1903-1965) AMERICAN
 R/ 350-1200
DUPONT, PIETER (1870-1911) DUTCH
 I/ 100-400
DUPRE, JULES (1811-1889) FRENCH
 P/ 100-400
DURAND, ASHER (1796-1886) AMERICAN
 I/ 500-3500*
DURLEUX, CAROLINE (B. 1896) AMERICAN
 P/ 100-600

E

EDMONDSON, LEONARD (B. 1916) AMERICAN
 I/ 300-750
EXLEY, J.R.G. (1878-1967) BRITISH
 I/ 100-450

F

FABRI, RALPH (1894-1975) AMERICAN
 I/ 200-400
FALCONER, JOHN M. (1820-1903) AMERICAN
 I/ 50-200
FALILEEF, VADIM DMITRI (1879-1948) RUSSIAN
 R/ 300-750
FARRER, HENRY (1843-1903) AMERICAN
 I/ 50-400
FAY, CLARK (1894-1956) AMERICAN
 I/ 200-750
FEITELSON, LORSER (1898-1978) AMERICAN
 P/ 500-1200*

FERREN, JOHN (1905-1970) AMERICAN
 I/ 500-1000* R/ 500-1500*
FISKE, GERTRUDE (1879-1961) AMERICAN
 I/ 200-500
FITTON, HEDLEY (1859-1929) BRITISH
 I/ 50-250
FLOETHE, RICHARD (1901-1988) AMERICAN
 P/ 200-400
FRANK, LEO (B. 1884) AUSTGRIAN
 R/ 200-350
FULLER, SUE (B. 1914) AMERICAN
 I/ 200-600
FULWIDER, EDWIN (20TH C) AMERICAN
 P/ 100-500

G

GANDARA, ANTONIO DE LA (1862-1917) FRENCH
 P/ 300-600
GASKELL, PERCIVAL (1868-1934) BRITISH
 I/ 100-300
GEARHART, MAY (1872-1951) AMERICAN
 I/ 200-500
GELLERT, HUGO (B. 1892) HUNGARIAN/AMERICAN
 P/ 250-850
GIBBINGS, ROBERT (1889-1958) BRITISH
 R/ 50-400
GIFFORD, ROBERT SWAIN (1840-1905) AMERICAN
 I/ 100-500
GILES, WILLIAM (1872-1939) BRITISH
 I/ 200-500 R/ 200-500
GLINTENKAMP, HENRY (1887-1946) AMERICAN
 R/ 100-300
GOODEN, STEPHEN (B. 1892) BRITISH
 I/ 100-300
GOSSE, SYLVIA (1881-1968) BRITISH
 I/ 250-400
GOTTLIEB, HARRY (B. 1894) AMERICAN
 I/ 50-250
GREAVES, WALTER (1846-1930) BRITISH

I/ 200-400
GREENWOOD, MARION (1909-1970) AMERICAN
 P/ 100-300
GROSS, ANTHONY (1905-1984) BRITISH
 I/ 300-600
GROSS-BETTELHEIM, JOLAN (B. 1900) AMERICAN
 I/ 500-3000 P/ 1000-10000*

H

HALL, NORMA BASSETT (1889-1957) AMERICAN
 R/ 400-800
HALL, OLIVER (1869-1957) BRITISH
 I/ 100-200
HANDFORTH, THOMAS (1897-1948) AMERICAN
 I/ 50-150
HARARI, HANANIAH (B. 1912) AMERICAN
 P/ 400-800
HARDIE, MARTIN (1875-1952) BRITISH
 I/ 50-250
HARKER, KATHARINE VAN DYKE (1872-1966) AMERICAN
 R/ 300-600
HAUPERS, CLEMENT (B. 1900) AMERICAN
 I/ 100-400
HAVENS, JAMES D. (B. 1900) AMERICAN
 R/ 150-350
HAY, JAMES HAMILTON (1874-1916) BRITISH
 I/ 50-200
HAZEN, BESSIE ELLA (1861-1946) AMERICAN
 R/ 100-300
HECKMAN, ALBERT (1893-1971) AMERICAN
 I/ 150-500 P/ 200-500
HEINS, JOHN (1896-1960) AMERICAN
 P/ 100-300
HENDERSON, LESLIE (B. 1895) AMERICAN
 I/ 75-250
HERVIER, ADOLPHE (1821-1879) FRENCH
 I/ 100-500
HEYMAN, CHARLES (1881-1915) BRITISH
 I/ 100-250

HIGGINS, EUGENE (1874-1958) AMERICAN
I/ 50-250
HNIZDOVSKY, JACQUES (1915-1985) AMERICAN
R/ 50-400
HOBART, CLARK (1868-1948) AMERICAN
P/ 300-600
HOOK, JAMES (1819-1907) BRITISH
I/ 100-300
HOWARTH, ALBANY E. (1872-1936) BRITISH
I/ 50-150
HUGO, IAN (1900-1984) AMERICAN
I/ 200-450
HUNT, WILLIAM HOLMAN (1827-1910) BRITISH
I/ 250-800
HUNT, WILLIAM MORRIS (1824-1879) AMERICAN
P/ 500-1500*
HUTCHINSON, LEONARD (1896-1980) CANADIAN
R/ 100-300
HUTTY, ALFRED (1877-1954) AMERICAN
I/ 200-450

J

JACOBI, ELI (1898-1984) AMERICAN
R/ 100-800
JACQUEMART, JULES (1837-1880) FRENCH
I/ 100-600
JANES, NORMAN (B. 1892) BRITISH
I/ 50-200
JOHNSON, SARGENT CLAUDE (1888-1967) AMERICAN
P/ 200-500
JOHNSTON, DAVID CLAYPOOL (1797-1865) AMERICAN
I/ 300-500
JO MESS, GEORGE (1898-1962) AMERICAN
I/ 100-400
JUDSON, JANE BERRY (20TH C) AMERICAN
R/ 200-400
JULES, MERVIN (B. 1912) AMERICAN
P/ 100-400 R/ 75-150

K

KEENE, CHARLES (1823-1891) BRITISH
 I/ 100-350
KELLY, JOHN MELVILLE (B. 1879) AMERICAN
 P/ 100-400
KENT, NORMAN (1903-1972) AMERICAN
 R/ 50-150
KINNEY, TROY (1871-1938) AMERICAN
 I/ 50-200
KIPNISS, ROBERT (B. 1931) AMERICAN
 P/ 200-600
KNATHS, KARL (1891-1971) AMERICAN
 P/ 250-500 R/ 1000-1800
KNIGHT, CLAYTON (B. 1891) AMERICAN
 P/ 100-250
KOMJATI, JULIUS (1894-1958) HUNGARIAN
 I/ 50-250
KOVNER, SAUL (B. 1904) AMERICAN
 P/ 150-500
KRASNOW, PETER (1887-1980) AMERICAN
 P/ 400-1000
KUPFERMAN, LAWRENCE (B. 1909) AMERICAN
 I/ 250-1500

L

LACY, LUCILE LAND (B. 1901) AMERICAN
 P/ 100-400
LANDON, EDWARD (1911-1984) AMERICAN
 P/ 300-700
LANFAIR, HARRIET KEESE (B. 1900) AMERICAN
 P/ 100-200
LANKES, JULIUS J. (1884-1960) AMERICAN
 R/ 75-250
LARKINS, WILLIAM (1901-1974) BRITISH
 I/ 50-300
LATHROP, DOROTHY (B. 1891) AMERICAN
 P/ 500-200

Technique Key

Under each <u>printing technique</u> you may encounter the following types of prints (or combination of processes):

I <u>Intaglio:</u>
- etching
- drypoint
- steel engraving
- stipple engraving
- aquatint
- mezzotint
- soft-ground etching
- crayon manner

P <u>Planographic:</u>
- lithograph
- monotype
- silk-screen
- cliche verre
- serigraph

R <u>Relief:</u>
- wood block
 - woodcut
 - chiaroscuro
 - wood engraving
- linoleum cut (linocut)

LEAR, EDWARD (1812-1888) BRITISH
 P/ 100-450
LEE, DORIS (1905-1983) AMERICAN
 P/ 100-300
LEE, SYDNEY (1866-1949) BRITISH
 I/ 50-250
LEITHAUSER, MARK (B. 1950) AMERICAN
 I/ 500-1000
LINDSAY, LIONEL (1874-1961) AUSTRALIAN
 R/ 100-400
LITTEN, SIDNEY M. (1887-1949) BRITISH
 I/ 50-250
LOGAN, ROBERT (B. 1890) AMERICAN
 I/ 50-200
LOGGIE, HELEN A. (D. 1976) AMERICAN
 I/ 50-100
LOVET-LORSKI, BORIS (1894-1973) LITHUANIAN-AMERICAN
 P/ 400-800
LOWELL, NAT (B. 1880) AMERICAN
 I/ 100-400
LOWENGRUND, MARGARET (1905-1957) AMERICAN
 P/ 200-500
LUCAS, DAVID (1802-1881) BRITISH
 I/ 150-1500
LUNDBERG, HELEN (B. 1908) AMERICAN
 P/ 300-1000

M

MACBETH-RAEBURN, HENRY (1869-1947) BRITISH
 I/ 50-200
MACLAUGHLAN, DONALD SHAW (1876-1938) CANADIAN/AMERICAN
 I/ 100-250
MACLEOD, WILLIAM DOUGLAS (1892-1963) BRITISH
 I/ 50-200
MACNAB, IAIN (1890-1967) BRITISH
 R/ 50-300
MAGAFAN, ETHEL (B. 1916) AMERICAN
 P/ 100-400
MAGAFAN, JENNE (1916-1952) AMERICAN

P/ 100-400
MALET, GUY (1900-1973) BRITISH
R/ 50-200
MANDELMAN, BEATRICE (B. 1912) AMERICAN
P/ 200-500
MARTIN, FLETCHER (1904-1979) AMERICAN
P/ 300-1500
MASON, ALICE TRUMBULL (1904-1971) AMERICAN
I/ 1000-2000
MAZUR, MICHAEL (B. 1935) AMERICAN
I/ 300-1500 P/ 300-3000
MCCLELLAN, JOHN (1808-1886) AMERICAN
P/ 200-500
MCVICKER, JAY (B. 1911) AMERICAN
I/ 300-700
MEESER, LILIAN (1864-1942) AMERICAN
R/ 500-1200
MEISSNER, LEO (B. 1895) AMERICAN
R/ 50-500
MEISSONIER, JEAN LOUIS ERNEST (1815-1891) FRENCH
I/ 100-500
MENIHAN, JOHN (B. 1908) AMERICAN
I/ 150-500
MERSHIMER, FREDERICK (B. 1958) AMERICAN
I/ 150-500
MESSENGER, IVAN (1895-1983) AMERICAN
P/ 150-300
MEYEROWITZ, WILLIAM (B. 1908) AMERICAN
I/ 250-750
MIELATZ, CHARLES FREDERICK (1864-1919) AMERICAN
I/ 200-600
MILLER, LILLIAM MAY (1895-1945) AMERICAN
R/ 100-300
MONKS, JOHN AUSTIN (1850-1917) AMERICAN
I/ 75-250
MORAN, MARY NIMMO (1842-1899) AMERICAN
I/ 150-750
MORGAN, WILLIAM E.C. (B. 1903) BRITISH
I/ 100-300
MORTIMER, JOHN HAMILTON (1740-1779) BRITISH
I/ 200-500
MORTON, CONCORD AND CAVENDISH (B. 1911) BRITISH
R/ 250-500
MOY, SEONG (B. 1921) AMERICAN

R/ 500-2000
MUENCH, JOHN (B. 1914) AMERICAN
 P/ 300-500 R/ 300-500
MULLINEUX, MARY (1875-1965) AMERICAN
 R/ 800-2500*
MURPHY, JOHN J.A. (1888-1967) AMERICAN
 R/ 1000-3500
MYERS, JEROME (1867-1940) AMERICAN
 I/ 100-500

N

NAGLER, FRED (B. 1891) AMERICAN
 I/ 50-100
NANKIVELL, FRANK (B. 1869) AMERICAN
 I/ 100-300
NANTEUIL, CELESTIN (1813-1873) FRENCH
 I/ 100-400
NICHOLL, JAMES C. (1847-1918) AMERICAN
 I/ 50-200
NIXON, JOB (1891-1938) ENGLISH
 I/ 100-300
NORTON, ELIZABETH (B. 1887) AMERICAN
 R/ 200-500

O

OGILVIE, HELEN (B. 1902) AUSTRALIAN
 R/ 100-250
OLDS, ELIZABETH (B. 1896) AMERICAN
 P/ 500-1000
O'NEILL, GEORGE BERNARD (1828-1917) BRITISH
 I/ 50-200
OSBORNE, MALCOLM (B. 1880) BRITISH
 I/ 50-300

P

PAXTON, WILLIAM (1869-1941) AMERICAN
 I/ 400-1200
PEAVY, PAULINA (B. 1901) AMERICAN
 R/ 100-200
PECK, EDIKTH HOGEN (B. 1884) AMERICAN
 I/ 100-250
PETERS, ROBERT C. (B. 1888) BRITISH
 I/ 100-250
PETERSEN, MARTIN (1866-1956) AMERICAN
 I/ 150-600
PICKHARDT, CARL (B. 1908) AMERICAN
 P/ 150-450
PINTO, ANGELO (B. 1908) AMERICAN
 R/ 150-600
PINTO, SALVATORE (1905-1966) AMERICAN
 R/ 150-600
PITTMAN, HOBSON (1900-1972) AMERICAN
 R/ 200-300
PLATT, CHARLES ADAMS (1861-1933) AMERICAN
 I/ 150-500
POND, CLAYTON (B. 1941) AMERICAN
 I/ 100-300
PREISSIG, VOJTECH (1873-1944) CZECHOSLOVAKIAN
 I/ 200-400
PROUVE, VICTOR (1853-1943) FRENCH
 I/ 200-800
PULSIFER, MINA (B. 1899) AMERICAN
 P/ 200-400
PYTLACK, LEONARD (B. 1910) AMERICAN
 P/ 300-750 R/ 250-500

R

RAFFET, AUGUSTE (1804-1860) FRENCH
 P/ 100-500
RATHBONE, AUGUSTA (B. 1897) AMERICAN
 I/ 200-500

REED, DOEL (B. 1894) AMERICAN
 I/ 200-600
REIN, HARRY (B. 1914) AMERICAN
 P/ 200-400
RENOUARD, PAUL (1845-1924) FRENCH
 I/ 200-500
RICE, WILLIAM S. (1873-1963) AMERICAN
 R/ 300-750
RICKETTS, CHARLES (1866-1931) BRITISH
 R/ 100-400
RIST, LUIGI (1888-1959) AMERICAN
 R/ 1000-2500
ROBERTSON, DAVID (B. 1885) BRITISH
 I/ 50-200
ROBERTSON, PERCY (1869-1934) ENGLISH
 I/ 50-200
ROBINS, WILLIAM P. (1882-1959) BRITISH
 I/ 50-250
ROBINSON, BOARDMAN (1876-1952) AMERICAN
 P/ 100-400
ROGALSKI, WALTER (B. 1925) AMERICAN
 I/ 100-400
ROSE, RUTH STARR (1887-1965) AMERICAN
 P/ 200-400
ROSENBERG, JAMES N. (1874-1970) AMERICAN
 P/ 400-800
ROYDS, MABEL A. (1874-1941) BRITISH
 R/ 200-600
RUELLAN, ANDREE (B. 1905) AMERICAN
 P/ 100-250
RUSHBURY, SIR HENRY (1880-1968) BRITISH
 I/ 100-250
RUSSELL, SHIRLEY (B. 1886) AMERICAN
 R/ 150-350
RUZICKA, RUDOLPH (1883-1962) AMERICAN
 R/ 100-400

S

SALEMME, LUCIA (B. 1919) AMERICAN
R/ 250-450
SANDBY, PAUL (1730-1809) BRITISH
I/ 100-750
SANDZEN, BIRGER (1871-1954) SWEDISH/AMERICAN
R/ 150-450
SARGENT, JOHN SINGER (1856-1925) AMERICAN
P/ 7500-20000*
SCHALDACH, WILLIAM (B. 1896) AMERICAN
I/ 150-400
SCHILLING, ALEXANDER (1859-1937) AMERICAN
I/ 100-300
SCHOPPE, PALMER (B. 1912) AMERICAN
P/ 300-750
SCHREIBER, GEORGE (B. 1904) AMERICAN
P/ 100-300
SCHWARTZ, WILLIAM S. (1896-1933) AMERICAN
P/ 400-1200
SCOTT, STANLEY (20TH C) AMERICAN
R/ 150-350
SEABY, ALLEN (1867-1953) BRITISH
R/ 400-800
SENSENEY, GEORGE (1874-1943) AMERICAN
I/ 300-750
SHARP, WILLIAM (1803-1875) AMERICAN
P/ 100-2000
SHARPE, WILLIAM (1900-1961) AMERICAN
I/ 200-400
SHERMAN, RUSSELL (20TH C) AMERICAN
P/ 50-200
SHORE, HENRIETTE (1880-1963) AMERICAN
P/ 300-500
SIMPSON, JOSEPH (1879-1939) BRITISH
I/ 100-200
SMART, DOUGLAS IAN (1879-1970) BRITISH
I/ 50-200
SMITH, DAVID (B. 1906) AMERICAN
P/ 1500-10000*
SMITH, PERCY (1882-1948) BRITISH
I/ 50-300
SMITH, WUANITA (1866-1959) AMERICAN
R/ 500-1500
SPARKS, NATHANIEL (1880-1957) BRITISH
I/ 100-250

Technique Key

Under each <u>printing technique</u> you may encounter the following types of prints (or combination of processes):

I <u>Intaglio:</u>

- etching
- drypoint
- steel engraving
- stipple engraving
- aquatint
- mezzotint
- soft-ground etching
- crayon manner

P <u>Planographic:</u>

- lithograph
- monotype
- silk-screen
- cliche verre
- serigraph

R <u>Relief:</u>

- wood block
 - woodcut
 - chiaroscuro
 - wood engraving
- linoleum cut (linocut)

SPENCER, NILES (1893-1952) AMERICAN
P/ 5000-15000*
STEFFEN, BERNARD (1907-1980) AMERICAN
P/ 300-800
STORRS, JOHN (1885-1956) AMERICAN
R/ 500-3500*
STRANG, IAN (B. 1886) SCOTTISH
I/ 100-400
SURENDORF, CHARLES (B. 1906) AMERICAN
R/ 100-300
SWANN, JAMES (1905-1985) AMERICAN
I/ 100-500
SZANTO, LOUIS (1889-1965) AMERICAN
I/ 50-200

T

TAKAL, PETER (B. 1905) AMERICAN
I/ 300-750
TANNER, ROBIN (B. 1904) BRITISH
I/ 200-850
TAYLOR, CHARLES WILLIAM (1878-1960) BRITISH
I/ 50-150
TAYLOR, GRACE MARTIN (B. 1903) AMERICAN
R/ 1000-2500*
THRASH, DOX (B. 1892) AMERICAN
I/ 200-400
TROY, ADRIAN (B. 1901) AMERICAN
R/ 100-250
TUBIS, SEYMOUR (B. 1919) AMERICAN
I/ 200-500
TURNBULL, JAMES (1907-1977) AMERICAN
P/ 300-600
TUSHINGHAM, SIDNEY (1884-1968) BRITISH
I/ 100-300

U

UCHIMA, ANSEI (B. 1921) AMERICAN
　R/ 400-900
UNWIN, NORA (1907-1982) AMERICAN
　R/ 50-250
URBAN, ALBERT (B. 1911) AMERICAN
　P/ 200-400

V

VALERIO, ALESSANDRO MASTRO (1887-1953) AMERICAN
　I/ 200-400
VAN ELTEN, KRUSEMAN (1829-1904) DUTCH/AMERICAN
　I/ 50-200
VAN VLIET, CLAIRE (B. 1933) CANADIAN-AMERICAN
　P/ 100-250
VELONIS, ANTHONY (B. 1911) AMERICAN
　P/ 150-1500
VOGEL, DONALD (B. 1917) AMERICAN
　I/ 200-600
VONDROUS, JAN C. (B. 1884) CZECH
　I/ 50-250
VON NEUMANN, ROBERT (B. 1888) AMERICAN
　P/ 50-150
VONWICHT, JOHN (1888-1970) AMERICAN
　P/ 400-700

W

WACKERNAGEL, OTTO (B. 1885) AMERICAN
　I/ 50-150
WALD, SYLVIA (B. 1915) AMERICAN
　P/ 500-1500
WALES, GEORGE C. (1868-1940) AMERICAN

I/ 50-250 P/ 100-300
WARD, JAMES (1769-1859) BRITISH
 P/ 500-1500
WARD, LYND (1905-1985) AMERICAN
 R/ 50-250
WARING, LAURA WHEELER (1877-1948) AMERICAN
 R/ 100-300
WARLOW, HERBERT GORDON (1885-1942) BRITISH
 I/ 50-150
WARSAGER, HYMAN (1909-1974) AMERICAN
 P/ 150-300
WARTHEN, FEROL (1890-1987) AMERICAN
 R/ 750-2500*
WASHBURN, CADWALLADER (1866-1965) AMERICAN
 I/ 50-250
WATERS, HERBERT (B. 1903) AMERICAN
 R/ 50-200
WAY, THOMAS (1862-1913) BRITISH
 P/ 100-350
WAYNE, JUNE (B. 1918) AMERICAN
 P/ 500-2500
WEIDENAAR, REYNOLD (1915-1985) AMERICAN
 I/ 500-2500
WENDELL, THEODORE (1859-1932) AMERICAN
 I/ 200-500
WEIR, J. ALDEN (1852-1919) AMERICAN
 I/ 500-2000*
WHEETE, GLENN (B. 1884) AMERICAN
 R/ 100-300
WHYDALE, ERNEST HERBERT (1886-1952) BRITISH
 I/ 50-200
WICKEY, HARRY (B. 1892) AMERICAN
 I/ 100-300
WILBUR, LAWRENCE (B. 1897) AMERICAN
 I/ 200-400 R/ 200-400
WILKIE, SIR DAVID (1785-1841) BRITISH
 I/ 100-400
WILKINS, GLADYS M. (B. 1907) AMERICAN
 R/ 75-200
WILKINSON, NORMAN (1878-1971) BRITISH
 I/ 50-200
WOICESKE, RONAU (1887-1953) AMERICAN
 I/ 100-200
WOOD, THOMAS WATERMAN (1823-1903) AMERICAN

I/ 250-1500
WRIGHT, JOHN BUCKLAND (1897-1954) BRITISH
 I/ 100-400

Z

ZORACH, MARGUERITE (1887-1968) AMERICAN
 R/ 500-2500*
ZORACH, WILLIAM (1887-1966) AMERICAN
 R/ 1000-3500*
ZSISSLY, MALVIN MARR ALBRIGHT (B. 1897) AMERICAN
 P/ 100-250

APPENDIX

BIBLIOGRAPHY

AMERICAN PRINTS

Acton, David. *A Spectrum of Innovation; Color in American Printmaking 1890-1960*. New York: W.W. Norton & Co., 1990

Adams, Clinton. *American Lithographers, Nineteen Hundred to Nineteen Sixty: The Artists & Their Printers*. Apollo.

Art & Commerce: American Prints of the Nineteenth Century. University Press of Virginia, 1978.

Bruhn, Thomas P.. *American Etchings: The 1880's*. Storrs, Connecticut: Benton, Museum of Art, 1985

Carey, Francis and Griffiths, Anthony. *American Prints 1879-1979*. London, The British Museum, 1980

Dolmetsch, Joan D. *Eighteenth-Century Prints in Colonial America: To Educate & Decorate*. University Press of Virginia, 1979.

Falk, Peter Hastings. *Who Was Who in American Art*. Sound View Press, 1985

Feinblatt, Ebria and Davis, Bruce. *Los Angeles Prints 1883-1980*. Los Angeles : Los Angeles County Museum of Art, 1980

Field, Richard S. et al. *American Prints 1900-1950*. New Haven : Yale University Art Gallery, 1983.

Fielding, Mantle. *American Engravers upon Copper & Steel*. B. Franklin, 1964. Reproduction of 1917 edition.

Flint, Janet. *Provincetown Printers: A Woodcut Tradition*. Washington: Smithsonian Institution Press, 1983.

Fowble, E. McSherry. *Two Centuries of Prints in America, 1680-1880:*

A Selective Catalogue of the Winterthur Collection. University Press of Virginia, 1988.

Getscher, Robert H. and Staley, Allen. *The Stamp of Whistler.* Oberlin, Ohio: Allen Memorial Art Museum, 1977

Hitchings, Sinclair; Lewis, R.E.; Vershbow, Arthur. *Print Collecting Today*—A Symposium. Boston: Boston Public Library, 1969.

Jacobowitz, Ellen S. and Marcus, George. *American Graphics 1860 - 1940.* Philadelphia; Philadelphia Museum of Art, 1982.

Johnson, Deborah J., and Urbanelli, Lora S. *American Prints Eighteen Seventy to Nineteen Fifty: Whistler to Weidenaar.* Museum of Art Rhode Island, 1987.

Johnson, Una. *American Prints and Printmakers.* Garden City, New York: Doubleday & Co., 1980.

Kraeft, June and Norman. *Great American Prints 1900-1950.* New York: Dover Publications, 1984

Munsing, Stephanie A., ed. *Made in America: Printmaking, 1760-1860).* Library Co. Philadelphia, 1973.

Museum of Graphic Art. *American Printmaking: The First 150 Years.* Washington, D.C.: Smithsonian Institution Press, 1972.

Museum of Mordern Art, New York, *American Prints 1960-1985,* In The Collection of the Museum of Modern Art; Princeton New Jersey, Princeton University Press, 1986

O'Gorman, James F., ed. *Aspects of American Printmaking, 1800-1950.* Syracuse University Press, 1988

Reaves, Wendy Wick, ed. *American Portrait Prints.* Charlottesville: University of Virginia Press, 1984.

Reese, Albert. *American Prize Prints of the 20th Century.* New York: American Artists Group, 1949.

Reps, John W. *Cities on Stone: Nineteenth Century Lithograph Images of the Urban West.* Univ. of Texas Press: Amon Carter, 1976.

Tatham, David, ed. *Prints & Printmakers of New York State, 1825-1940.* Syracuse University Press, 1986.

Tyler, Francine. *American Etchings of the Ninteenth Century*, New York : Dover Publications, 1984

Tyler, Ron, ed. *Prints of the American West*. Fort Worth: Amon Carter Museum 1983.

Watrous, James. *A Century of American Printmaking, 1880- 1980.* University of Wisconsin Press, 1984.

Whitehill, Walter M., and Hitchings, Sinclair H., eds. *Boston Prints & Printmakers, Sixteen Seventy to Seventeen Seventy-Five.* Published by Colonial Society MA. University Press of Virginia, 1973.

Williams, Reba and Dave. *American Screenprints*. New York: National Academy of Design, 1987.

Wilson, Raymond L. *Index of American Print Exhibitions, 1882-1940.* Scarecrow, 1988.

Young, W. *Dictionary of American Artists, Sculptors & Engravers.* Apollo.

GENERAL

American Lithographers 1900-1960: The Artists & Their Printers. Univ. of New Mexico Press, 1987.

Baas, Jacquelynn and Field, Richard S. *The Artistic Revival of the Woodcut in France 1850-1900.* Ann Arbor: University of Michigan, 1984

Bridgewater, Alan & Bridgewater, Gill. *Printing with Wood Blocks, Stencils & Engravings.* Arco, 1983.

Buckland-Wright, John *Etching & Engraving.* Dover, 1973.

Carlson, Victor and Ittlmann, John. *Regency to Empire, French Printmaking 1715-1814.* Minneapolis: Minneapolis Institute of Arts, 1984

Carey, Francis and Griffiths, Anthony. *From Manet to Toulouse-Lautrec.* London: British Museum, 1978

Carey, Francis and Griffiths, Anthony. *The Print in Germany 1880-1933.* New York: Harper and Row. 1984.

Chamberlain, Walter. *The Thames & Hudson Manual of Etching & Engraving.* Thames Hudson, 1978.

Cleaver, James. *History of Graphic Art.* Greenwood, 1963.

Buchwald, Emilie, ed. *One-of-a-Kind Monoprints: A Creative Process.* Forecast Pap., 1984.

Dyson, Anthony. *Pictures to Print: The Nineteenth- Century Engraving Trade.* Book Press Ltd., 1985.

Eichenberg, Fritz. *The Art of the Print.* New York: Abrams, 1976

Getlein, Frank and Dorothy. *The Bite of the Print.* New York: Clarkson N. Potter, 1963.

Gilmour, Pat. *Modern Prints.* London: Studio Vista, 1970.

Gingold, Diane J., ed. *Master Prints from the Fifteenth Through Eighteenth Centuries.* Montgomery Museum, 1977.

Godfrey, Richard T. *Printmaking in Britain.* New York: New York University Press, 1978.

Guichard, Kenneth. *British Etchers 1850-1940.* london: Robin Gaston, 1983

Haab, Armin. *Mexican Graphic Art.* English edition. Switzerland: C.C. Palmer, 1957.

Harper, J. Russell. *Early Painters & Engravers in Canada.* Apollo, 1981.

Hayter, Stanley William. *About Prints.* London: Oxford University Press, 1962.

Heller, Reinhold, et. al., *Brucke, German Expressionist Prints from the Granvil and Marcia Specks Collection.* Evanston: Northwestern University, 1988.

Hind, Arthur M. *History of Engraving & Etching: From the Fifteenth Century to the Year 1914.* Dover, 1923.

Hind, Arthur M. *A History of Engraving and Etching.* London and New York, 1935. Reprint. New York: Dover Publications, 1963.

Ives, Colta Feller. *The Great Wave: The Influence of Japanese Woodcuts on French Prints.* New York: Metropolitan Museum of Art, 1974.

Ivins, William M., Jr. *Notes on Prints*. Cambridge: M.I.T. Press, 1967.

Ivins, William M., Jr. *Prints & Books*. Da Capo, 1969.

Johnson, Diane and Schrader, J.L. *1450-1550: The Golden Age of Woodcut. The Woodcut Revival 1800-1925*. Lawrence, Kan.: University of Kansas Museum of Art, 1968.

Johnson, Una E. *Ambrose Vollard, Editeur*. New York: Museum of Mordern Art, 1977

Karpinski, Caroline. *Italian Printmaking, Fifteenth & Sixteenth Centuries: An Annotated Bibliography*. G.K. Hall, 1987.

Lieberman, William S. "Prints" in *German Art of the Twentieth Century*. New York: Museum of Modern Art, 1957.

Ludman, Joan, and Mason, Lauris. *Fine Print References: A Selected Bibliography of Print-Related Literature*. Sirefman, Carol, ed.: Kraus International, 1982.

Man, Felix H. *Artists' Lithographs*. New York: G.P. Putnam's Sons, 1970.

Mason, Lauris, & Ludman, Joan, eds. *Print Collector's Quarterly: An Anthology of Essays on Eminent Printmakers of the World, 10 Volumes*. Kraus International, 1977.

Masterworks in Wood: The Woodcut Print, from the 15th to the Early 20th Century. Published by Portland Art Museum: University of Washington Press, 1976.

Mayor, A. Hyatt. *The Metropolitan Museum Guide to the Collections-Prints*. New York: Metropolitan Museum of Art, 1964.

Museum of Modern Art. *The Abby Aldrich Rockefeller Print Room*. New York, 1949. New York, 1958.

Opitz, Glenn B. *Mantle Fieldings Dictionary of American Painters, Sculptors, and Engravers*. 2nd revised edition. Apollo, 1986

The Painterly Print; Monotypes from the Seventeenth to the Twentieth Century. New York: Metropolitan Museum of Art, 1980.

Passeron, Roger. *French Prints of the 20th Century*. New York: Praeger, 1970.

Peterdi, Gabor. *Great Prints of the World.* New York: Macmillan, 1969.

Print Reference Sources: A Selected Bibliography, 18th- 20th Centuries. 2nd edition: Kraus International, 1979.

Reed, Sue W. and Wallace, Richard. *Italian Etchers of the Renaissance and Baroque.* Boston: Museum of Fine Arts, 1989

Ross, John & Romano, Clare. *The Complete Intaglio Print.* Free Press, 1974.

Ross, John & Romano, Clare. *The Complete Screen Print & the Lithograph.* Free Press, 1974.

Sachs, Paul J. *Modern Prints and Drawings.* New York: Alfred A. Knopf, 1954.

Sheppard's International Directory of Print & Map Dealers. Published by Europa Publications Ltd., England. Seven Hills Books, 1987.

Shikes, Ralph e. *The Indignant Eye.* Boston: Beacon Press, 1969

Stubbe, Wolf. *Graphic Arts in the Twentieth Century.* New York: Praeger, 1963.

Urbanelli, Lora. *The Grosvenor School, British Linocuts Between the Wars.* Providence: Rhode Island School of Design, 1988

Weber, Wilhelm. *A History of Lithography.* London, Thames & Hudson, 1966.

Wechsler, Herman J. *Great Prints & Printmakers.* New York: Harry N. Abrams, 1967.

Weisberg, Gabriel P. *Social Concern and the Worker: French Prints from 1830-1910.* Salt Lake City: Utah Museum of Fine Arts, 1974.

Wilder, F. L. *How to Identify Old Prints.* London: G. Bell and Sons, 1969.

Zigrosser, Carl. *The Appeal of Prints.* Philadelphia: Leary's Book Co., 1970.

Zigrosser, Carl. *Prints and Their Creators, A World History.* New York: Crown Publishers, 1974.

CONTEMPORARY PRINTS

Ackley, Clifford S. *70's into 80's: Printmaking Now.* Boston: Museum of Fine Arts, 1987

Baro, Gene. *30 Years of American Printmaking.* New York: Brooklyn Museum, 1977

Bloch, E. Maurice. *Tamarind; A Renaissance of Lithography.* International Exhibitions Foundation, 1972

Castleman, Riva. *American Impressions: Prints Since Pollock.* New York: Knopf, 1985

Castleman, Riva. *Contemporary Prints.* New York: Viking Press, 1973.

Castleman, Riva. *Prints of the Twentieth Century.* London, Thames & Hudson, 1976

Field, Richard S., and Fine, Ruth E. *A Graphic Muse: Prints by Contemporary American Women.* Dist. by Rizzoli, 1987.

Field, Richard S. *Recent American Etching.* Middletown, Conn.: Davison Art Center, 1975.

Fine, Ruth E. *The 1980's: Prints from the Collection of Joshua P. Smith.* Washington National Gallery of Art, 1989.

Haslem, Jane. *The Innovators: Renaissance in American Printmaking.* Washington, D.C.: Haslem Fine Arts, 1973.

Johnson, Una E. *Ten Years of American Prints: 1947- 1956.* New York: Brooklyn Museum, 1956.

Smith, Selma. *Printworld Directory of Contemporary Prints and Prices, 1988-1989.* Printworld, 1988.

Tancock, John L. *Multiples — The First Decade.* Philadelphia: Philadelphia Museum of Art, 1971.

PRINT COLLECTING

Brown, J.H.V. *A Guide to Collecting Fine Prints*, Metuchen, NJ: Scarecrow Press, 1989

Calloway, Stephen. *English Prints for the Collector.* Overlook Press, 1981.

Donson, Theodore B. *Prints and the Print Market.* New York: T.Y. Crowell, 1977.

Foster, Donald L. *Prints in the Public Library.* Metuchen (N.J.): Scarecrow Press, 1973.

Gilmour, Pat. *Artists in Print: An Introduction to Prints & Printmaking.* Parkwest Publications, 1984.

Hayden, Arthur, and Blunt, Cyril G.E. *Chats on Old Prints.* London, Benn, 1957.

Hughes, Therle. *Prints for the Collector: British Prints from 1500 to 1900).* New York: Praeger, 1971.

Rosenwald, Lessing G. *Recollections of a Collector.* Jenkintown (Pa.): The Alverthorpe Gallery, 1976.

Salamon, Fernando. *A Collector's Guide to Prints and Printmakers from Durer to Picasso.* New York: American Heritage Press, 1972.

Shapiro, Cecile, and Mason, Lauris. *Fine Prints: Collecting, Buying & Selling.* New York: Harper & Row, 1976.

Simons, Rosemary. *Collecting Original Prints.* The Christies International Collectors Series: Mayflower Books. Smith Publishers, 1980.

Weitenkampf, Frank. *The Quest of the Print.* New York: Charles Scribner's Sons, 1932.

Zigrosser, Carl and Gaedhe, Christa M. *A Guide to the Collecting and Care of Original Prints.* New York: Crown Publishers, 1965.

PRINTMAKING

Alexander, Dorothy & Strauss, Walter L. *The German Single-Leaf Woodcut, 1600-1700.* 2 Volumes. Abaris Books, 1978.

Antreasian, Garo Z., and Adams, Clinton. *The Tamarind Book of Lithography: Art and Techniques.* New York: Harry N. Abrams, 1971.

Arnold, Grant. *Creative Lithography & How to Do It.* Dover, 1941.

Biggs, John R. *Classic Woodcut Art & Engraving: An International Collection & Practical Handbook.* England: Blandford Press, 1988.

Brunner, Felix A. *A Handbook of Graphic Reproductive Processes.* New York: Hastings House, 1962. 3rd ed., 1968.

Chatto, William A. *Treatise on Wood Engraving, Historical and Practical.* Gale, 1969.

Clark, Alvin L., Jr. *From Mannerism to Classicism: Printmaking in France, 1600-1660.* Baier, Lesley K., and Kenney, Elise K., eds. Yale Art Gallery, 1987.

Clemson, Katie, and Simmons, Rosemary. *The Complete Manual of Relief Printmaking.* Knopf, 1988.

Daniels, Harvey. *Printmaking.* New York: Viking Press, 1971.

Eichenberg, Fritz. *Lithography & Silkscreen - Art and Technique.* Apollo.

Field, Richard S., and Sperling, Louise. *Offset Lithography.* Middletown (Conn.): Davison Art Center, 1973.

Gilmour, Pt. *Lasting Impressions: Lithography as Art.* University of Pennsylvania Press, 1988.

Goldman, Judith. *American Prints: Process & Proofs.* Icon Editions Series. Harper Row, 1982.

Griffiths, Antony. *Prints & Printmaking: An Introduction to the History & Techniques.* Knopf, 1981.

Heller, Jules. *Printmaking Today: A Studio Handbook.* New York: Holt, Rinehart & Winston, 1972.

Hitchings, Sinclair. *The Flowering of American Printmaking.* Amon Carter Museum: U.of Texas Press, 1988.

Ivins, William M., Jr. *Prints & Books.* Da Capa, 1969.

Lehmann-Haupt, Hellmut. *An Introduction to the Woodcut of the Seventeenth Century.* Abaris Books, 1978.

Linton, W.J. *The History of Wood-Engraving in America.* Longwood Publications Group, 1977. Reproduction of 1882 edition library binding.

Peterdi, Gabor. *Printmaking Methods Old and New.* New York: Macmillan Company, 1971.

Rhein, Erich. *The Art of Print Making.* New York: Van Nostrand Reinhold Co., 1966. Ravensburg (German): Otto Maier Verlag, 1956.

Ross, John, and Romano, Clare. *The Complete Printmaker.* New York: Free Press (Macmillan Company), 1972.

Rothenstein, Michael. *Relief Printing.* New York: Watson-Guptill Publications, 1970.

Rumpel, Heinrich. *Wood Engraving.* Geneva: Editions de Bonvent, 1973.

Russ, Stephen. *A complete Guide to Printmaking.* New York: Viking Press, 1975.

Sopher, Marcus S., and Lazzaro-Bruno, Claudia. *Sixteenth-Century Italian Prints.* Galleries Coll., 1978.

Strauss, Walter L. *The German Single-Leaf Woodcut, 1550- 1600.* Abaris Books, 1976.

Tatham, David. *Prints & Printmakers of New York State, 1825-1940.* New York State Studies: Syracuse University Press, 1986.

Wallen, Burr, and Stein, Donna. *The Cubist Print.* University of Washington Press, 1981.

PRINT CONNOISSEURSHIP

Arnau, Frank. *Art of the Faker.* Boston: Little, Brown & Co., 1961.

Castleman, Riva. *Printed Art: A View of Two Decades.* Museum of Modern Art, 1979.

Churchill, W.A. *Watermarks in the XVII and XVIII Centuries.* Amsterdam, 1935. Reprint. Amsterdam: Menno Hertzberger & Co., 1965.

Druick, Douglas, and Gordon, Martin. *Buyer Beware!* New York: Martin Gordon Gallery, 1970.

Falk, Peter. *Print Price Index* (1991 Edition). Madison, Connecticut: Sound View Press, (September 1991)

Field, Richard S. *Everything you always wanted to know about prints...* Middletown (Conn.): Davison Art Center, 1973.

Gascoigne, Bamber. *How to Identify Prints: A Complete Guide to Manual and Mechanical Processes from Woodcut to Ink- Jet.* Thames Hudson, 1986.

Gordon, Martin. *Gordon's Print Price Annual, 1991.* Martin Gordon Inc., Naples, Florida,1991

Heawood, Edward. *Watermarks, Mainly of the 17th and 18th Centuries.* Hilversum, 1950. Reprint. 1969.

Hunter, Dard. *Papermaking.* New York: Alfred A. Knopf, 1967.

Ivins, William M., Jr. *How Prints Look.* Revised edition, Cohn, Marjorie B., ed. Beacon Press, 1987.

Ivins, William M., Jr. *How Prints Look.* New York: Metropolitan Museum of Art, 1943. Reprint. Boston: Beacon Press, 1968.

Journal of the Print World. 1000 Winona Road, Meredith, NH 03253. Published quarterly (by subscription only).

Kurz, Otto. *Fakes.* New Haven, 1948. Rev'd ed. New York: Dover Publications, 1967.

Mayer, E. E. *Mayer 1991 International Auction Records.* Editions Publisol, 1991

Passeron, Roger. *Impressionist Prints.* S. Konecky Associates, 1988.

Print Collector's Newsletter., 16 East 82nd Street, NY, NY 10028. Published bi-monthly (by subscription only).

Print Quarterly. 80 Carlton Hill, London NW8 0ER, England. Published quarterly. (by subscription only).

Riggs, Timothy A. *The Print Council Index to Oeuvre- Catalogues of Prints by European & American Artists.* Kraus International, 1983.

Sachs, Samuel, and Johnson, Kathryn C. *Fakes and Forgeries.* Minneapolis: Minneapolis Institute of Arts, 1973.

CARE AND CONSERVATION OF PRINTS

Barrow, W.J. *The Barrow Method of Restoring Deteriorated Documents.* Richmond, Va.: W.J. Barrow Restoration Shop, 1973.

Clapp, Anne F. *Curatorial Care of Works of Art on Paper.* N. Lyons Books, 1987.

Clapp, Anne F. *Curatorial Care of Works of Art of Paper.* Oberlin, Ohio: Intermuseum Laboratory, 2d rev. ed., 1974.

Dolloff, Francis W., and Perkinson, Roy L. *How to Care for Works of Art of Paper.* Boston: Museum of Fine Arts, 1971.

Gaehde, Christa M. *The Care and Conservation of Fine Prints* in Zigrosser, Carl, and Gaehde, Christa M. *A Guide to the Collecting and Care of Original Prints.* New York: Crown Publishers, 1966.

Glaser, Mary Todd. *Framing & Preservation of Works of Art on Paper.* New York: Parke Bernet Galleries, 1971.

Haney, W.F. *Handbook of Paper Art Conservation.* 3rd edition. Art Conservation Handbook Series: Vol. IX. Acad. Prof. Art, 1983.

PRINT DEALERS

Beginning with this second edition, dealers in original fine art prints will be allowed to run either a simple listing in this section, or a display ad - up to a full page. If you are interested in a listing, or placing a display ad, please contact **Currier Publications**, P. O. Box 2098, Brockton, MA 02405 (tel: (508) 588-4509) for details.

ARIZONA

John Lawrence Fine Art
4160 North Craftsman Court, #201
Scottsdale, AZ 85251
Tel: (602) 994-3499
Fax: (602) 994-0481

ARKANSAS

Picturesque
4618 JFK Boulevard, #210
North Little Rock, AR 72116
(501) 834-0584

CONNECTICUT

Allinson Gallery, Inc.
46 Fieldstone Lane
Coventry, CT 06238
Tel: (203) 742-8990
Fax: (203) 742-5588
Member: Appraiser Assoc. of America

N.W. Lott
1771 Post Road East
Suite 271
Westport, CT 06880
Tel: (203) 221-0747
Fax: (203) 221-0756

(please see Display Ad)

MASSACHUSETTS

Rebecca Hoffmann
P.O. Box 269
Hudson, MA 01749
(508) 562-4716

William P. Carl
Astor Station
P.O. Box 600
Boston, MA 02123
(617) 353-1367

(please see Display Ad)

Ernest S. Kramer
Fine Art & Prints
P.O. Box 37
Wellesley Hills, MA 02181
Tel: (617) 237-3635
Fax: (617) 235-0112

(please see Display Ad)

VERMONT

Steven Thomas, Inc.
Box 41-CP
Woodstock, VT 05091
(802) 457-1764

(please see Display Ad)

NORTH CAROLINA

Seaside Art Gallery
Box 1 - Mile Post 11
Nags Head, NC 27959
Tel: (919) 441-5418
　　(800) 828-2444
Fax: (919) 441-8563

(please see Display Ad)

WANTED TO BUY

Fine old master and modern prints by
these and other artists

Arms	Escher	Marsh
Ault	Geerlings	Matisse
Avery	Goya	Matulka
Bacon	Haden	Meryon
Barker	Hartley	Millet
Baumann	Hassam	Moran
Bellows	Hayter	Munch
Benson	Heckel	Nason
Benton	Homer	Nordfeldt
Besnard	Hopkins	Pascin
Bone	Hopper	Patterson
Bonnard	Hunt	Pennell
Buhot	Kent	Picasso
Burchfield	Kirchner	Rembrandt
Burr	Kollwitz	Riggs
Cassatt	Kuniyoshi	Schanker
Chamberlain	Landacre	Sheeler
Coleman	Landeck	Sloan
Cook	Lazzell	Tissot
Corot	Lewis	Toulouse-Lautrec
Curry	Lozowick	Wengenroth
Davis	McBey	Whistler
Durer	Manet	Wood
Duveneck	Marin	Zorn

WILLIAM P. CARL

P.O. Box 600
Astor Station
Boston, MA 02123
(617) 353-1367

WANTED

Original etchings, engravings, lithographs and woodcuts
by the following artists :

Andrews	Gorky	Nevinson
Archipenko	Goya	Nicholson
Beckmann	Hamaguchi	Nolde
Bellows	Hasegawa	O'Conor
Bernard	Hassam	Palmer
Bevan	Hayter	Pechstein
Blake	Heckel	Picasso
Blampied	Helleu	Pissarro
Bomberg	Hockney	Prendergast
Bonnard	Homer	Ravilious
Bourgeois	Hopper	Redon
Braque	John	Renoir
Buffet	Kandinsky	Roussel
Calvert	Kirchner	Rouault
Cassatt	Kuniyoshi	Sargent
Cassigneul	Laurencin	Schanker
Chagall	Leger	Sheeler
Condor	Lewis	Sickert
Davis	Lozowick	Signac
Degas	Man Ray	Sloan
Delacroix	Manet	Smith
Delaunay	Marin	Spencer
Delvaux	Marsh	Stubbs
Dubuffet	Matisse	Sutherland
Duveneck	Meryon	Tissot
Feininger	Millet	Toulouse-Lautrec
Flight	Miro	Turner
Foujita	Morandi	Vuillard
Gainsborough	Moore	Wadsworth
Gauguin	Munch	Whistler
Gericault	Munakata	Zorach
Gill	Nash	Zorn

N. W. LOTT
1771 Post Road East, Suite 271
Westport, CT 06880

Tel. 203-221-0747 Fax 203-221-0756

Journal of the Print World

The Journal of the Print World is a quarterly publication devoted exclusively to information and advertisements concerning antique and modern works of art on paper from the past 6 centuries with a special interest in rare prints.

The Journal of the Print World has subscribers from all over the world who read articles on museum and gallery shows, art expositions and print shows, printmaking techniques, auction notices and reviews, in addition to advertisements from the finest galleries and expositions in the nation. The last issue was larger than *Time* and *Newsweek* combined, having 125 articles and over 200 advertisements from around the world.

Would you like a complimentary copy? Write to:

> **Mrs. Brenda Leighton**
> **Journal of the Print World**
> **1000 Winona Road**
> **Meredith, NH 03253-9599**

AUCTION HOUSES

Here is a list, worldwide, of those auction houses which sell a large volume of fine art prints each year. A good number have in-house print specialists who do the research on each consignment and see that it is properly catalogued.

Please keep in mind, most *major* auction houses today will not accept a single consignment unless it is valued at over $500. With prints you may find that the auction house will often suggest combining two or more prints together to make a "lot." Check the policies of each, when you initially contact them. In general, the commission rate charged the consignor will fall between 6% and 20%. The more valuable your piece, the lower the commission should be.

Kvaliten Auktionsverkeet
A B Stockholms Auktionsverk
Jacobgatan 10, Box 16356
103 25 Stockholm, Sweden
Tel# 08-14-24-40
Fax# 08-10-28-45

James R. Bakker Antiques Inc
370 Broadway
Cambridge, MA 02139
Tel# 617-864-7067

Galerie Gerda Bassenge
Erdener Strasse 5A
1000 Berlin 33, Germany
Tel# 030-8-92-90-13
Fax# 030-8-91-80-25

Bonhams
Montpelier Street
Knightsbridge
London SW7 1HH, England
Tel# 071-584-9161
Fax# 071-589-4072

Frank H. Boos Gallery
420 Enterprise Court
Bloomfield Hills, MI 48013
Tel# 313-332-1500
Fax# 313-332-6370

Butterfield & Butterfield
220 San Bruno Avenue
San Francisco, CA 94103
Tel# 415-861-7500
Fax# 415-861-8951

Christie's East
219 East 67th St
New York, NY 10021
Tel# 212-606-0400
Fax# 212-737-6076

Christie, Manson & Woods,
London
8 King St., St.James
London SW1Y 6QT, England
Tel# 071-839-9060
Fax# 071-839-1611

Christie, Manson & Woods,
New York
502 Park Ave
New York, NY 10022
Tel# 212-546-1000
Fax# 212-980-8163

Christie's South Kensington
85 Old Brompton Rd
London SW7 3JS, England
Tel# 071-581-7611
Fax# 071-584-0431

Bruce Collins
Seaboard Auction Gallery
Rte. 236 North
Eliot, ME
Tel# 207-452-2197

F. Dorling Buch Und
Kunstantiquariat
Neur Wall 40-42
2000 Hamburg 36, Germany
Tel# 040-36-67-07
Fax# 040-36-23-58

Dorotheum Kunstabteilung
Dorothegasse 17
1010 Vienna, Austria
Tel# 01-515-60-0
Fax# 01-515-60-443

William Doyle Galleries
175 East 87th St
New York, NY 10028
Tel# 212-427-2370
Fax# 212-369-0892

Hotel Druout
9, rue Druout
75009 paris, France
Tel# 14-246 17 11

Du Mouchelle Art Galleries
409 East Jefferson Ave
Detroit, MI 48226
Tel# 313-963-0248
Fax# 313-963-8199

Eberhart Auktionen
Seestrasse 13
8702 Zollikon 2, Switzerland
Tel# 01-392-02-30
Fax# 01 392-01-86

Robert C. Eldred Co., Inc.
Route 6A
East Dennis, MA 02641
Tel# 508-385-3116
Fax# 508-385-7201

Galerie Fischer
Haldenstrasse 19
CH-6006 Luzern, Switzerland
Tel# 041-51 57 72

Villa Grisbach
Fasanenstrasse 25
D-1000 Berlin 15, Germany
Tel# 030-882 68 11
Fax# 030-882 41 45

Grogan & Company
890 Commonwealth Ave.
Boston, MA 02215
Tel# 617-566-4100
Fax# 617-566-7715

Hartung & Hartung
Karolinenplatz 5A
D 8000 Munich 2, Germany
Tel# 089-28-40-34

Hauswedell & Nolte
Poseldorfer Weg 1
2000 Hamburg 13, Germany
Tel# 040-44-83-86
Fax# 040-4-10-41-98

Leslie Hindman
215 West Ohio
Chicago, IL 60610
Tel# 312-670-0100
Fax# 312-670-4248

Karl & Faber
Amirplatz 3
8000 Munich 2, Germany
Tel# 089-2-28-33-50

Galerie Wolfgang Ketterer
Brienner Strasse 25
8000 Munich 2, Germany
Tel# 089-59-11-81
Fax# 089-59-62-19

Galerie Koller
Ramistrasse 8
8024 Zurich, Switzerland
Tel# 01-47-50-40
Fax# 01-26-19-60-8

Galerie Kornfeld
Laupenstrasse 41
Bern, Switzerland
Tel# 41-31-26-46-73
Fax# 41-31-26-18-91

Kunsthallen
Kobmagergade 11
1150 Copenhagen K, Denmark
Tel# 33-13-85-69
Fax# 33-32-46-70

Kunsthaus Lempertz
Neumarkt 3
5000 Cologne 1, Germany
Tel# 0221-23-68-67
Fax# 0221-23-68-167

Litchfield Auction Gallery
Box 1337, Rte. 202
Litchfield, CT 06759
Tel# 203-567-3126

Neumeister Kunstauktionhaus
Barer Strasse 37
8000 Munich 40, Germany
Tel# 089-28-17-10-0
Fax# 089-23-17-10-55

Phillips, Son & Neale
11 New Bond Street
London W1Y 0AS, England
Tel# 01-629-6602
Fax# 01-629-8876

Poster Auctions International
37 Riverside Dr
New York, NY 10023
Tel# 212-787-4000
Fax# 212-877-2347

Arne Bruun Rasmussen
Bregade 33
1260 Copenhagen K, Denmark
Tel# 33-13-69-11
Fax# 33-32-49-20

Robert K. Skinner
2 Newbury St
Boston, MA 02116
Tel# 617-236-1700

Sotheby's, London
34 & 35 New Bond St
London W1A 2AA, England
Tel# 01-493-8080
Fax# 071-409-3100

Sotheby's, New York
1334 York Ave
New York, NY 10021
Tel# 212-606-7000
Fax# 212-606-7107

Swann Galleries
104 East 25th St
New York, NY 10010
Tel# 212-254-4710
Fax# 212-979-1017

Galerie Henner Wachholtz
Mittelweg 43
2000 Hamburg 13, Germany
Tel# 040-44-04-14

Waverly Auctions
4931 Cordell Ave, Ste AA
Bethesda, MD 20814
Tel# 301-951-8883

Weschler's
905 E Street NW
Washington, DC 20004
Tel# 202-628-1282
Fax# 202-628-2366

Winter Associates
21 Cooke St, Box 823
Plainville, CT 06062
Tel# 203-793-0288

Arno Winterberg
Blumenstrasse 15
6900 Heidelberg 1, Germany
Tel# 06-221-22-631
Fax# 06-221-164631

Wolf's Auction Gallery
1239 West 6th Street
Cleveland, OH 44113
Tel# 216-575-9653

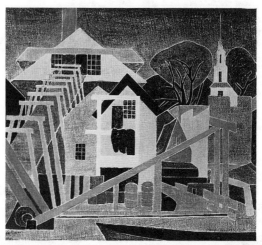

RESOURCES FOR PRICING

Reference Books

For a complete list of art and print references available, both "in print" and "out of print", please, write or call the following book dealers and request their catalog. These book dealers specialize in books dealing with fine art and prints. You should become familiar with all of the art and print price guides and print reference books available to you, before you start buying prints.

Fine Art and Print Books

NEW ENGLAND GALLERY
RR 2 BOX 959
WOLFEBORO, NH 03894

(603) 569-3501 (NH)
(305) 733-9237 (FL)

Dealer's Choice Books, Inc.
P. O. Box 710
Land O'Lakes, FL 34639
(please see Display Ad)

In Fla.:(813) 996-6599
(800) 238-8288 (toll free)

Fine Art and Print Books: Rare & Out of Print

JOSLIN HALL RARE BOOKS
P.O. BOX 516
CONCORD, MA 01742
(508) 371-3101

INSTITUTIONS

The following list is a compilation of those institutions, nationally, which house large collections of prints and are great resources for research. Many have extensive libraries as well as immense collections of fine art prints.

Achenbach Foundation for
 Graphic Arts
California Palace of the
 Leigon of Honor Museum
Lincoln Park
San Francisco, CA 94121

Addison Gallery of Amer. Art
Phillips Academy
Andover, MA 01810

Albright Knox Art Gallery
1285 Elmwood Ave
Buffalo, NY 14222

Allen Memorial Art Museum
OBerlin College
Oberlin, OH 44074

Alvethorpe Gallery
Lessing J.Rosenwald Collection
511 Meetinghouse Rd
Jenkintown, PA 19046

Art Institute of Chicago
Michigan and Adams
Chicago, IL 60611

Baltimore Museum of Art
Art Museum Dr
Baltimore, MD 21218

William Benton Museum of Art
University of Connecticut
Storrs, CT 06226

Boston Athenaeum
10 1/2 Beacon St
Boston, MA 02108
617-227-0270

Boston Public Library
Print Department
Dartmouth St
Boston, MA 02117

Brooklyn Museum
188 Eastern Pkwy
Brooklyn, NY 11238

Busch-Reisinger Museum
29 Kirkland St
Cambridge, MA 02138

Cincinnati Art Museum
Department of Prints
Eden Park
Cincinnati, OH 45202

Sterling & Francine Clark
Art Institute
South St
Williamstown, MA 01267

Cleveland Museum of Art
11150 East Blvd
Cleveland, OH 44106

Colonial Williamsburg Found.
Department of Collections
Williamsburg, VA 23185

Cooper-Hewitt Museum of Design
9 East 90th St
New York, NY 10028

Davison Art Center
301 High St
Wesleyan University
Middletown, CT 06457

Detroit Institute of Arts
Dept. of Graphic Arts
5200 Woodward Ave
Detroit, MI 48202

Fogg Art Museum
Dept. of Prints & Photographs
Harvard University
Cambridge, MA 02138

Free Library of Philadelphia
Print & Picture Dept
Logan Sq
Philadelphia, PA 19103

The Frick Collection
1 East 70th St
New York, NY 10021

Grolier Club Library
47 East 60th ST
New York, NY 10022

Grunwald Center for the
Graphic Arts
Univ. of Cal., Los Angeles
405 Hilgard Ave
Los Angeles, CA 90024

Solomon R. Guggenheim
Museum
1071 Fifth Ave
New York, NY 10028

Herbert I. Johnson
Museum of Art
Cornell University
Ithaca, NY 14853

High Museum of Art
1280 Peachtree St NE
Atlanta, GA 30309

Hispanic Society of America
Broadway & 155 St
New York, NY 10032

Houghton Library
Harvard University
Dept. of Printing & Graphic
Arts
Cambridge, MA 02138

Henry E. Huntington Library
Art Gallery & Botanical
Gardens
1151 Oxford Rd
San Marino, CA 91108

Kimbell Art Museum
P.O. Box 9440
Will Rogers Road West
Fort Worth, TX 76107

Library of Congress
Prints & Photographs Div.
2nd St. & Independence Ave SE
Washington, DC 20540

Los Angeles County Museum
of Art
5905 Wilshire Blvd
Los Angeles, CA 90036

Madison Art Center
720 East Gorham
Madison, WS 53703

Metropolitan Museum of Art
Dept. of Prints&Photographs
Fifth Ave at 82nd St
New York, NY 10025

Minneapolis Inst. of Art
Dept. of Prints & Dwgs
2400 Third Ave S.
Minneapolis, MN 55404

Pierpont Morgan Library
29 East 36th St
New York, NY 10016

Munson-Williams-Proctor
Institute
310 Genesee St
Utica, NY 13502

Museum of Fine Arts
479 Huntington Ave
Boston, MA 02115

Museum of Fine Arts-Houston
1001 Bissonnet
Houston, TX 77005

Museum of Modern Art
11 West 53rd St
New York, NY 10019

Nat'nl Museum of American Art
Smithsonian Institution
Ninth & G St., NW
Washington, DC 20560

National Gallery of Art
Sixth St. & Constitution
Ave, NW
Washington, DC 20565

Nelson Gallery-Atkins Museum
4525 Oak St
Kansas City, MO 64111

New York Historical Society
Print Room
170 Central Park West
New York, NY 10024

New York Public Library
Prints Divison
Fifth Ave & 42nd St
New York, NY 10018

Philadelphia Museum of Art
Benjamin Franklin Pkwy
@ 26th St
Philadelphia, PA 19101

Picker Art Gallery
Colgate University
Hamilton, NY 13346

Portland Museum of Art
1219 S.W. Park
Portland, OR 97205

Princeton Univ. Art Museum
Print Room
Princeton, NJ 18540

Rhode Island School of Design
Museum of Art
224 Benefit St
Providence, RI 02903

St. Louis Art Museum
Forest Park
St. Louis, MO 63110

San Francisco Museum of Art
Van Ness Ave @ McAllister St
San Francisco, CA 94102

Smith College Museum of Art
Northampton, MA 01060

Toledo Museum of Art
Toledo, OH 43697

Wadsworth Atheneum
Hartford, CT 06115

Walker Art Center
Vineland Pl
Minneapolis, MN 55403

Whitney Museum of
American Art
945 Madison Ave
New York, NY 10021

Henry Francis de Pont
Winterthur Museum
Winterthur, DE 19735

Worcester Art Museum
j55 Salisbury St
Worcester, MA 01608

Yale Univ Art Gallery
1111 Chapel St
New Haven, CT 06520

Important Notes

Important Notes